Dreamscapes

& Artificial Architecture

IMAGINED INTERIOR DESIGN IN DIGITAL ART

gestalten

TABLE OF CONTENTS

PP. 4–9
The Impossible Architecture of Dreams

PP. 10–15
Paul Milinski

PP. 16–17
Studio Brasch

PP. 18–21
Yambo Studio

PP. 22–23
Antoni Tudisco

PP. 24–27
Hugo Fournier

PP. 28–33
Seba Morales

PP. 34–35
Jonathan Monaghan

PP. 36–37
Blake Kathryn

PP. 38–41
Visual Citizens

PP. 42–43
Morten Lasskogen

PP. 44–45
Frank J. Guzzone

PP. 46–49
Simon Kaempfer

PP. 50–51
Rebecca Lee

PP. 52–63 PROFILE
Six N. Five

PP. 64–69
ZEITGUISED

PP. 70–71
Peter Favinger

PP. 72–79
Filip Hodas

PP. 80–81
Cameron Burns

PP. 82–85
Hayden Clay

PP. 86–89
Nareg Taimoorian

PP. 90–97 PROFILE
Charlotte Taylor

PP. 98–99
Stefano Giacomello

PP. 100–103
Daniel Ursuleanu

PP. 104–105
Friedrich Neumann

PP. 106–113
Santi Zoraidez

PP. 114–115
OUUM

PP. 116–117
Julien Missaire

PP. 118–125 PROFILE
PZZZA STUDIO

PP. 126–127
Thomas Traum

PP. 128–129
Blunt Action

PP. 130–133
Ana de Santos Díaz

PP. 134–139
Cristina Lello Studio

PP. 140–149
notooSTUDIO

PP. 150–157 PROFILE
Massimo Colonna

PP. 158–159
Roman Bratschi

PP. 160–163
Studio Manège

PP. 164–165
BÜRO UFHO

PP. 166–175 PROFILE
Alexis Christodoulou

PP. 176–183
Peter Tarka

PP. 184–191
Reisinger Studio

PP. 192–193
Spot Studio

PP. 194–195
Gonzalo Miranda

PP. 196–199
Filmdecay

PP. 200–205
Terzo Piano

PP. 206–207
Index

THE IMPOSSIBLE ARCHITECTURE OF DREAMS

Dreams have long been a subject of artistic enquiry. Where does our subconscious go during sleep? What do our dreamscapes mean, and can they ever be made into physical spaces?

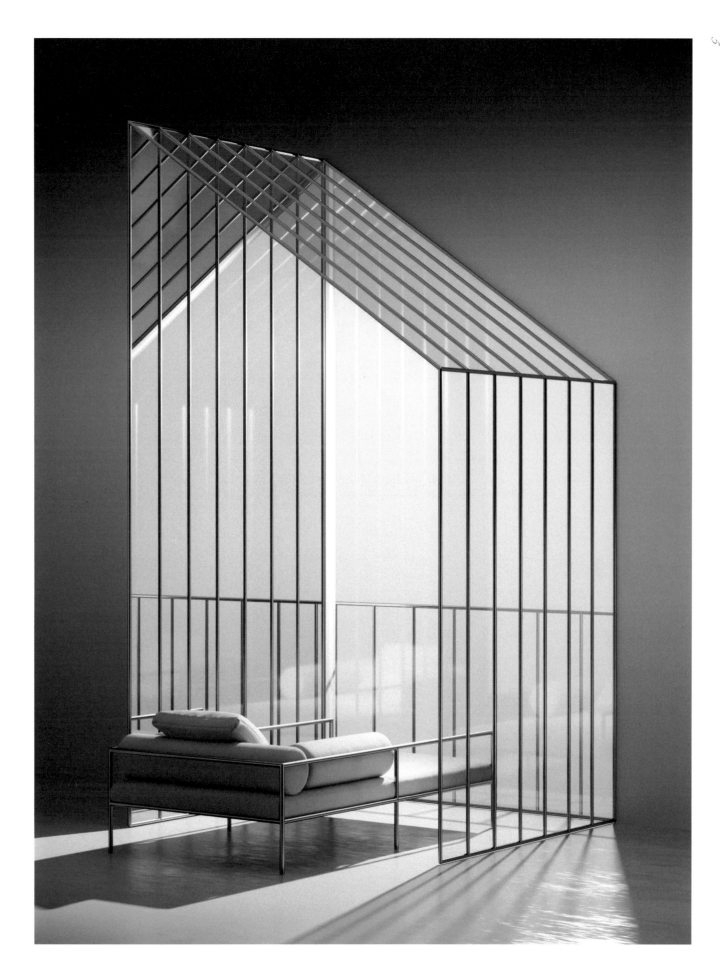

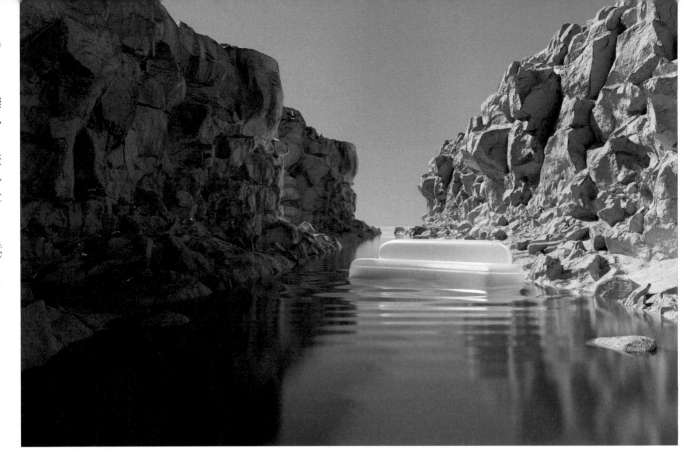

Where do we go when we dream? This surreal territory has proved fertile ground for a new generation of contemporary artists working at the intersection of architecture, interior design, and technology. Drawing upon utopian hopes and dystopian fears, the dreamscapes of these creations offer intriguing insight into a new movement in digital art.

This movement is closely tied to the rise of technology and social media—a pairing that has had an immeasurable effect on creative mediums and, most notably, on the crossover between them. In the digital realm, art, interior design, and architecture are no longer distinct. In the dreamscapes featured in this book, they coalesce entirely.

The widespread use of 3D modeling programs has made this aesthetic intermingling possible. Architecture and design are no longer only analogue. Today, buildings can be realized digitally with software such as Rhinoceros 3D, Enscape, Lumion, and Octane. Renderings of houses have become common to the point of ubiquity, and it can often be difficult to distinguish between what is real and what is not.

Modeling software is not industry specific; you don't have to be an architect to design a building, or an interior designer to render a space. In recent years it has become increasingly popular among artists, who take the visual language of traditional CGI and apply it in new and interesting ways. In this book, this is exemplified by renders of impossible spaces that cannot—and will not—be built.

Like many contemporary visual trends, the dreamscape movement has been shaped by the social media platform that it has proliferated on. On Instagram, user habits are regulated by the platform, and "likes" feed an algorithm that defines what is trending. In this digital echo chamber, trends spread memetically. The visual motifs common in dreamscapes—opalescent orbs, pink skies, curved doorways, swimming pools—recur across the platform in images of both art and life. While such elements and their popularity are not all new, these intriguing combinations are.

Within dreamscapes, different design movements mill alongside one another. Pastel postmodern structures are just as likely to house a surrealist pool and a suspended sphere as they are the undulating couches of Swiss artist Ubald Klug, or Faye Toogood's recent but iconic Roly Poly Chair. As artists are employed to render advertising campaigns for everything from fashion to furniture and technology, such blurring of the real and unreal is increasingly common, and it's an effective marketing tool.

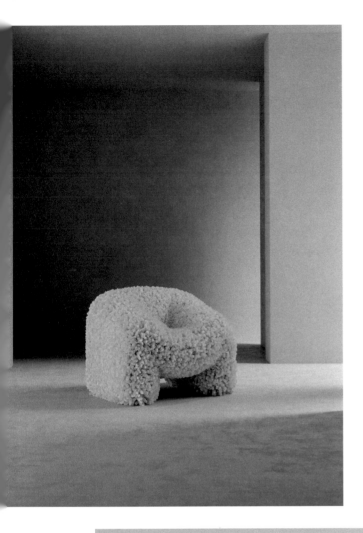
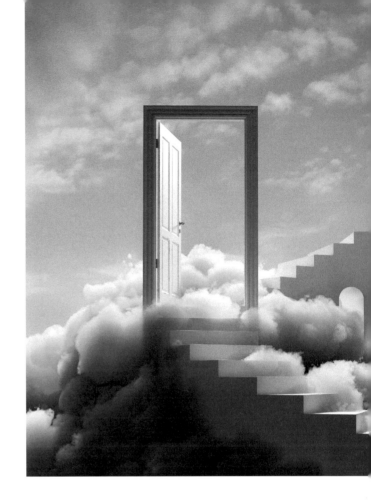
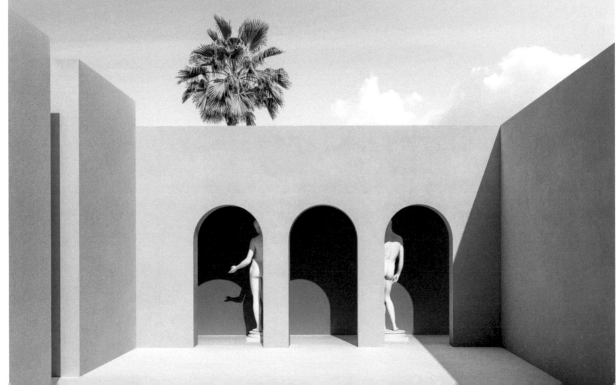

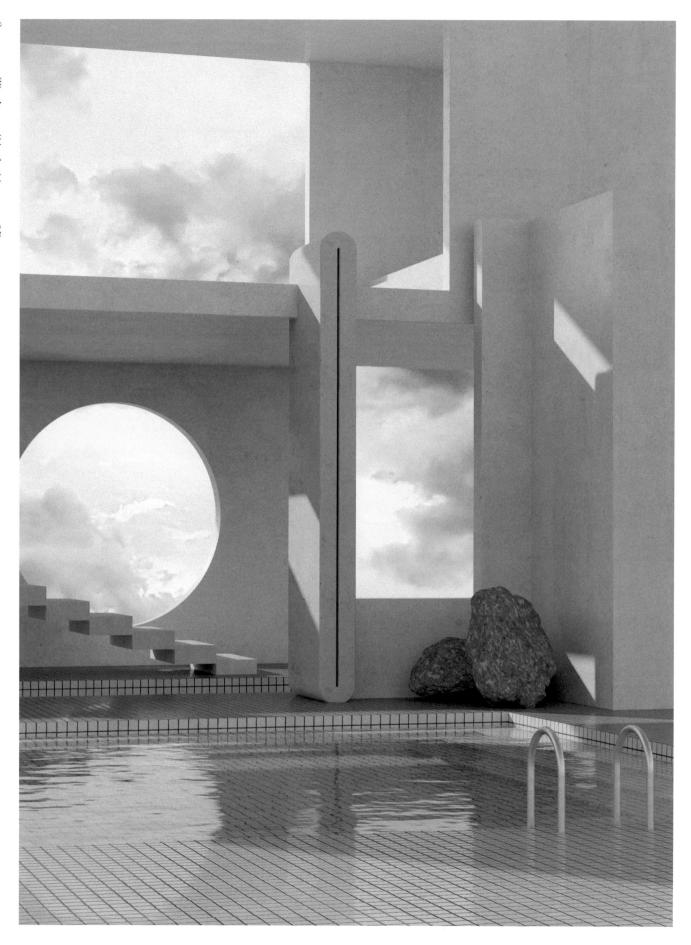

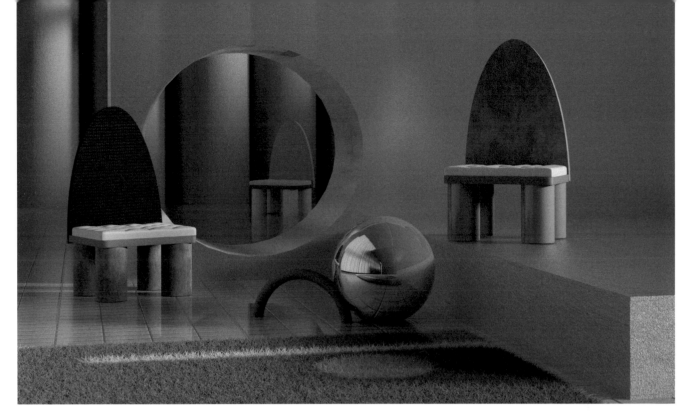

Samsung's "Perfect Reality" campaign from 2019 is an example of how rendering translates from art to advertising. In the two-part video series advertising the QLED 8K television, the hyperreal nature of Six N. Five's work conveys the ocular quality of the product. The campaign is set in a dreamscape where moons multiply and disappear, and "reality" is played to an audience through a television screen.

In 2018, the physical and the digital collided when artist Andrés Reisinger published a 3D image of the Hortensia Chair on Instagram. The dusky-pink CGI lounge chair went viral, garnering thousands of likes and winning fans. Customers contacted the studio, asking to buy a piece of furniture that did not physically exist. Reisinger gave in to popular demand, and, in 2019, the Hortensia Chair became a real product, its iconic, textured exterior rendered in real life through 20,000 fluttering pink petals. Here, the unreal engendered the real.

This discombobulation feels appropriate, given the surreal nature of dreamscapes. These scenes do not seek to answer questions, but to propose them. The improbable interiors of Alexis Christodoulou recall the work of M.C. Escher—whose staircases you can never climb all the way up—and there is no denying the overarching reference to René Magritte, whose palette and symbolic use of architecture recur throughout this book.

But the oneiric spaces that have arisen from this genre of digital art are not always utopian. Like the work of the surrealists, they can also be frightening and uncanny, designed to elicit apprehension or fear. Filip Hodas's post-apocalyptic renderings do just this: among the overgrown landscapes of his imagination stand derelict pop culture icons—lifeless Mickey Mouse heads and shattered Poké Balls. Though familiar, they are unsettling. Such scenes operate in the same way as those that are serene, working to splinter a fixed idea by introducing unreal possibilities to a scene that otherwise feels real.

Gaming, AR, VR, and special cinematic effects offer similarly strange experiences, where the laws of physics don't apply. The designer has the power to upend gravity, to manipulate time and space. From the cyberpunk streets of *Blade Runner 2049* to the Afrofuturist heart of Wakanda in *Black Panther*, advances in CGI are taking immersive world-building to new levels.

We have never before had such capacity to render the world as we would like it to be, which means 3D modeling software has the potential to be immensely liberating. If, as it does in the dreamscapes of this book, it can free architecture and design from the constraints of reality, then surely it can do the same for other aspects of our life. Are these then visions of dreams, or of a new world entirely? ✧

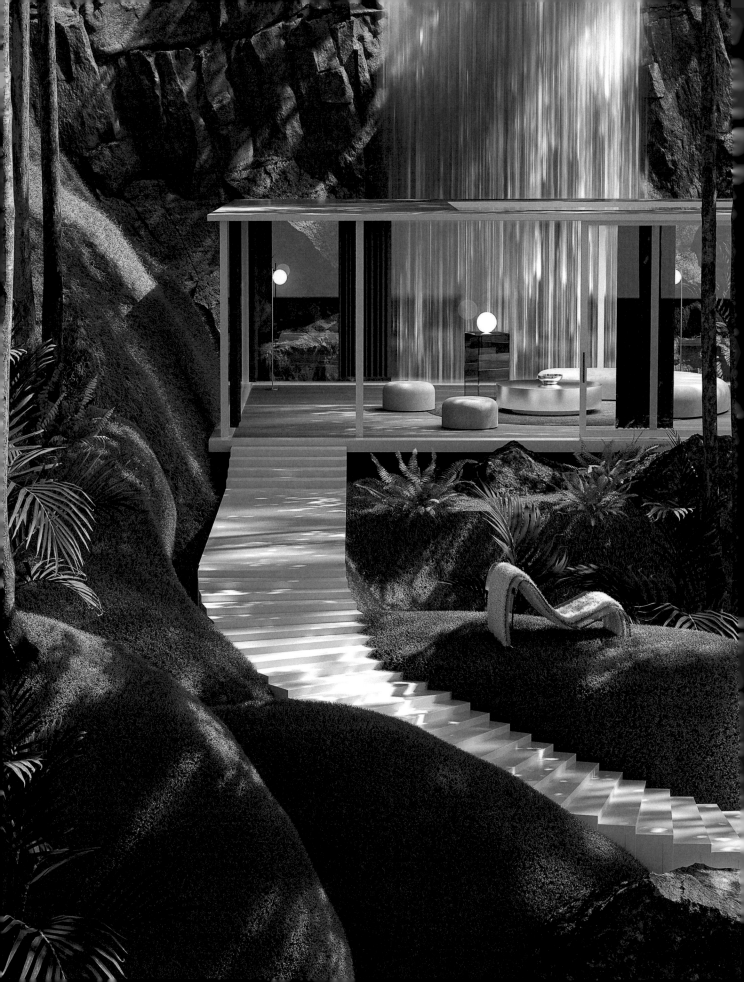

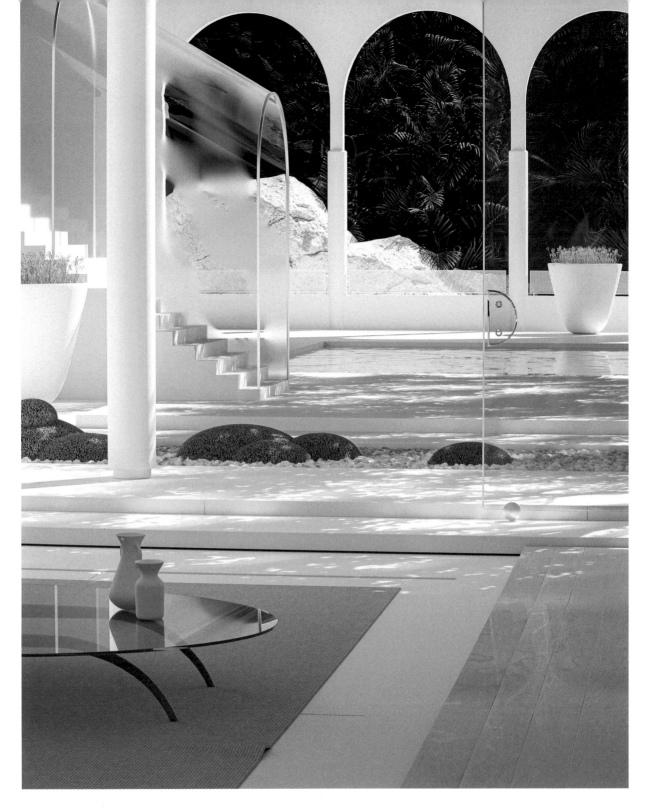

PAUL MILINSKI
Melbourne, Australia

In some of Paul Milinski's pieces, you might see patterns of steam on the glass objects. These are a subtle nod to his daily "epiphany showers," in which he comes up with the shapes and forms to fit the mood he wants to convey. Inspired by the film *Toy Story*, Milinski became interested in 3D as an art medium when he was nine years old. His surreal visualizations are dominated by vegetation, but he then adds architectural details and furniture to create a sense of security and comfort amid the eerier aspects of the natural world. ✧

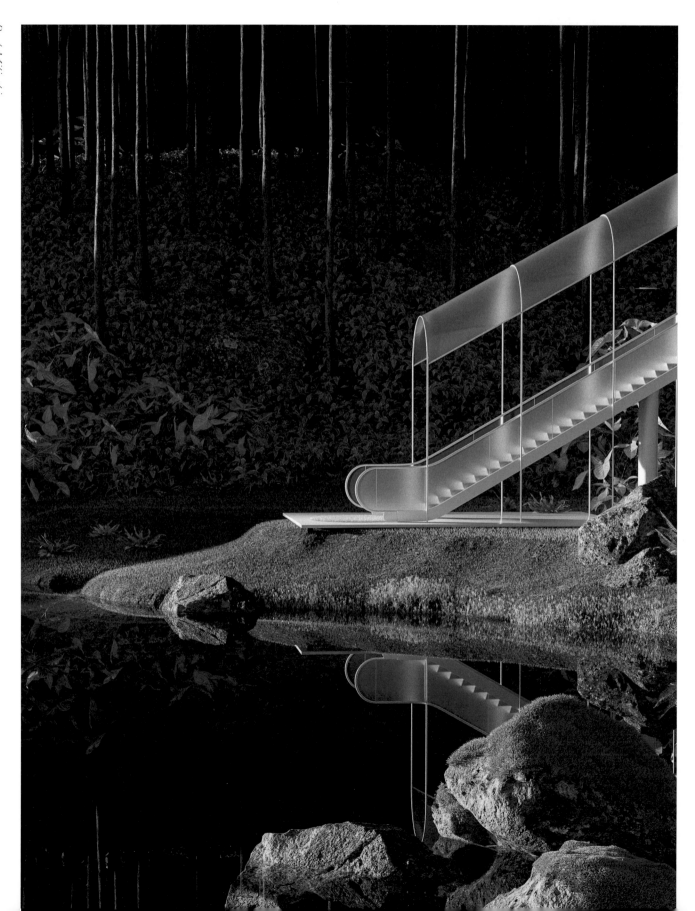

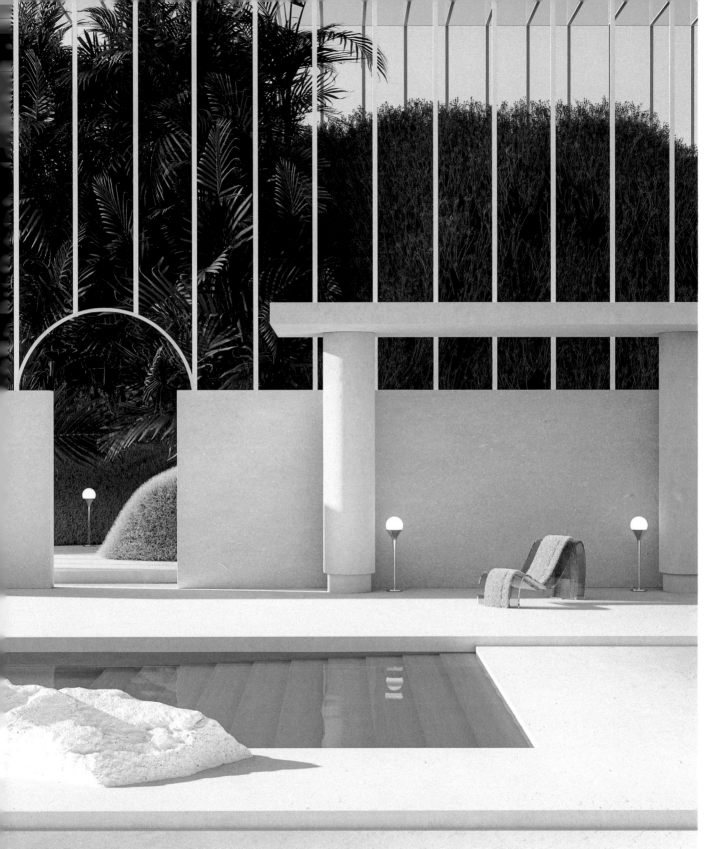

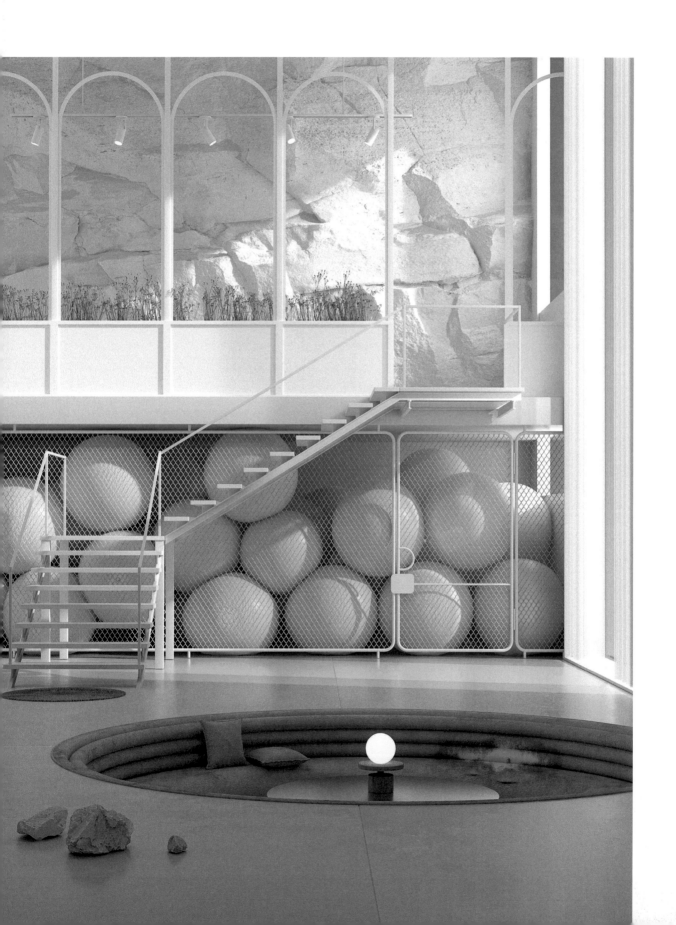

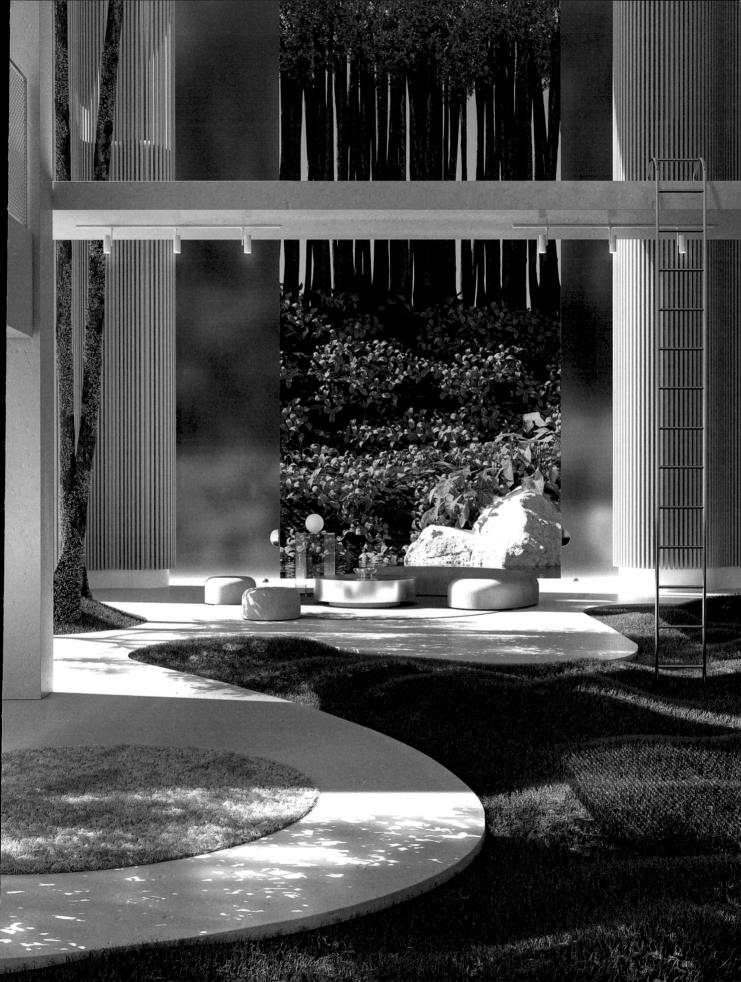

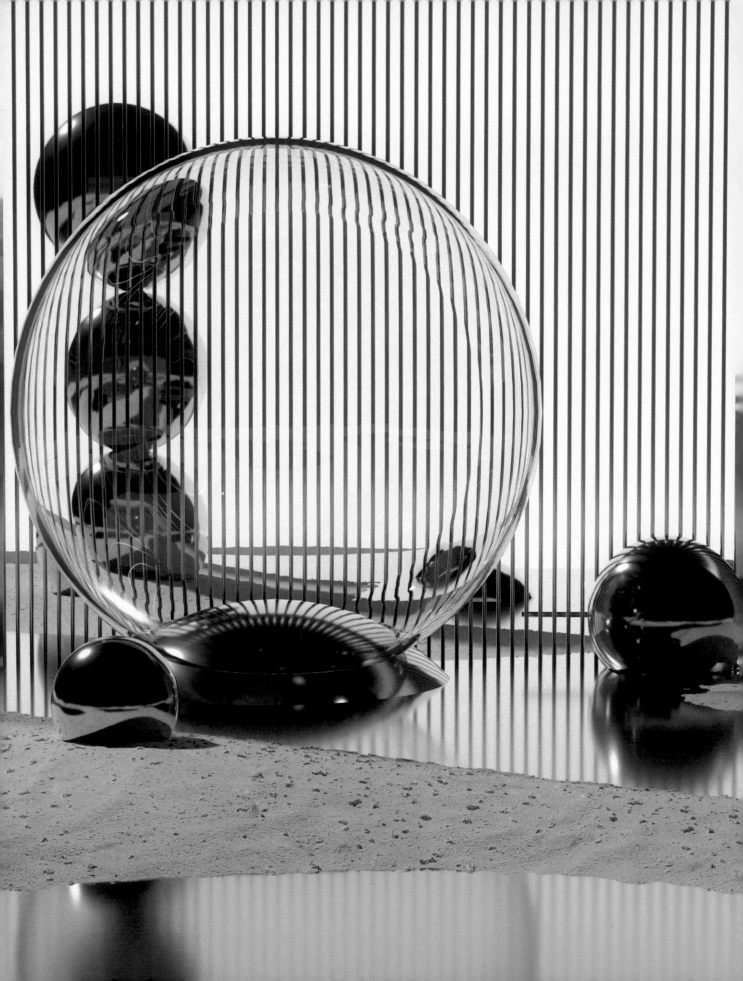

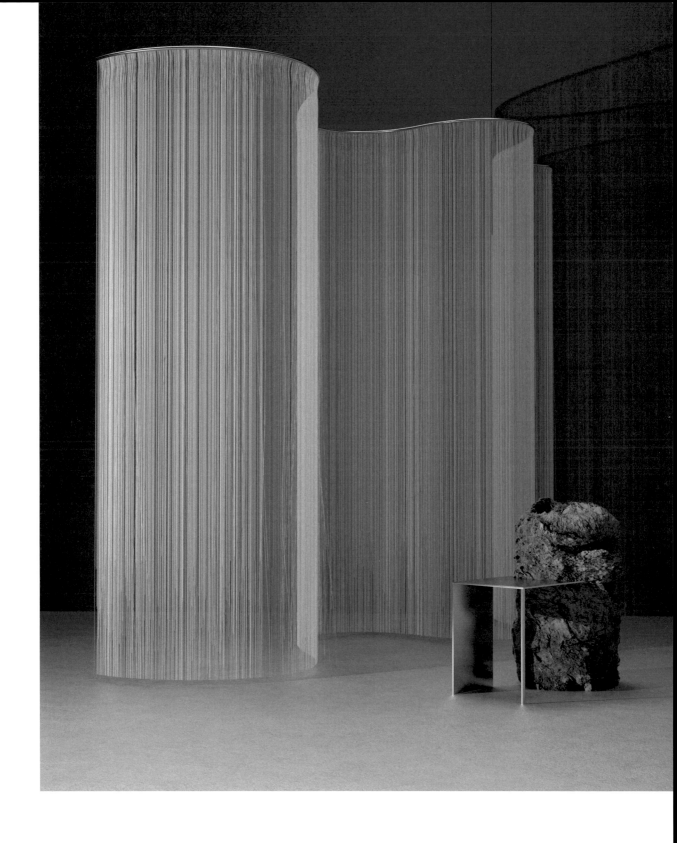

STUDIO BRASCH
Stockholm, Sweden

When Studio Brasch began its series *A Lucid Dream in Pink, Sleep Cycle No 1-7,* which consisted of phantasmagorical rooms in 3D, it sought to embody the fresh memories of the previous night's dreams. Using hyperrealism and mysterious details, Studio Brasch prompts viewers to access those alluring, disorientating emotions that dreams often provoke. In the studio's work with brands like Cartier and Chanel, high fashion products soften and dissolve, ultimately becoming the stuff of dreams. ✧

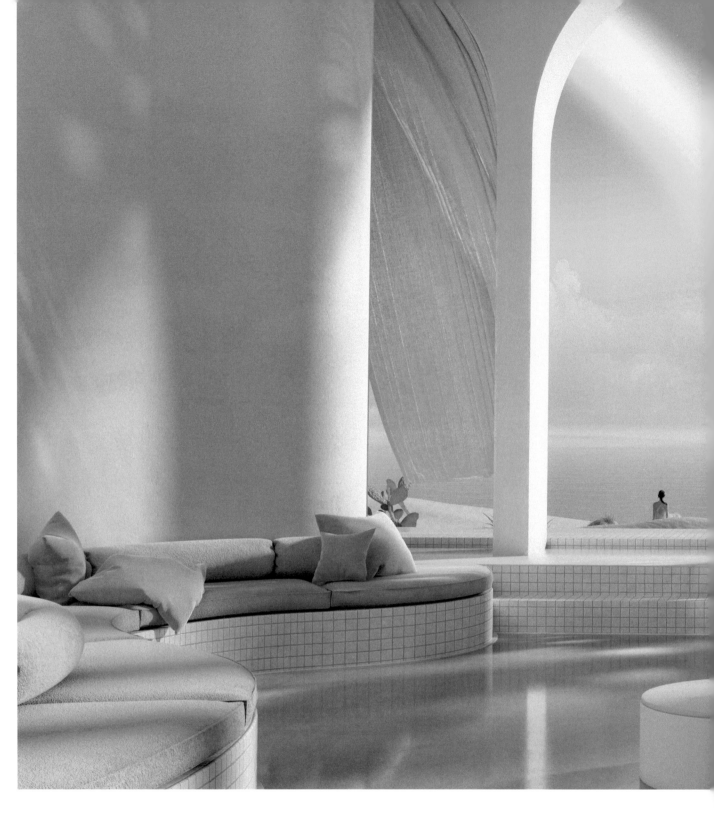

YAMBO STUDIO
Tel Aviv, Israel

With a central office in Tel Aviv, Yambo Studio is a global, multidisciplinary team of designers who collaborate through language barriers and time zones. In 2017, the studio began using architecture and interior design to mirror the shape of a phone for a project with Chinese electronics brand, Xiaomi. Now they bring interior design and architecture into almost every project they do. The studio has recently worked with Google, Nike, Oppo, and many more. ✦

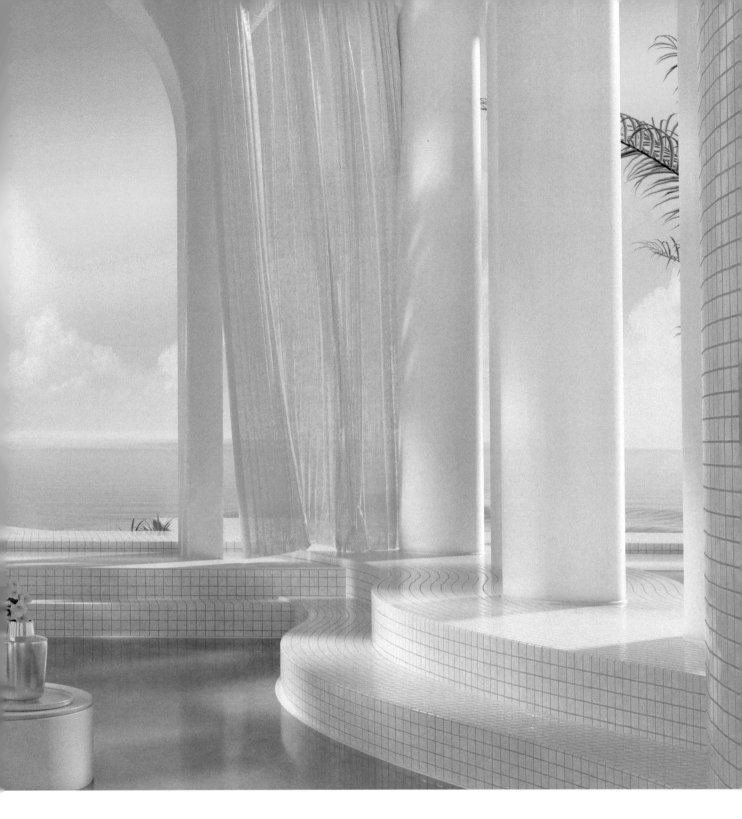

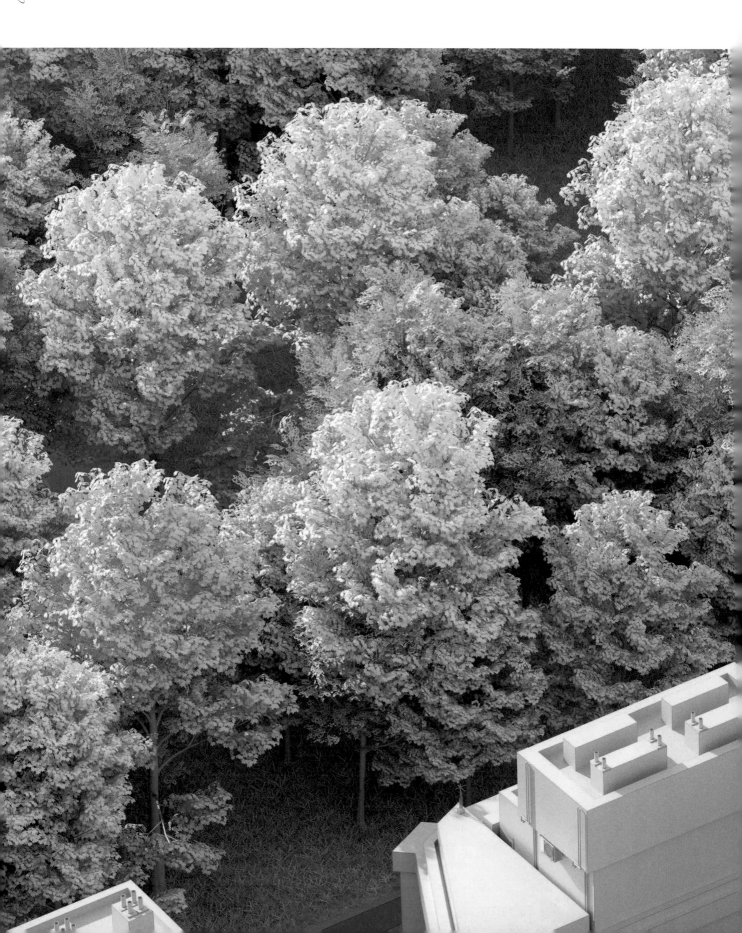

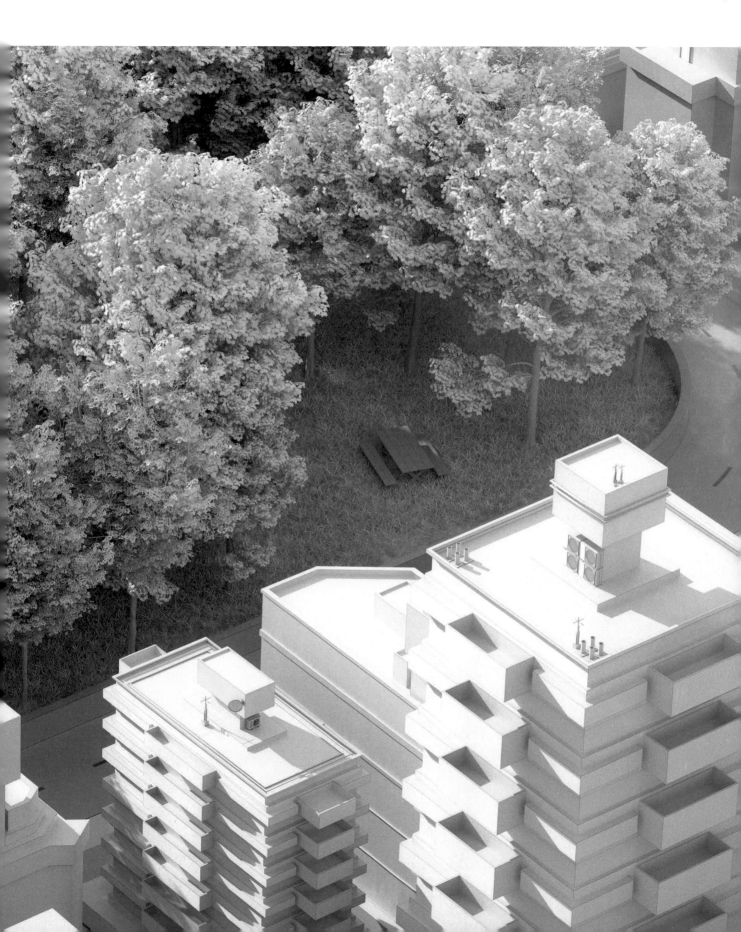

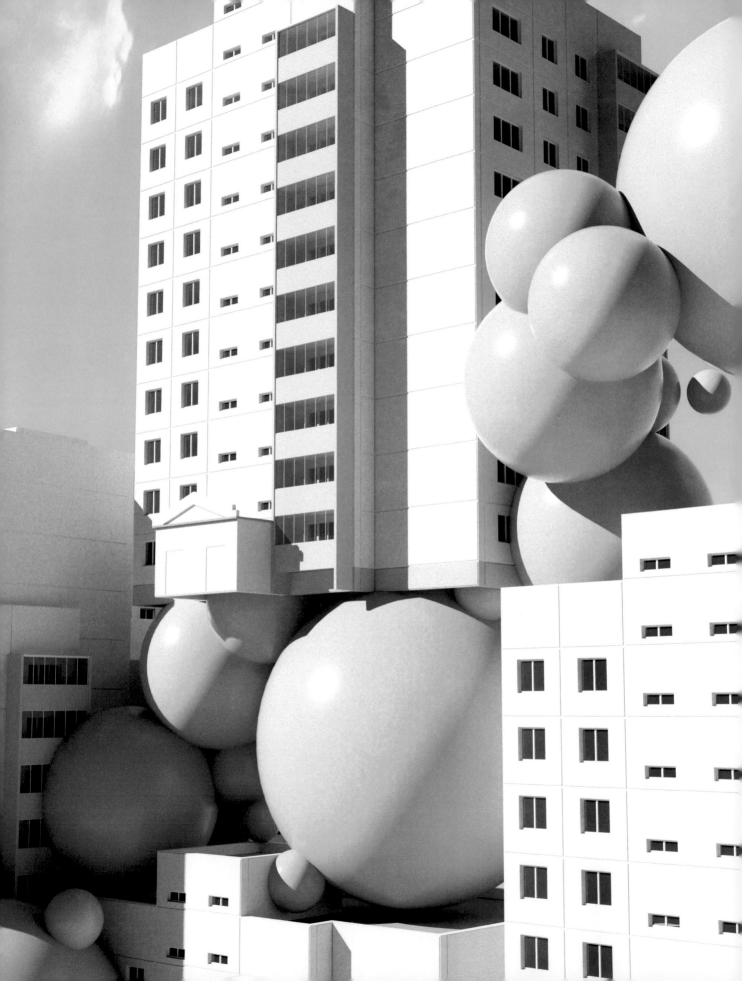

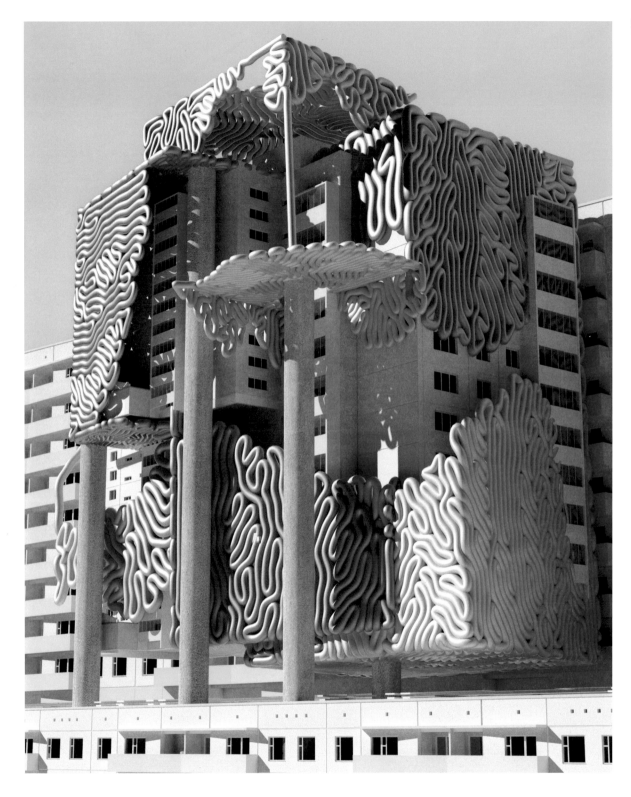

ANTONI TUDISCO
Hamburg, Germany

Antoni Tudisco has become known for his mix of street-style and surreal 3D images. Many of Tudisco's works feature human-like figures, contorted and modified into strangely fashionable alien hybrids, with gold teeth and emoji-tattooed faces. The dreamscapes he creates often contain something fleshy, like a hint of gray matter or a tongue, alongside soft textiles and glowing orbs. A self-professed "sneakerhead," Tudisco has worked with brands such as Nike, Reebok, Puma, and Adidas. ✦

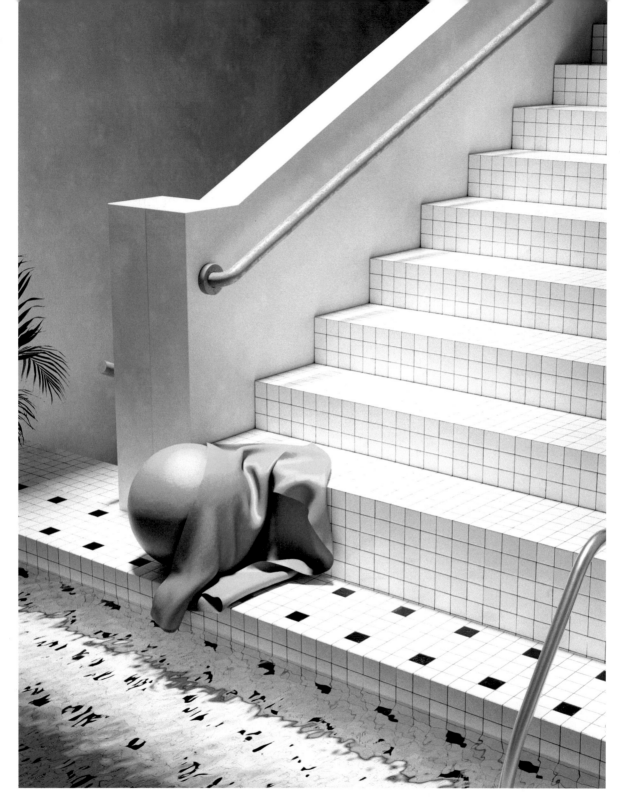

HUGO FOURNIER
Paris, France

Hugo Fournier's 3D works mix materials and colors into improbable sculptural configurations, combining furniture with household and art objects. His artistic trajectory began with Photoshop collages, but eventually he felt constrained and turned to 3D, which allowed him to develop his fantastical ideas. The architecture and design elements in Fournier's images are inspired by the creature-like shapes of Hungarian architect Antti Lovag, as well as more polished modernists including Claudio Silvestrin and Ludwig Mies van der Rohe. ✧

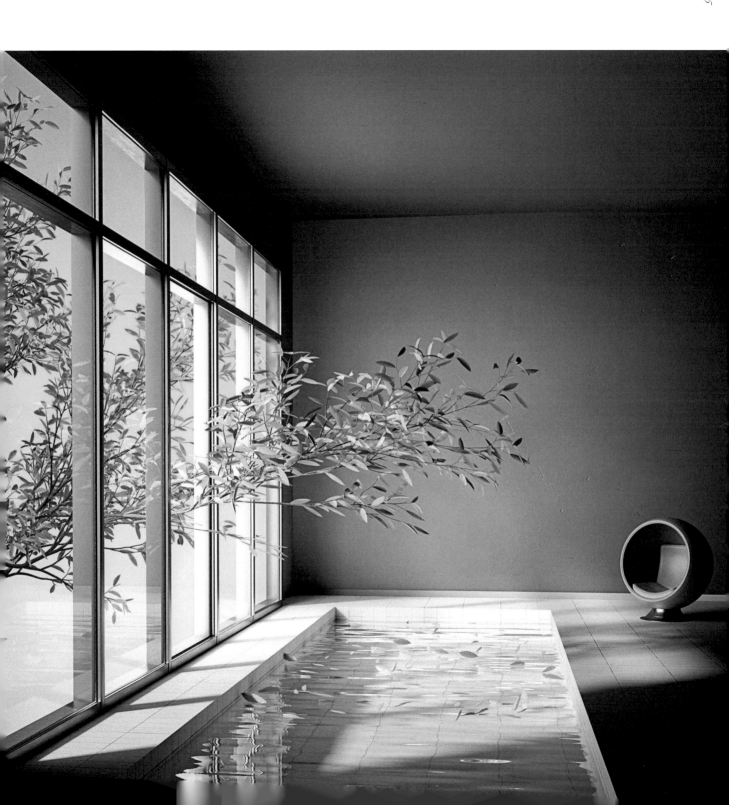

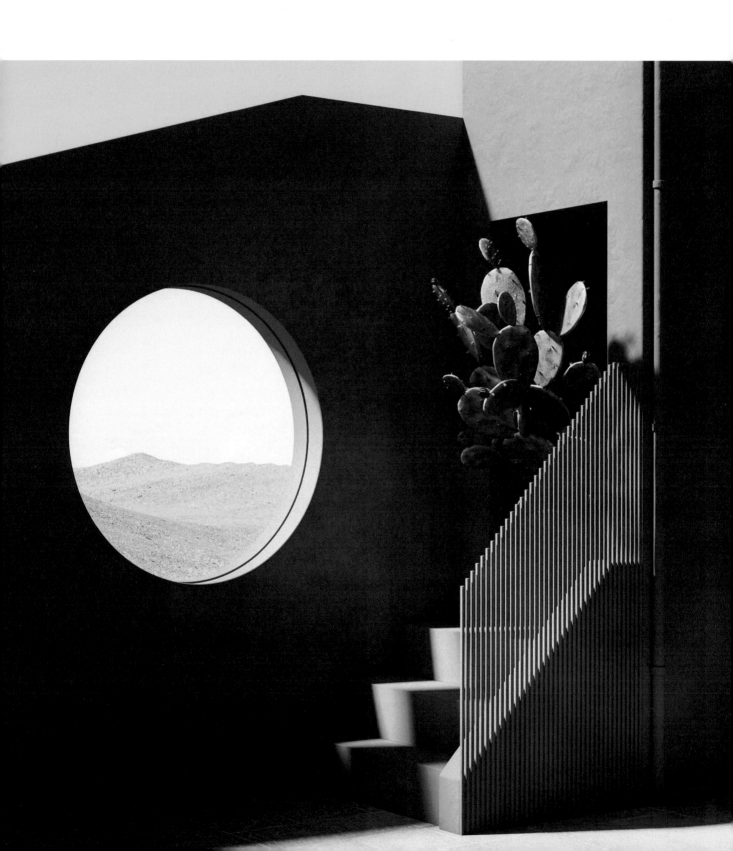

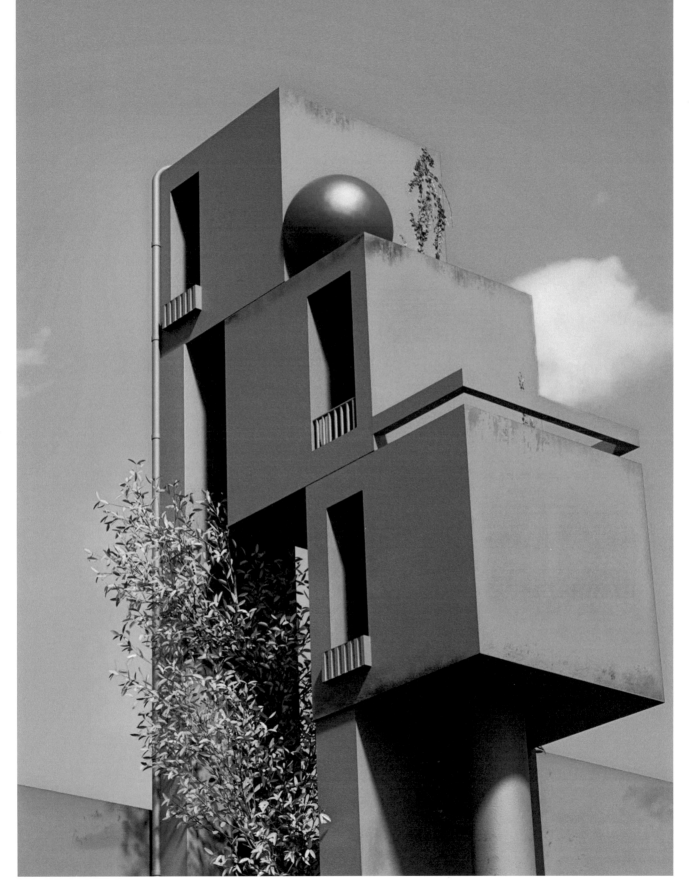

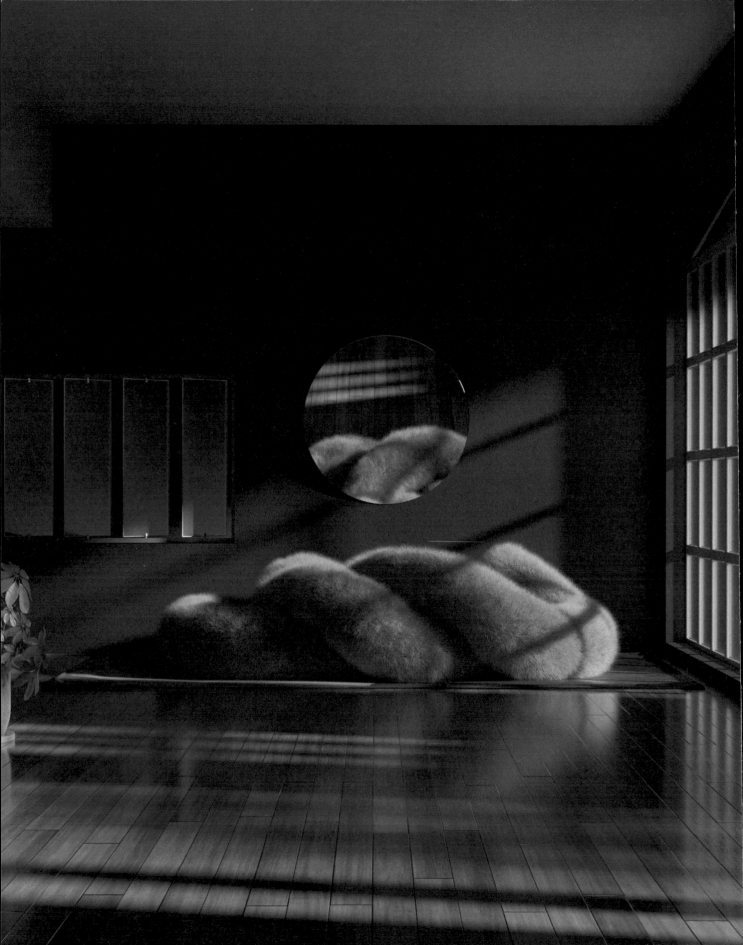

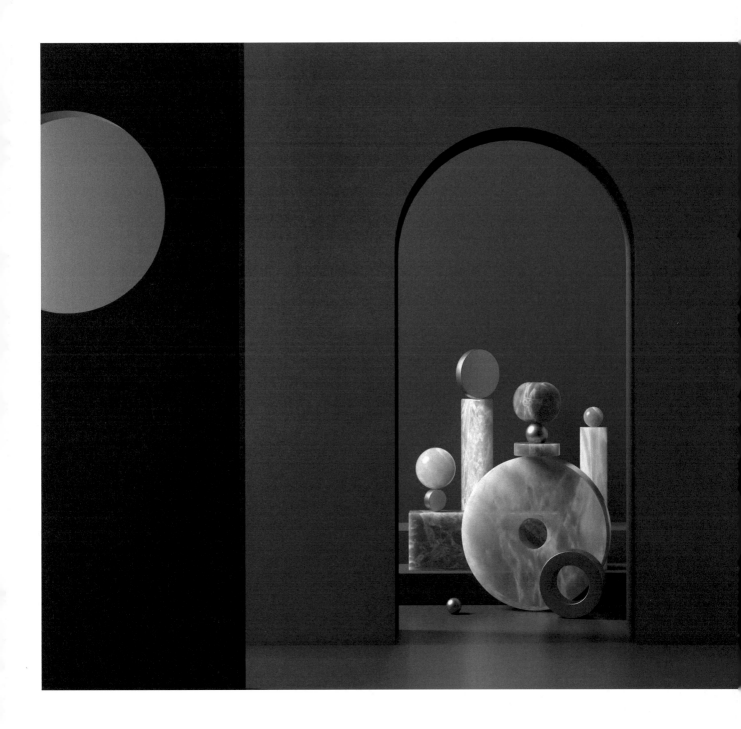

SEBA MORALES
La Plata, Argentina

Seba Morales creates environments that evoke a sense of peacefulness and escape. Paying particular attention to the interplay of light and shadow, he transmits a calming warmth with his interiors and landscapes, a quest that he began a year ago between commercial and experimental works. Morales describes his style as "eclectic," encompassing a range of inspiring objects and textures, and constantly evolving. For Morales, furniture and buildings are the ideal stage for showcasing the shape and structure of objects and products. ✦

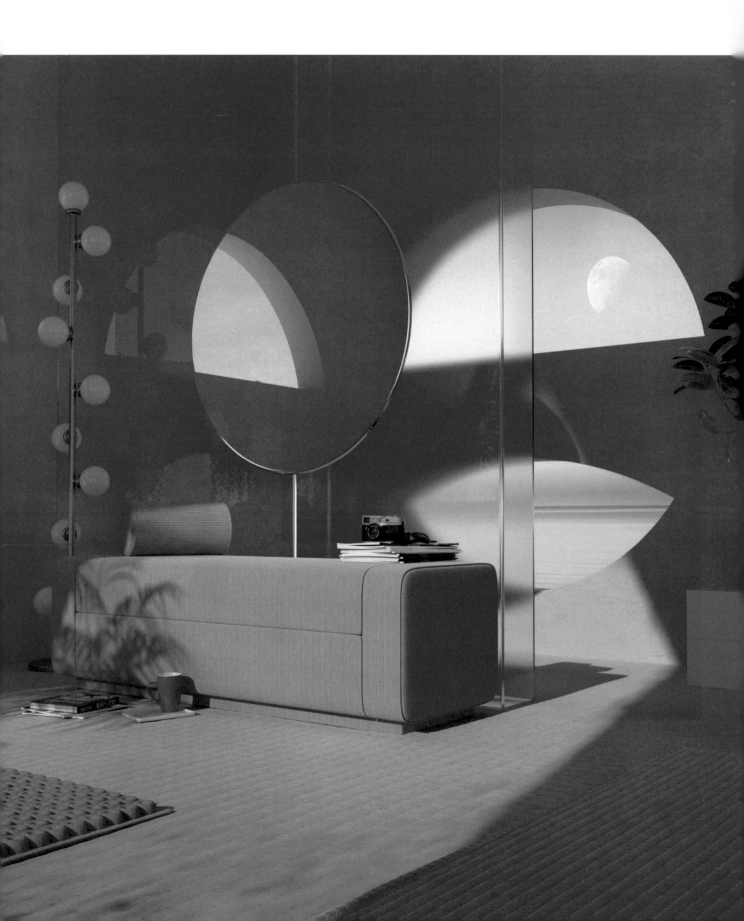

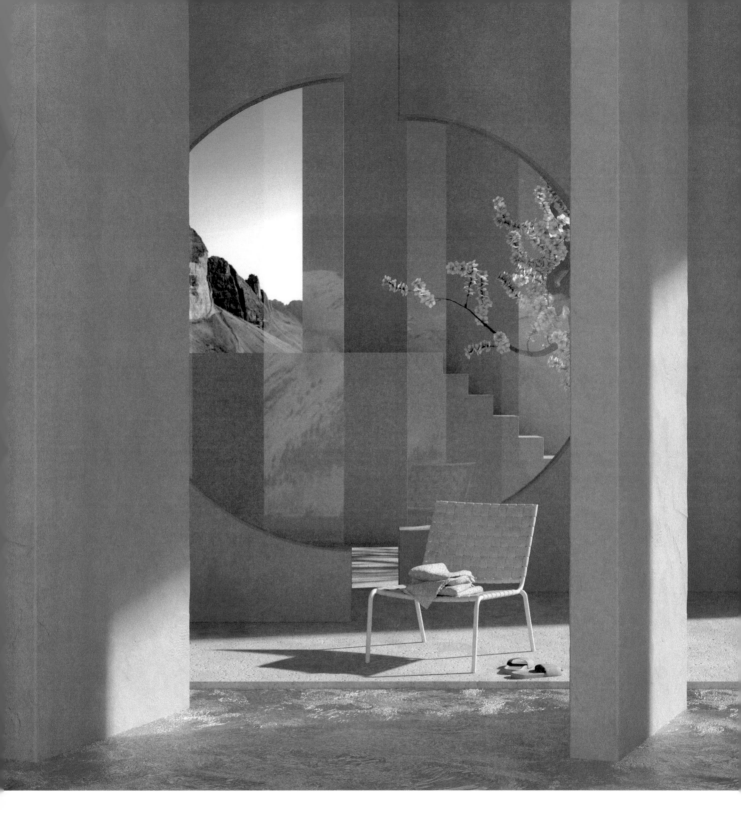

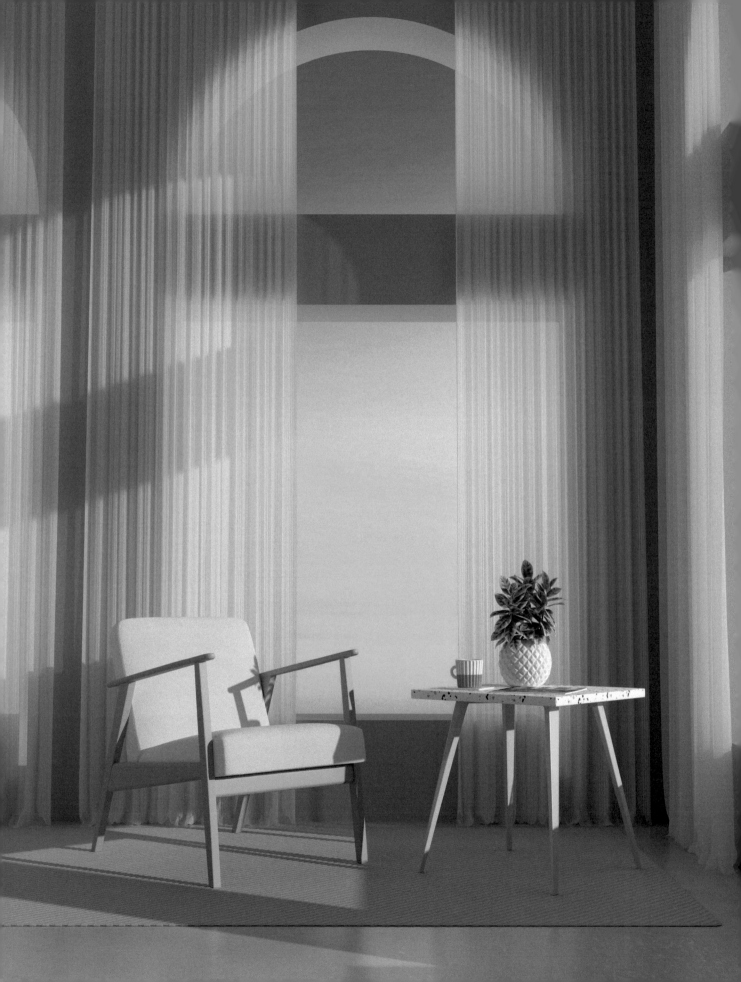

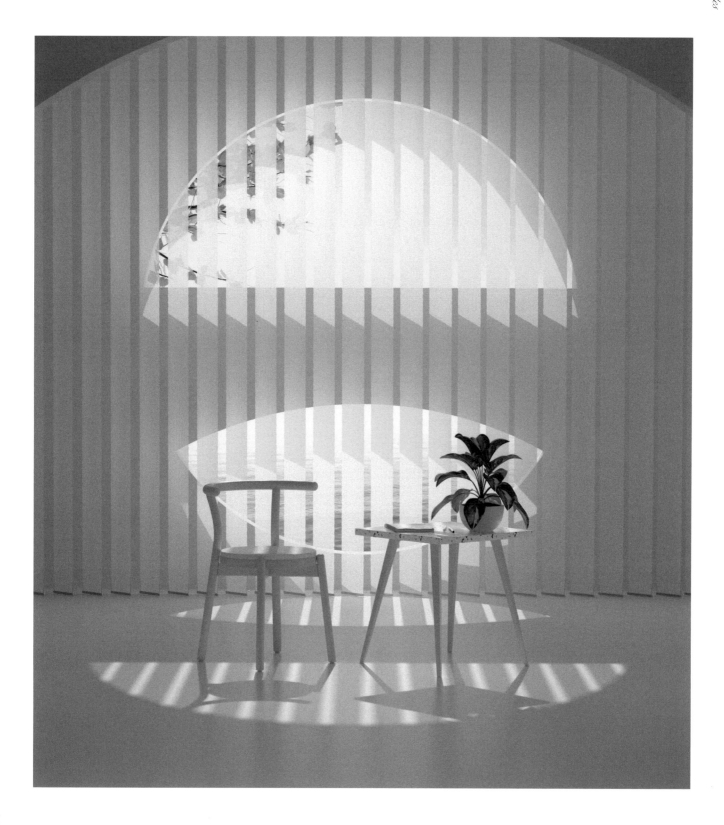

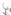

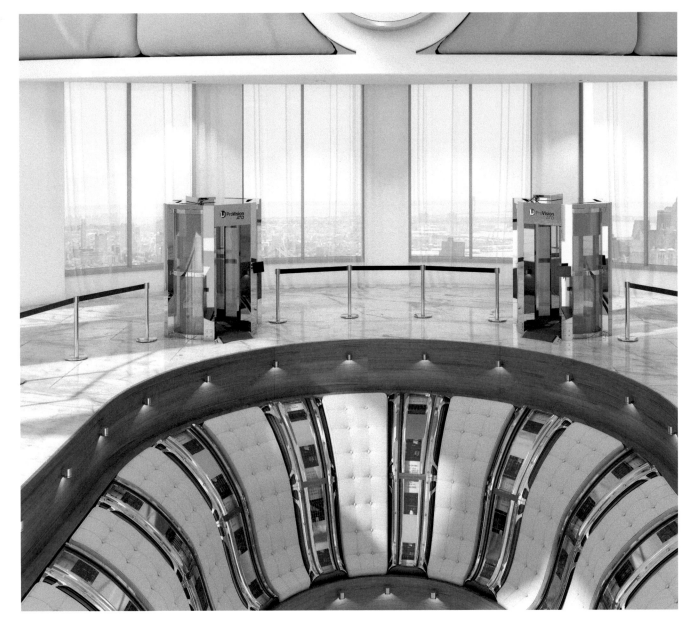

JONATHAN MONAGHAN
New York City, NY
USA

Drawn to the idea of creating photorealistic images in 3D, Jonathan Monaghan originally studied computer graphics. He quickly realized his scenes were weirder than what many of his fellow students were designing, and he branched out into the art world. Now, Monaghan creates a kind of contemporary mythology in his work, with soft-pink interiors and plush fabrics contrasting with robots and surveillance equipment. He explores our desire for luxury and wealth, and our anxiety about an increasingly technology-driven future. ✦

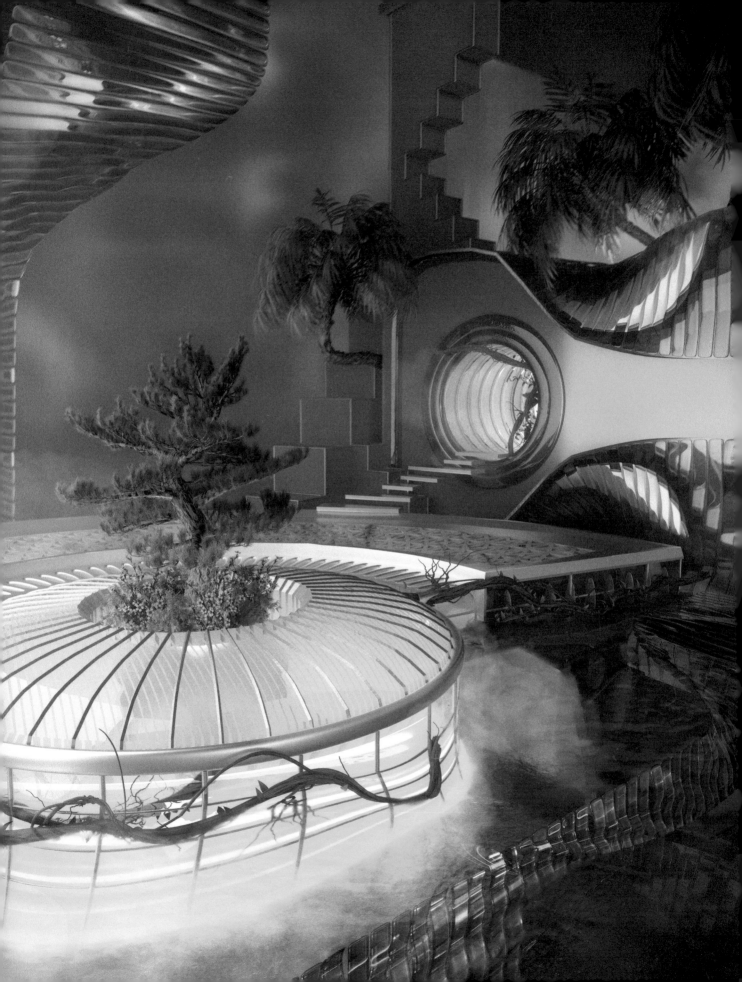

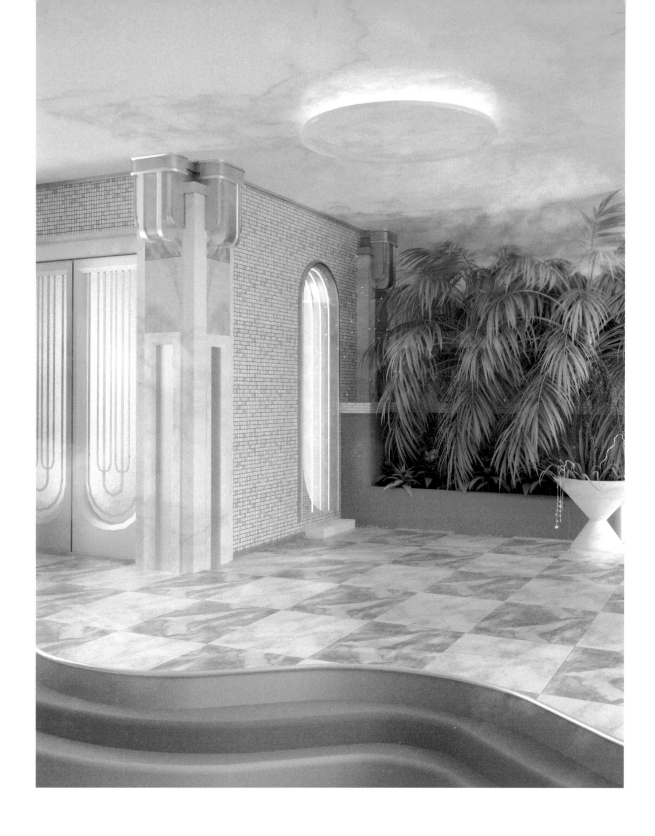

BLAKE KATHRYN
Los Angeles, CA
USA

Blake Kathryn has been a practicing digital artist for five years, but in 2018 she became tired of minimal aesthetics, so she began introducing architectural elements into her hallucinatory environments. Kathryn's futuristic designs awaken feelings of nostalgia and point to altered states of consciousness. Kathryn has worked with brands including Fendi, Adidas, and Facebook. ✧

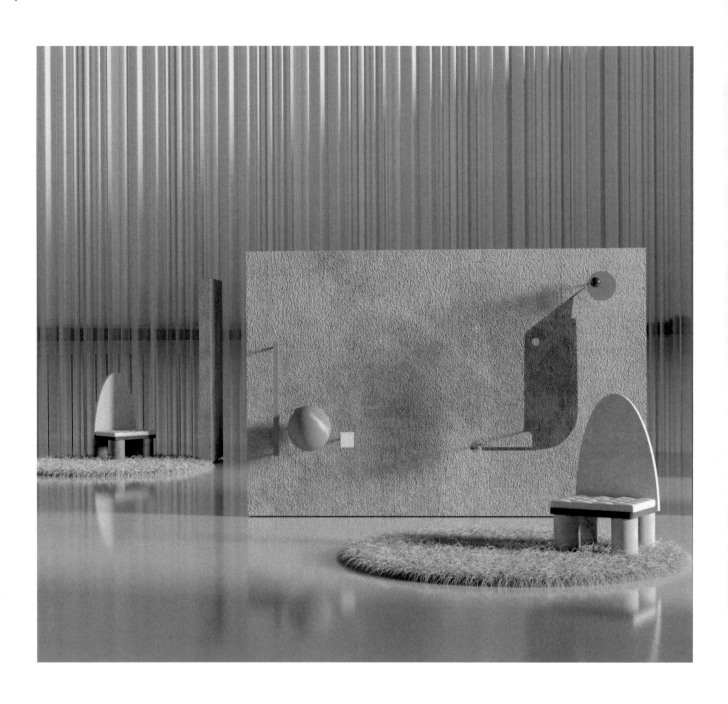

VISUAL CITIZENS
Rotterdam, Netherlands

Visual Citizens specializes in surreal immersive visuals. Its founders, Shali Moodley and Adam Kelly, met in an architecture office in Spain and founded the studio in Cape Town in 2018. Eschewing the constraints of practical design and architecture, the duo began rendering dream-like environments filled with fantastical objects. Visual Citizens collaborated with furniture designer Geke Lensink to present her new collection, *Souvenir*—a futuristic oasis—at Milan Design Week 2019. ✧

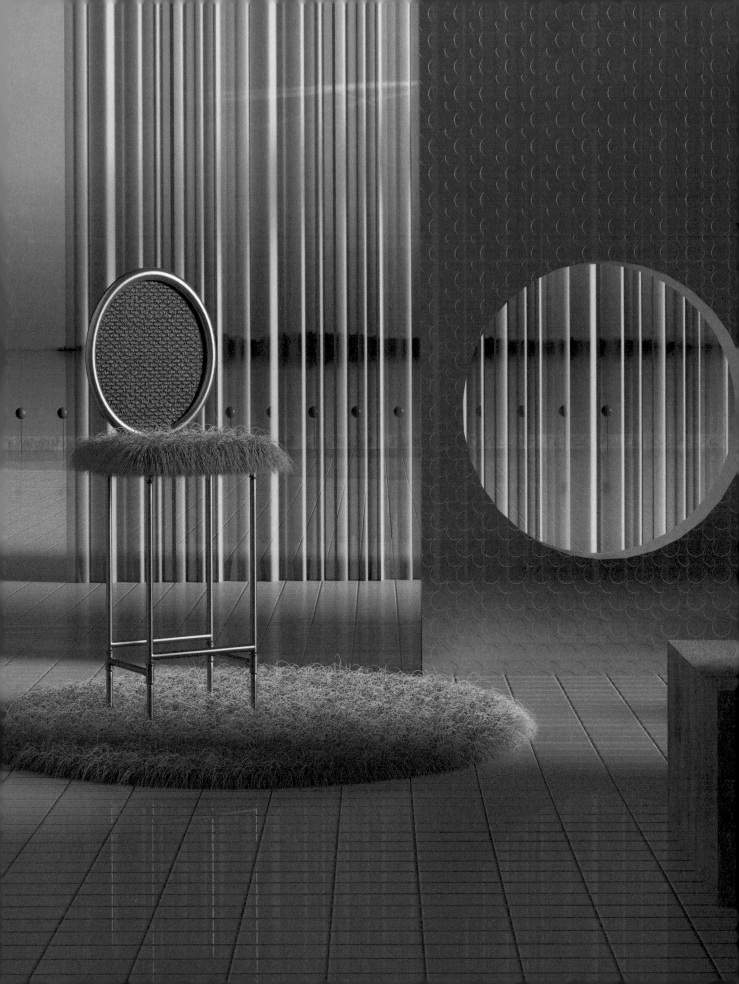

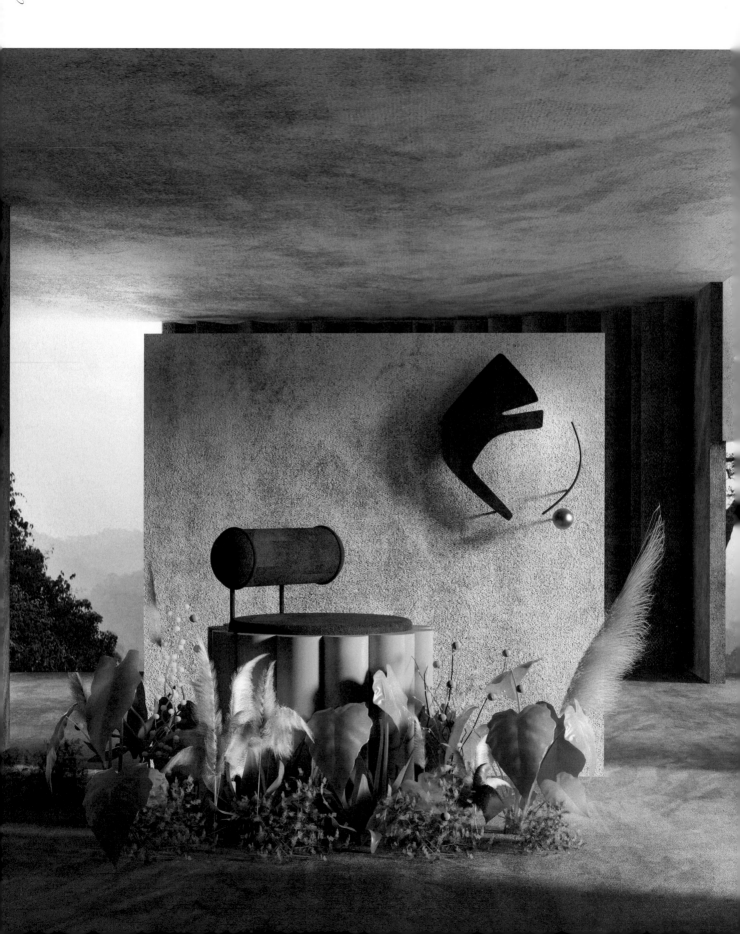

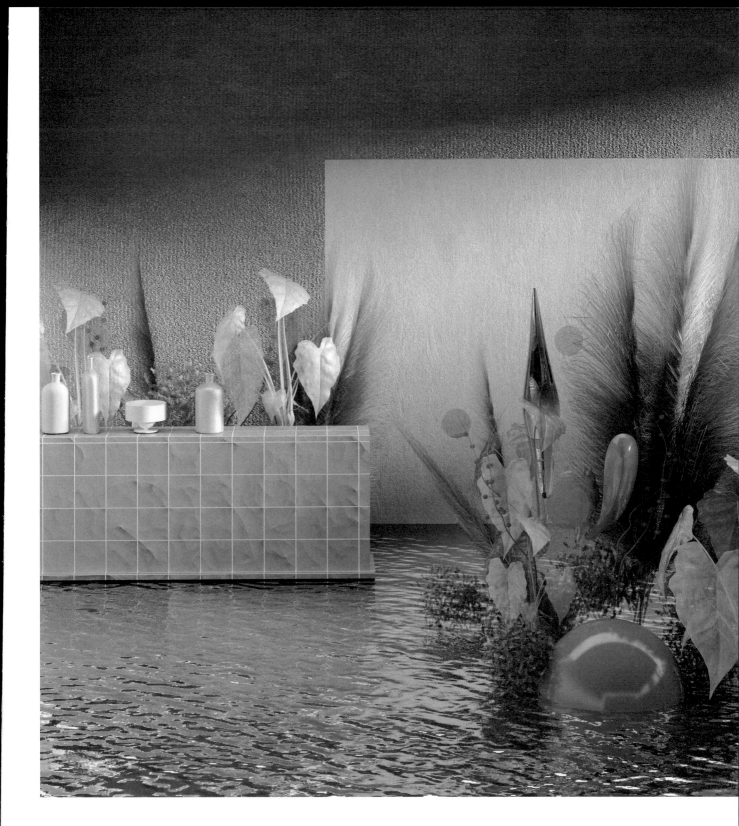

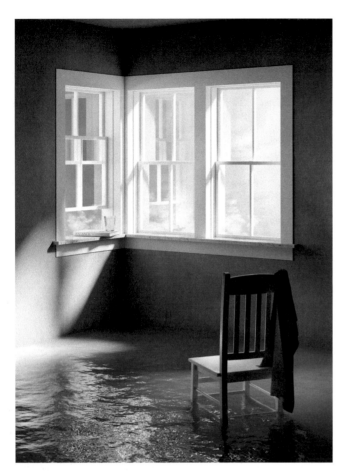 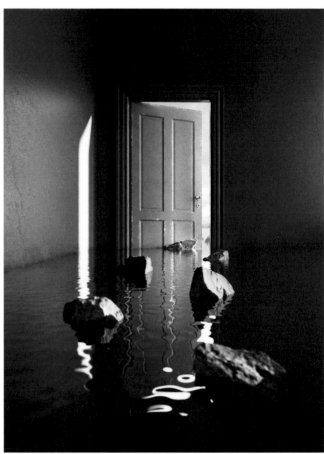

MORTEN LASSKOGEN
Copenhagen, Denmark

Having worked as a photographer for more than a decade, Morten Lasskogen began creating 3D visualizations in 2018. The same fascination with light and its possibilities, which was always clear in his photography, is also apparent in his digital work. Lasskogen captures a celestial tranquility with his images, in which lone chairs or open doors and windows act as metaphors for entry into other worlds. With a dedicated social media following in the tens of thousands, Lasskogen's goal is not to convey a utopian place, but to create a singular aesthetic that provokes an emotional response. ✧

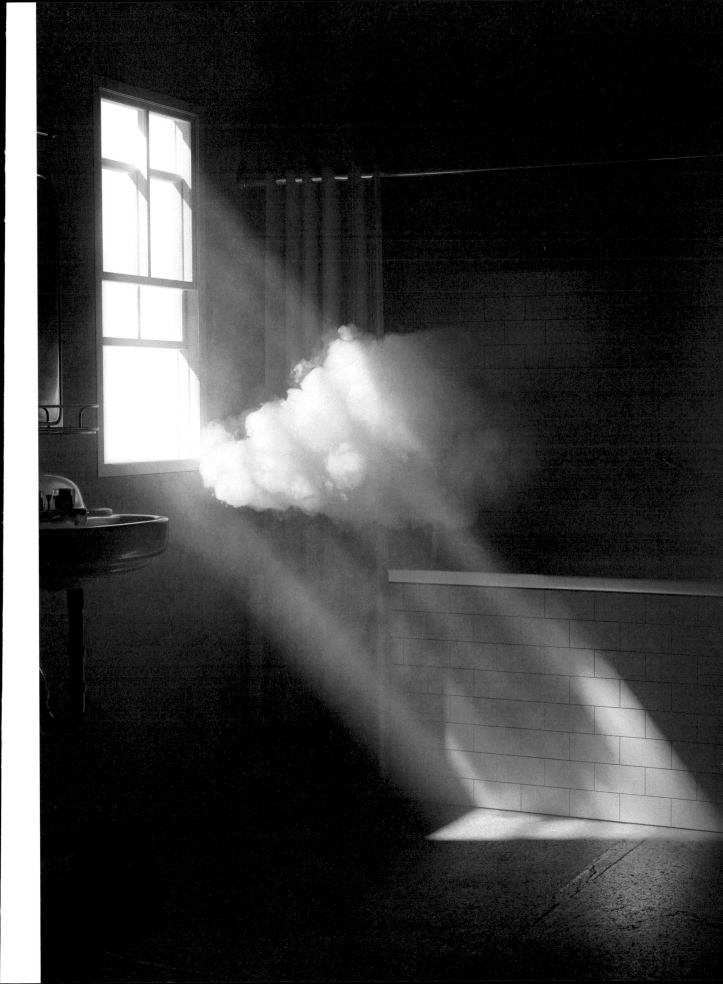

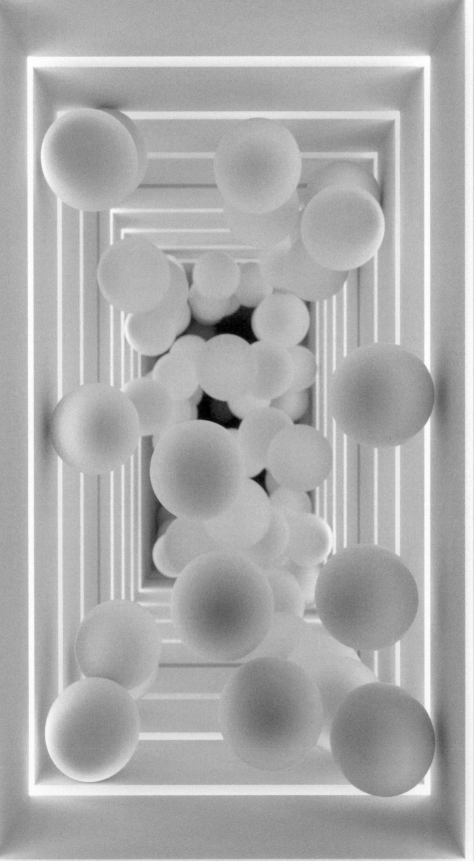

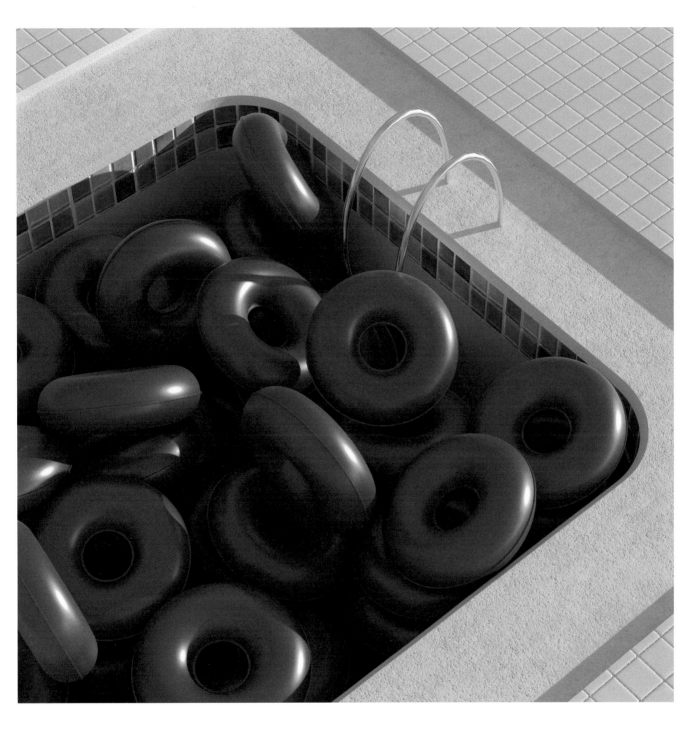

FRANK J. GUZZONE
New York City, NY
USA

When Frank J. Guzzone begins working with a new brand, he first considers how their product would look if it were made in Willy Wonka's chocolate factory. The image or animation that ensues is always playful and Guzzone hopes his visualizations will evoke a feeling of calm in the viewer. The soft colors and materials, in hard-to-imagine configurations and poses, make his images excite and appeal to all the senses. Guzzone has amassed thousands of followers on social media, and has worked with brands such as Kate Spade, Perrier, and Rimowa. ✧

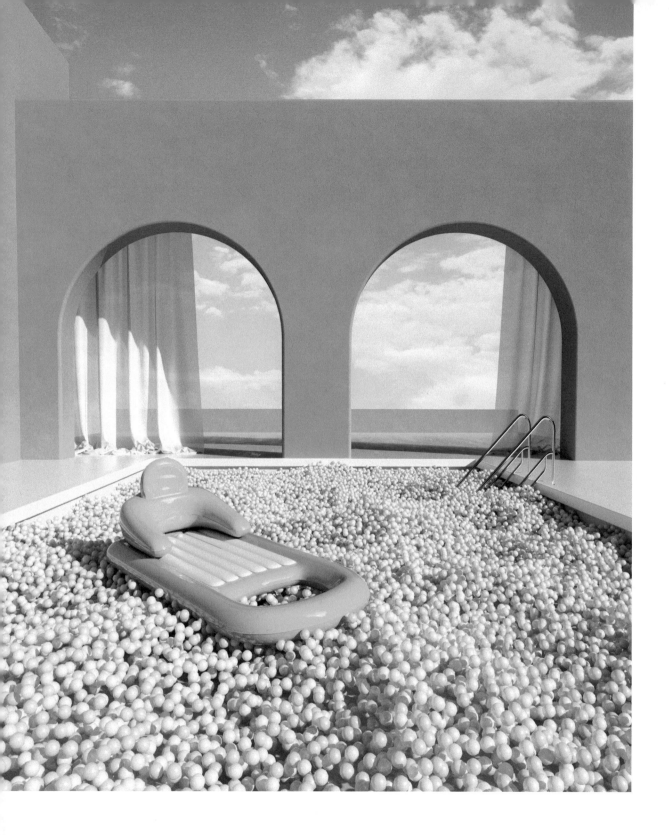

SIMON KAEMPFER
Bremen, Germany

Simon Kaempfer got his start in the gaming industry, creating dark, moody images in smoke-filled worlds. He soon found himself exploring the exact opposite—color, playfulness, and blue skies—which led him to his current artistic practice. He informs each concept with the images and references he collects on mood boards, before jumping into the world of 3D. His cheerful images are rich in narrative and have attracted a roster of clients across branding and advertising. ✧

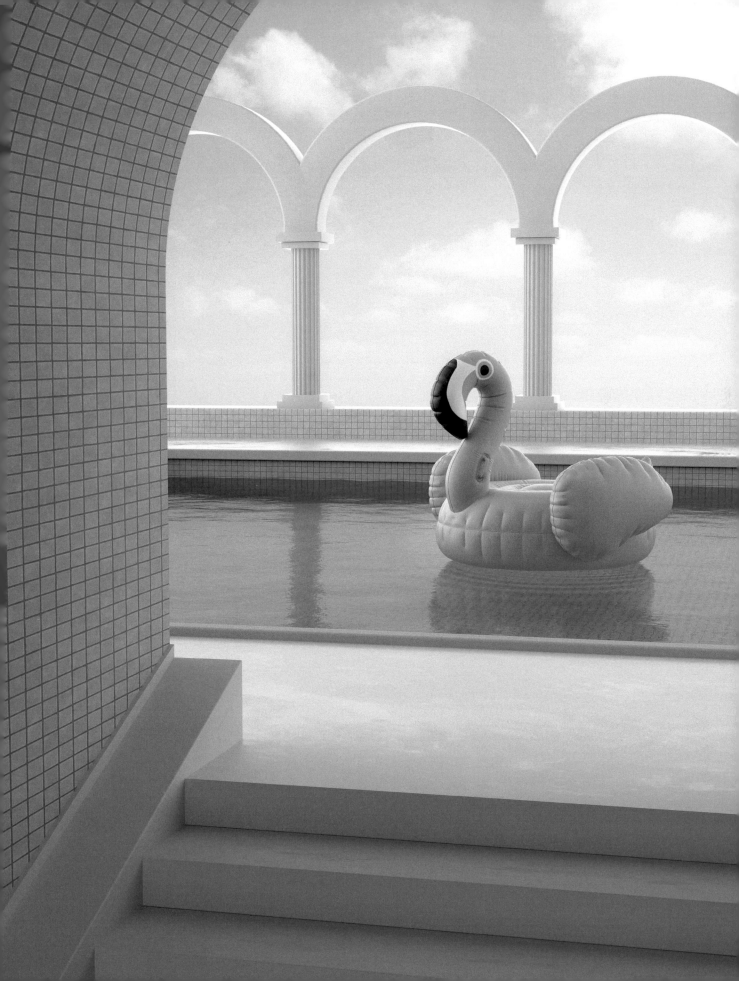

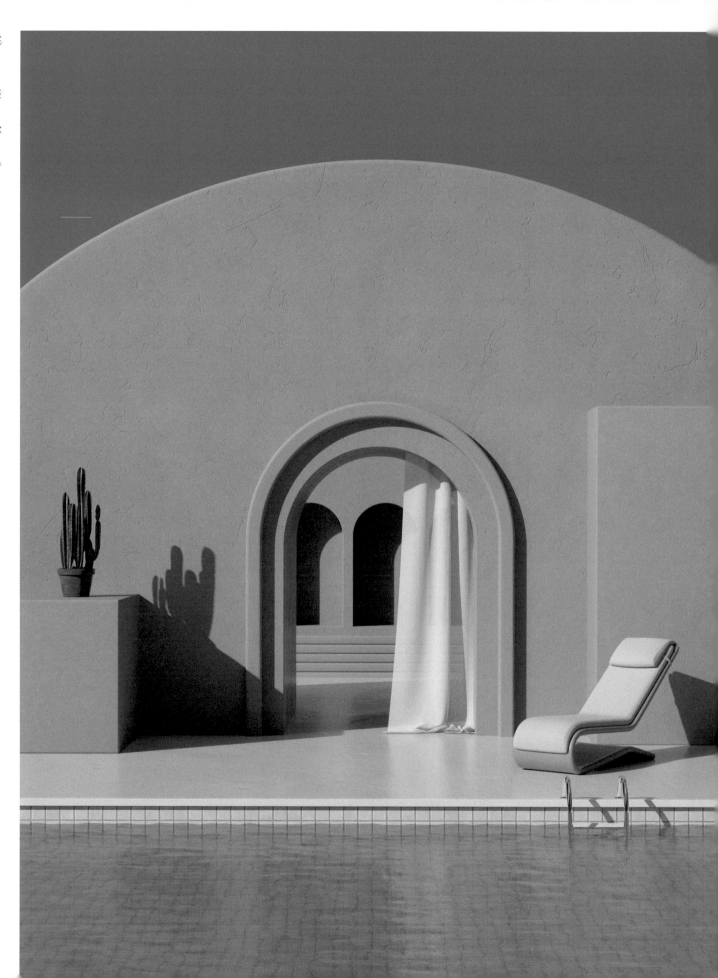

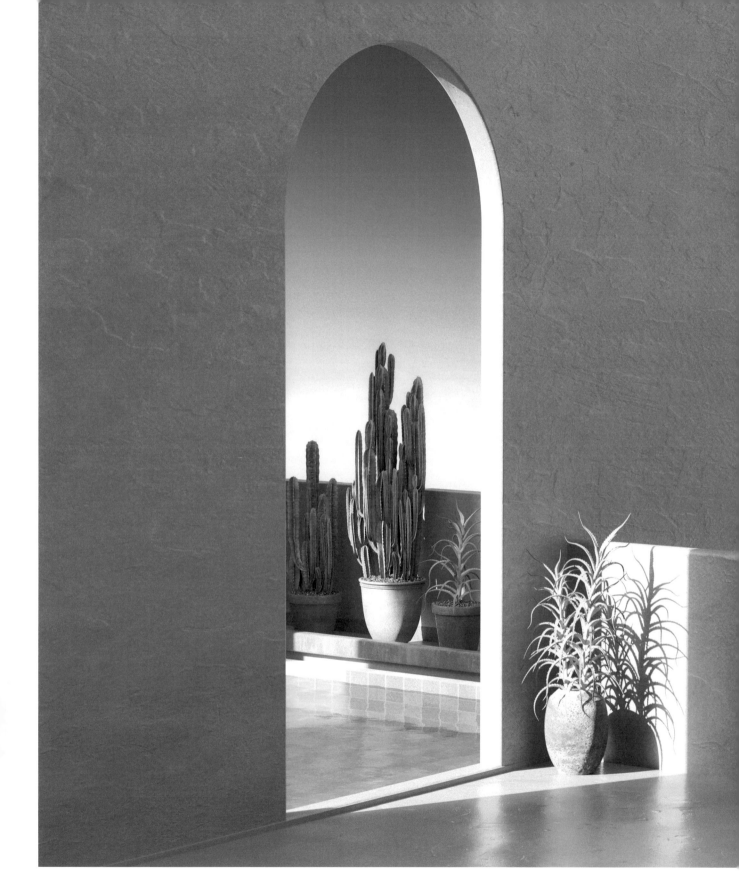

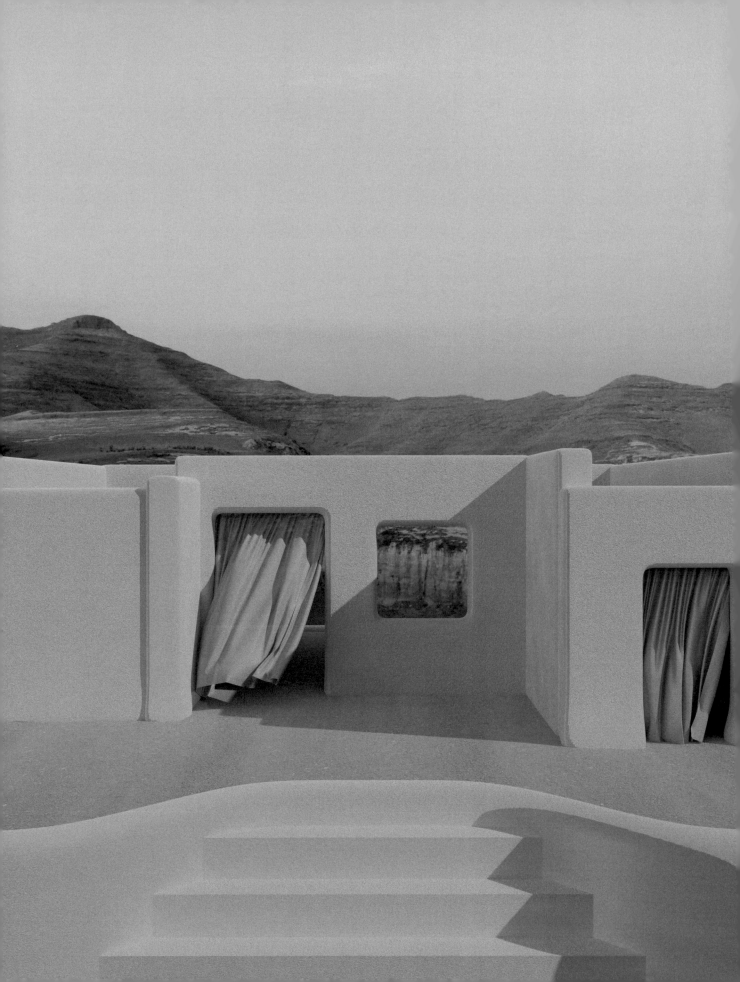

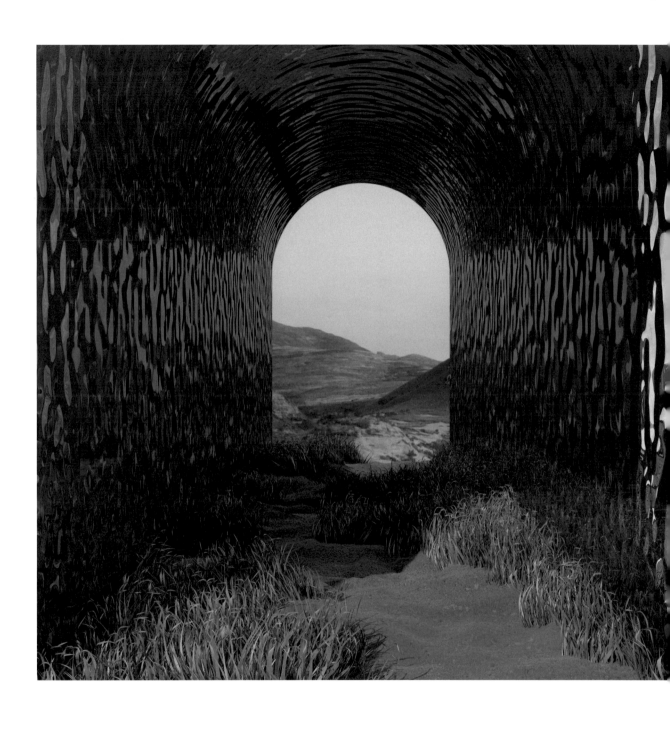

REBECCA LEE
New York City, NY
USA

Lee's working process begins with hope for a new world that she wants but doesn't yet see. Her utopian imagery often couples soft breezes with desert oases, using movement and lighting to capture a sense of fleeting time. Lee has collaborated with Spanish knitwear brand RUS to create a fictional environment that complements their soft knits, and with Danish textile designer Emdal Studio to explore the relationship between physical fabrics and digital spaces. She also works on immersive environments through virtual and augmented reality. ✣

Take a moment in utopia with BARCELONA-based studio SIX N. FIVE, whose pastel-hued vistas have been deployed by leading brands to communicate a different kind of reality.

Six N. Five's surreal 3D renders feel like film stills from early sci-fi blockbusters, evoking scenes like the deserted landscape and monolithic apparition of Kubrick's *2001: A Space Odyssey*. The studio's founding director, Ezequiel Pini, finds parallels to the silver screen in his own trajectory as well. "My background is in motion design. I started working as a 3D designer in Buenos Aires where my designs came to life as animations," he says. "But I also finished my studies as a graphic designer, a discipline where I learned about scale, color, shapes, and typography. This knowledge applied to the 3D space is pretty related to scenography."

The studio's designs aim to move viewers into a utopian space, if only momentarily. An overdose of visual information prompted Six N. Five to consider "willful escapism" as a strategy to access tranquility: lone furniture often takes center stage in their compositions, evoking a sense of existential solitude. They've exercised this technique in their practice, as well, periodically closing the studio to escape external deadlines and focus on in-house projects, in what they refer to as "the Lab."

Founded in 2014, the studio has created an impressive roster of advertising, editorial, and video commissions for clients like Samsung, Rimowa, and Microsoft. Their foray into dreamscapes began in 2018, with a project for Samsung, where they designed and developed an interior and exterior composition using the TV as a window connecting two worlds. "It was the first time we did this kind of complex landscape," Pini explains. But they still find time to focus on experimentation outside of brand collaborations, pushing the limits of CGI as a mode of artistic expression. ✦

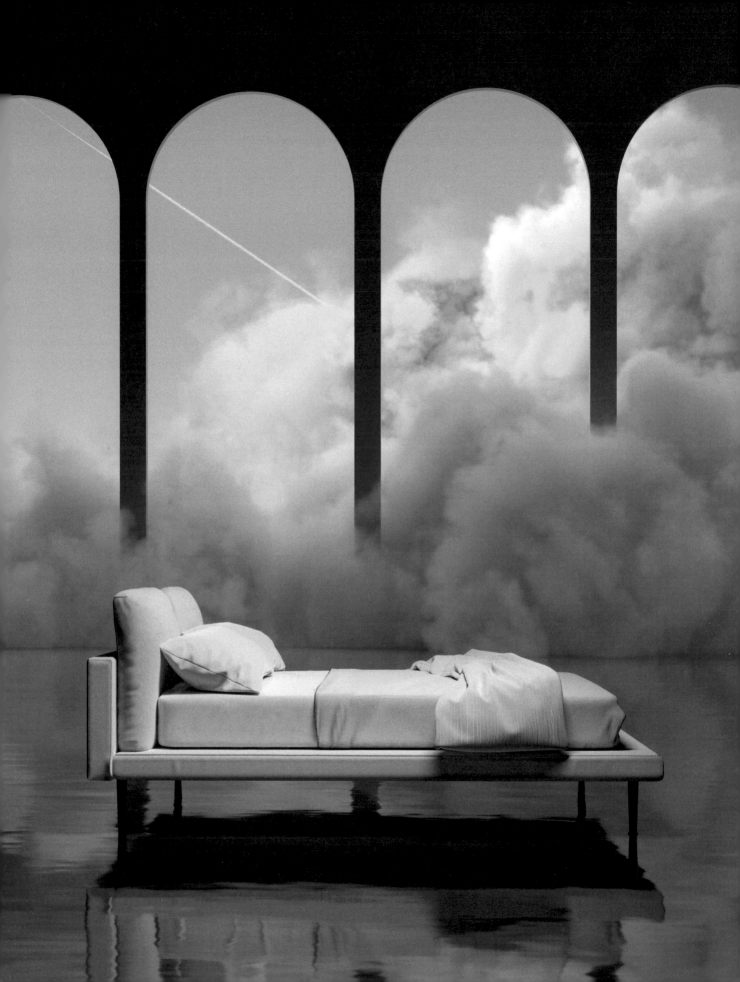

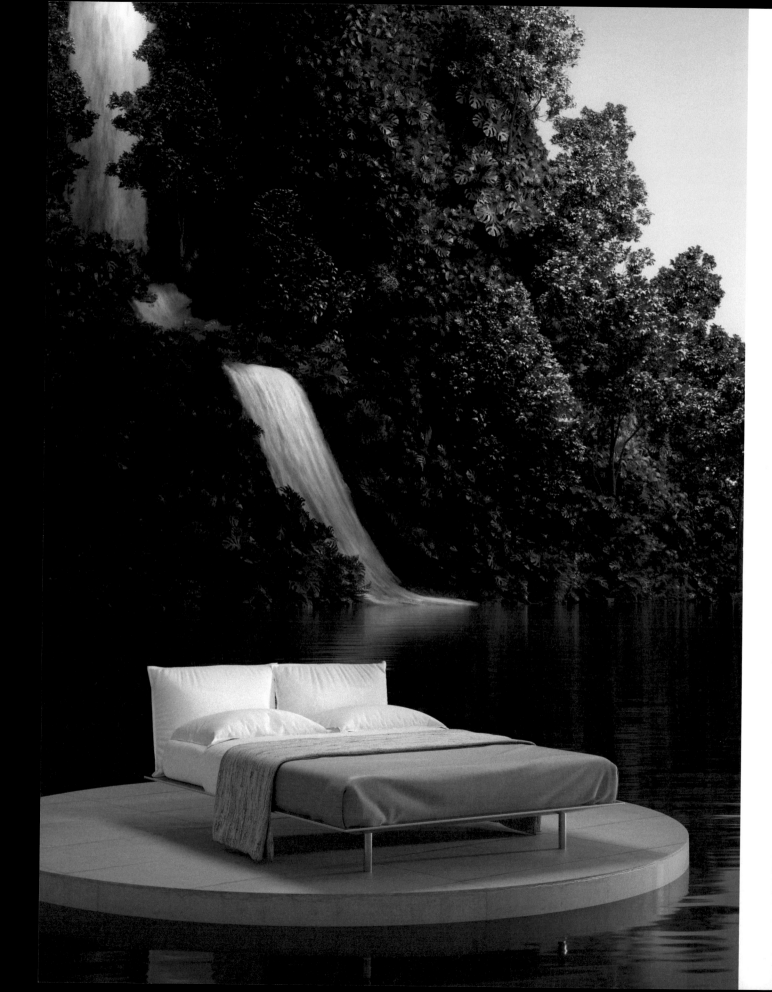

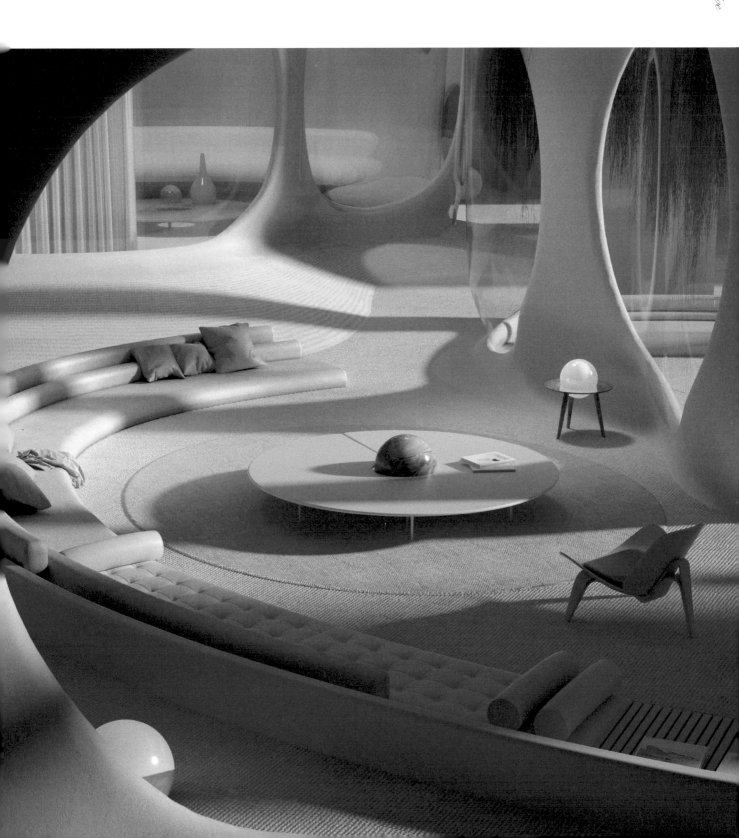

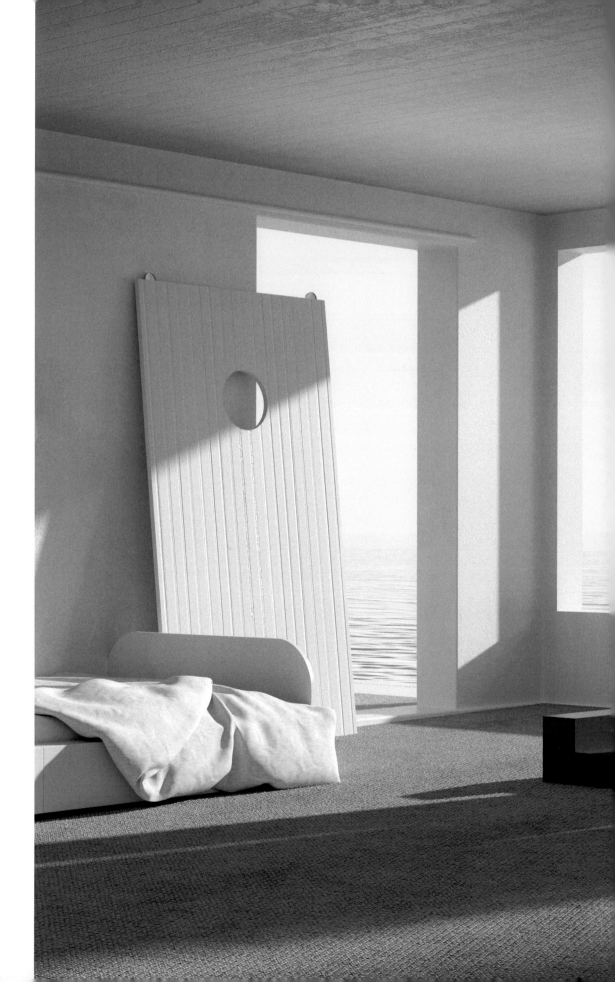

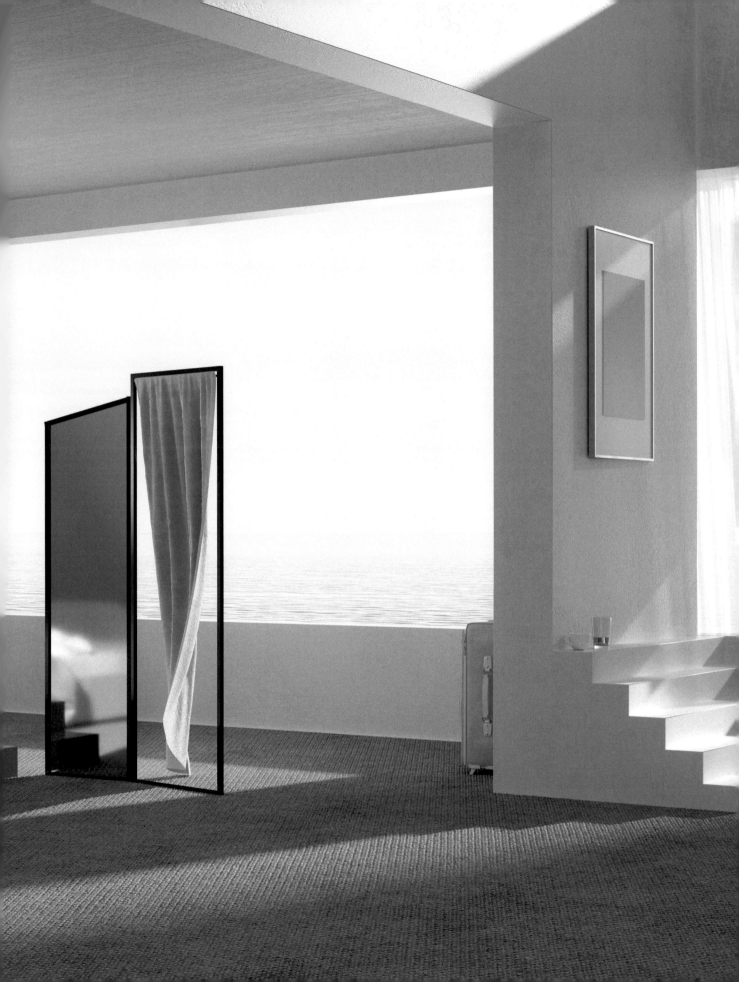

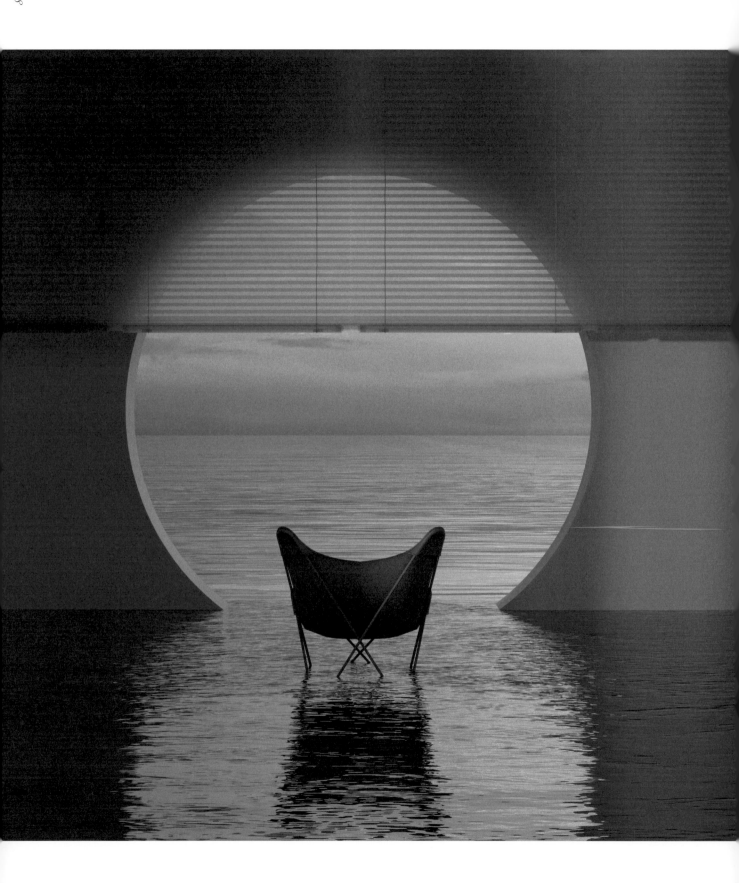

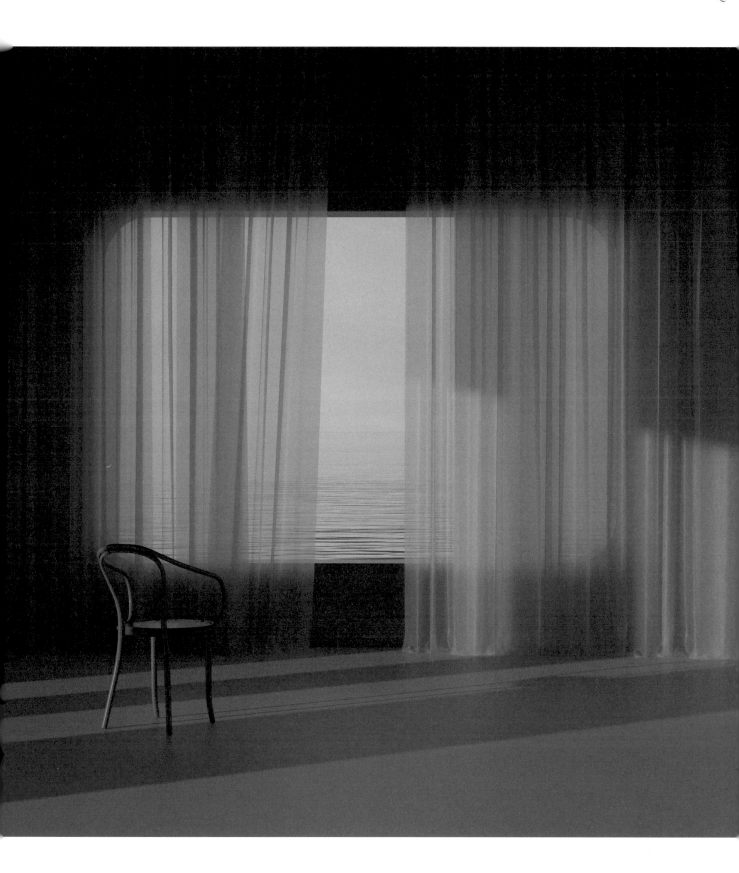

*The studio's designs aim to move viewers
into a utopian space, if only momentarily.*

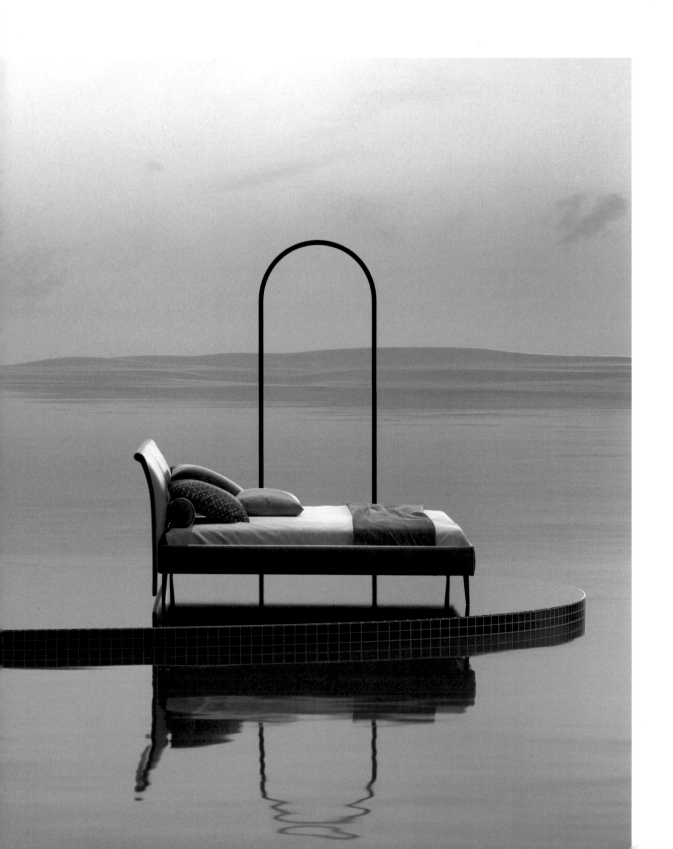

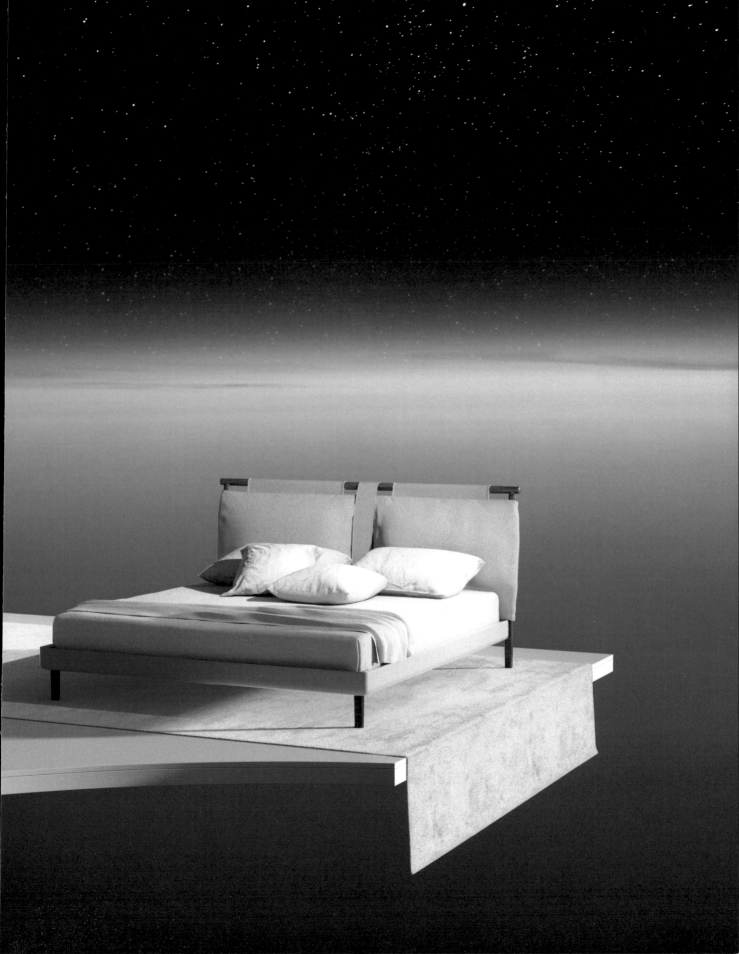

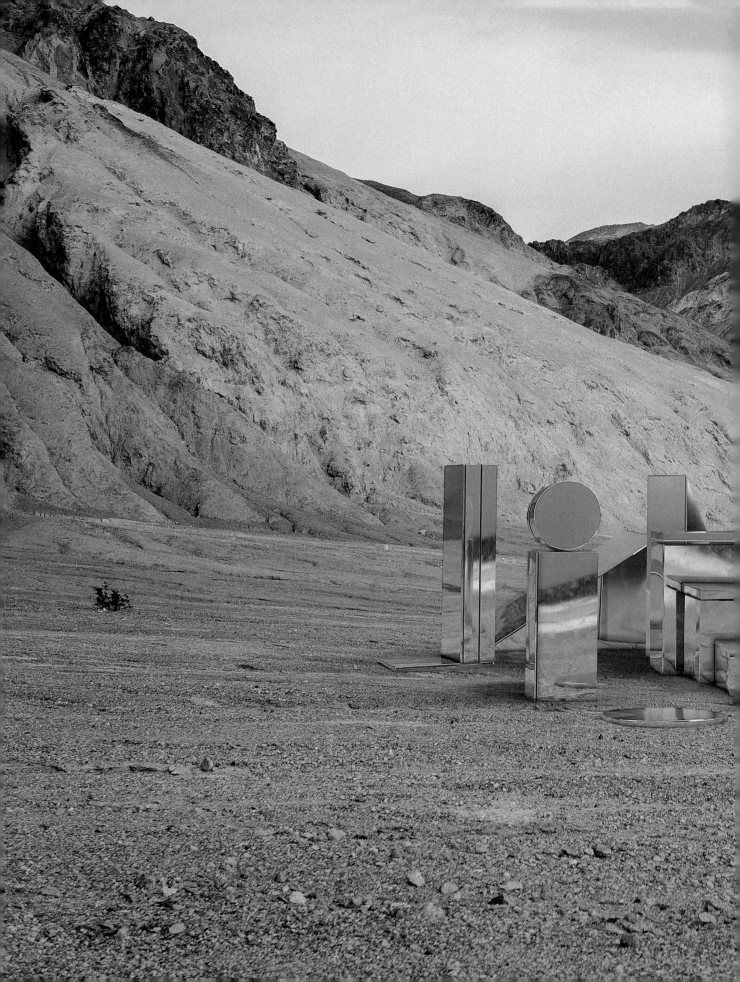

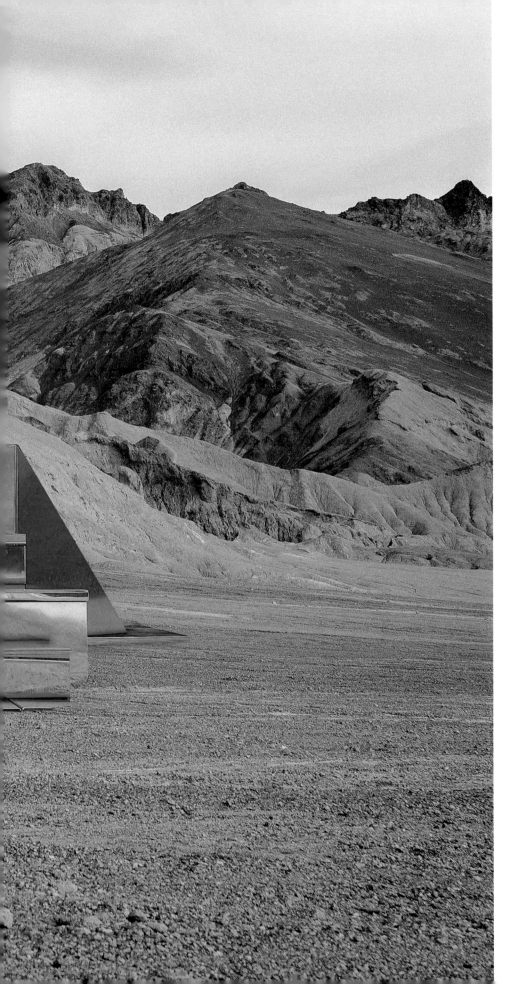

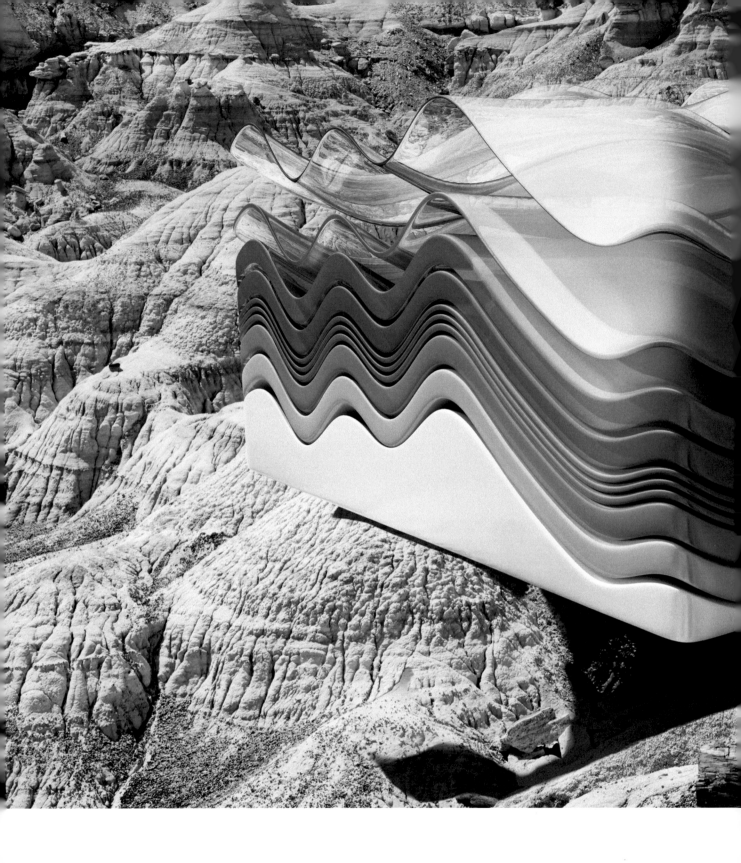

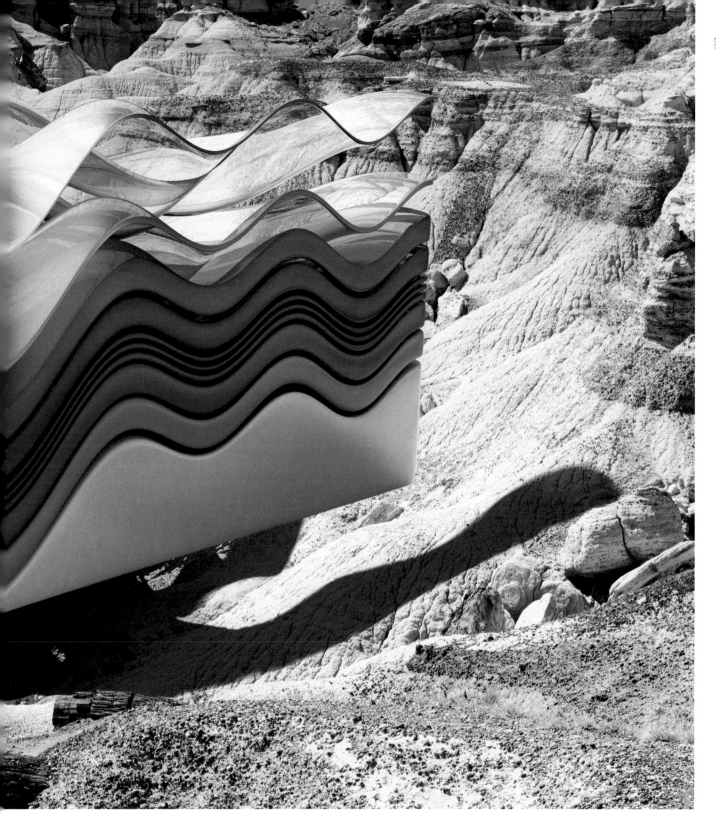

ZEITGUISED
Berlin, Germany

Henrik Mauler of ZEITGUISED made his first 3D render in 1987 on a Commodore Amiga using Sculpt 3D software. The image was a red reflecting sphere and prism on a checkerboard that took almost a day to render. Over the years, ZEITGUISED has developed new approaches to working within this field, which they call "synthetic photography," and which they helped establish in 2001. ZEITGUISED likens their process to artisanal craft, in which everything visible has to be either made by hand or generated. A few years ago, they established foam Studio to offer commercial services for brands and have since worked with clients including Chanel, Prada, Mercedes Benz, and Toyota. ✧

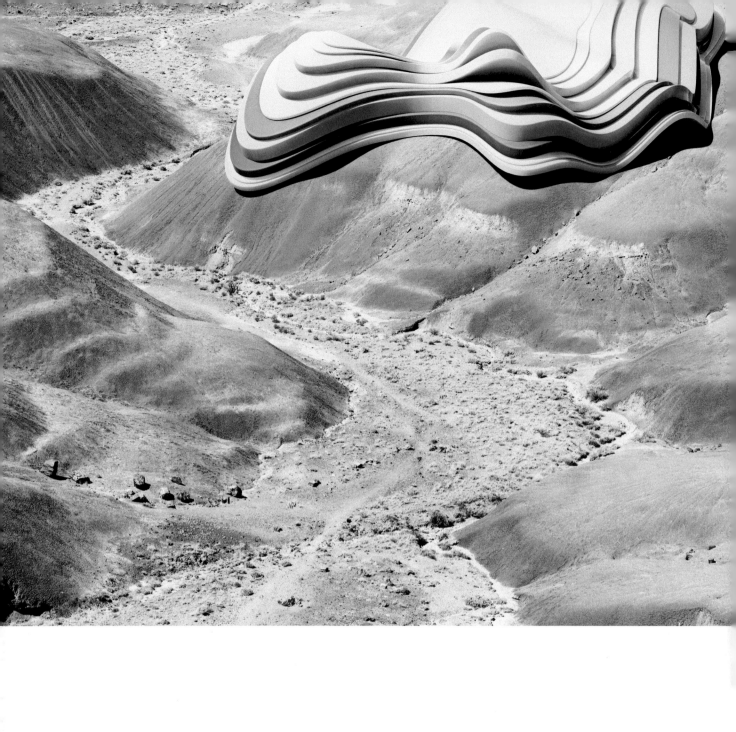

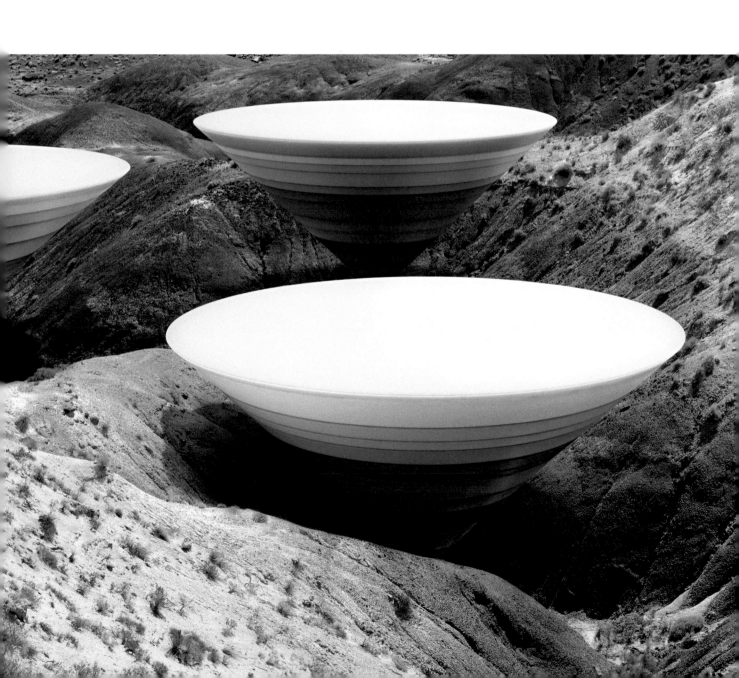

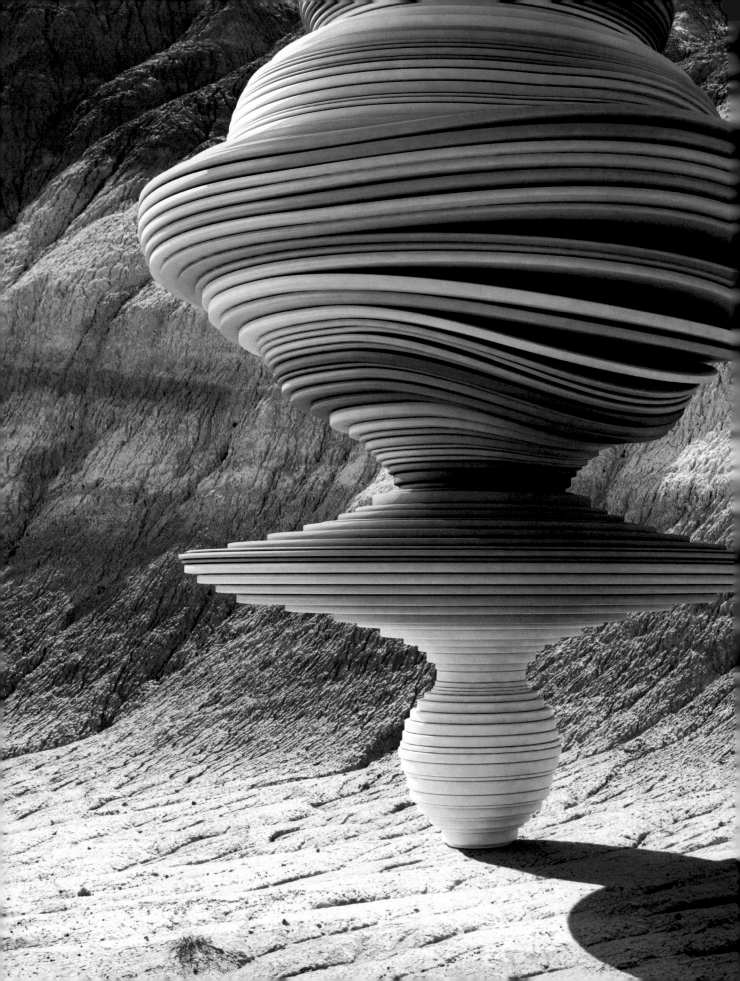

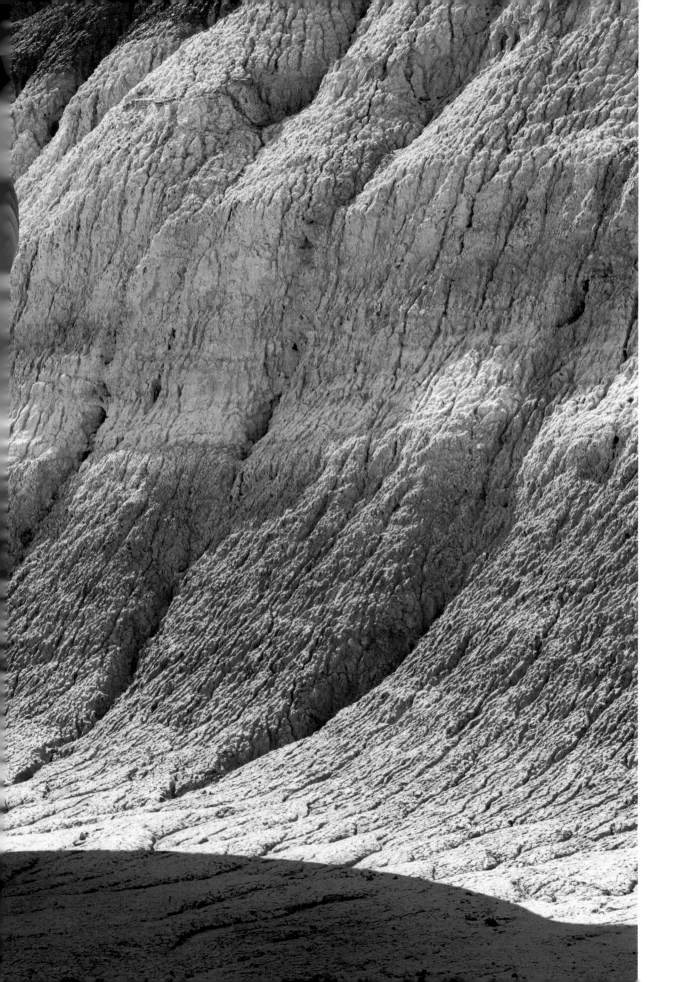

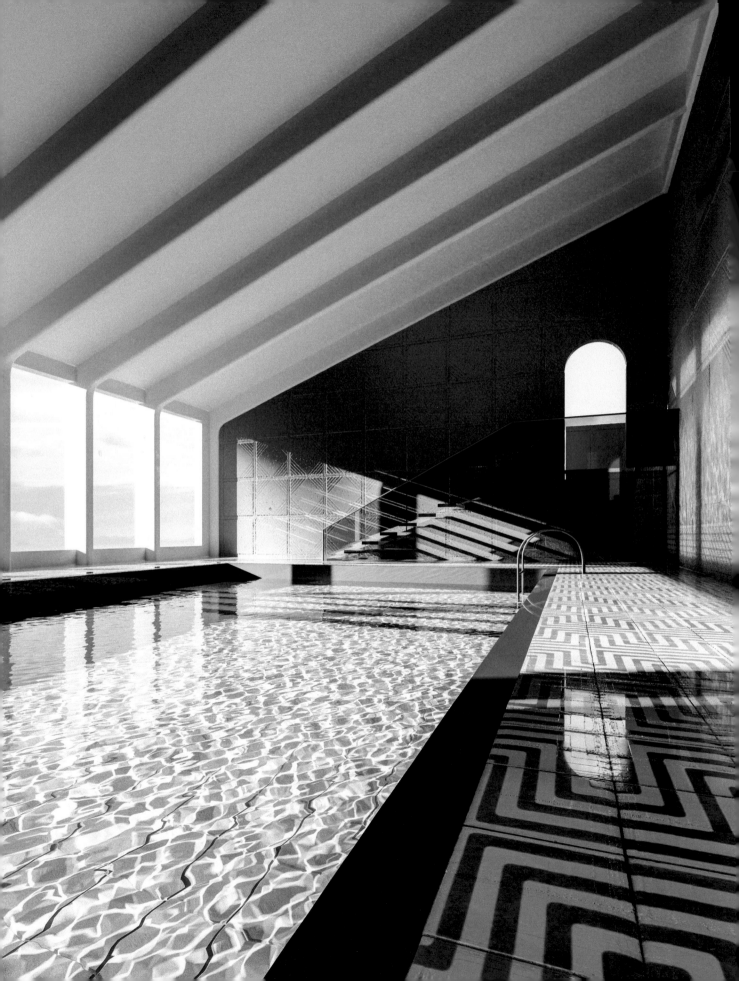

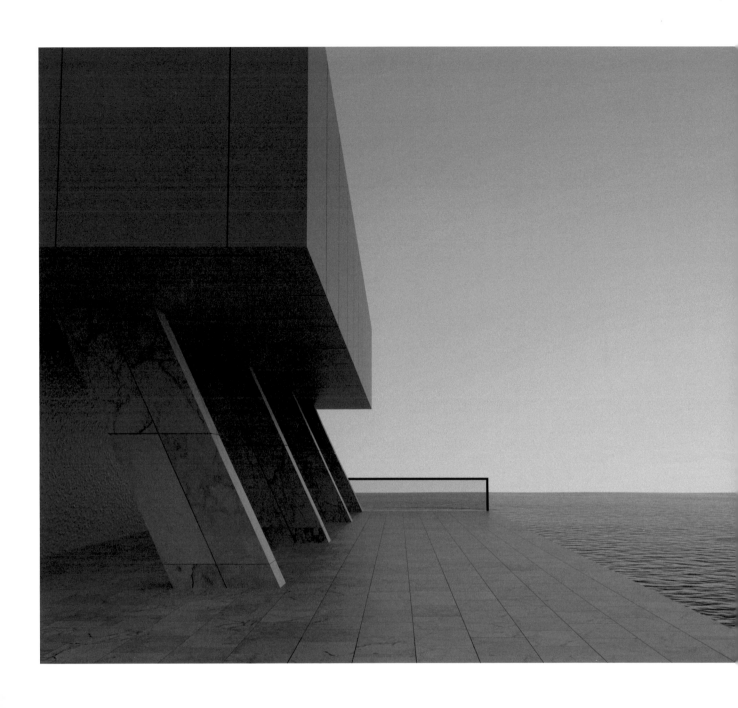

PETER FAVINGER
New York City, NY
USA

Music is a huge drive behind Peter Favinger's practice. He creates his spaces while listening to dreamwave, a genre that relies on the atmosphere and ethereal nature of 1980s pop synth progressions and tones. Favinger starts by asking himself: "Is this the kind of environment where I would want to experience this generated nostalgia, this cyber euphoria?" His aim is to create a visual representation of the music's state of being, untethered from the constraints of reality but appealing as living spaces. Favinger's idea of utopia is refined and clutter free. ✧

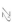

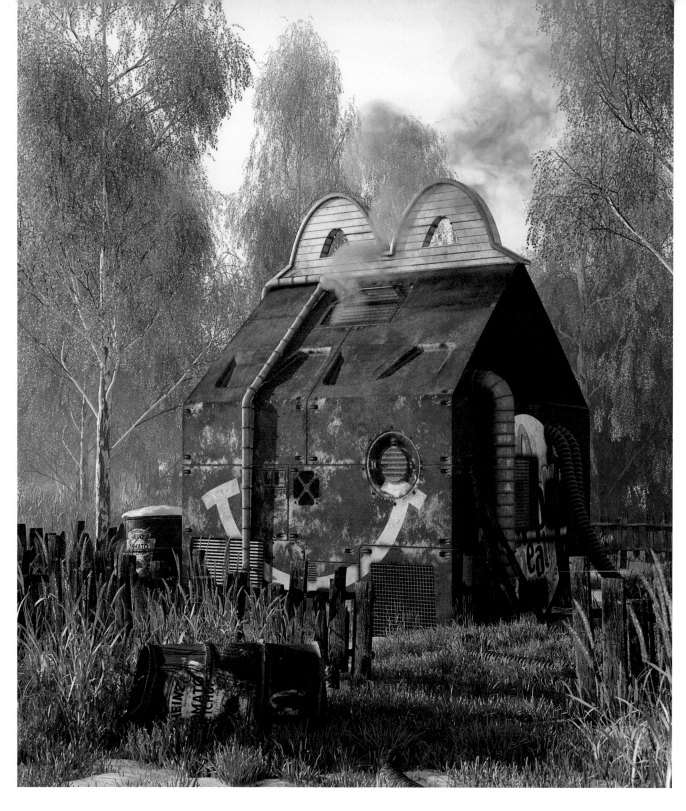

FILIP HODAS
Prague, Czechia

In 2015, Filip Hodas challenged himself to create one new 3D render every day. Since then, his practice has expanded into a mixture of personal and commercial art, having worked with clients including Adidas, Apple, Coca-Cola, and Samsung.

Inspired by science fiction, his personal works, such as his series *Pop Culture Dystopia*, often portray post-apocalyptic, run-down concrete structures, or larger-than-life, defunct pop culture icons as remnants of a bygone world. ✧

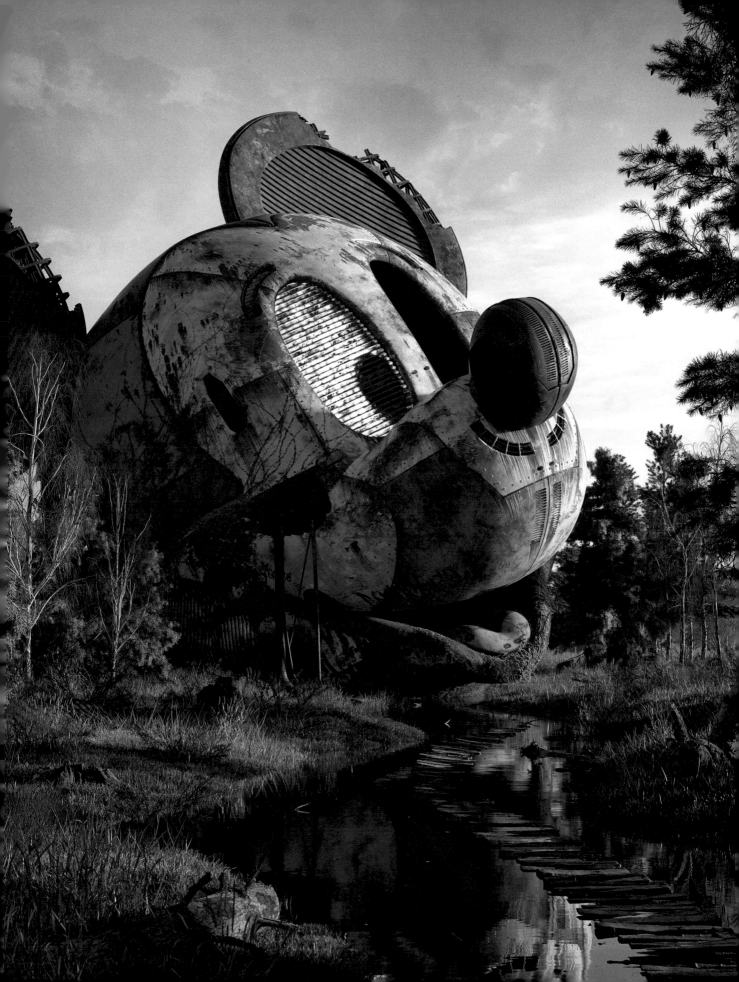

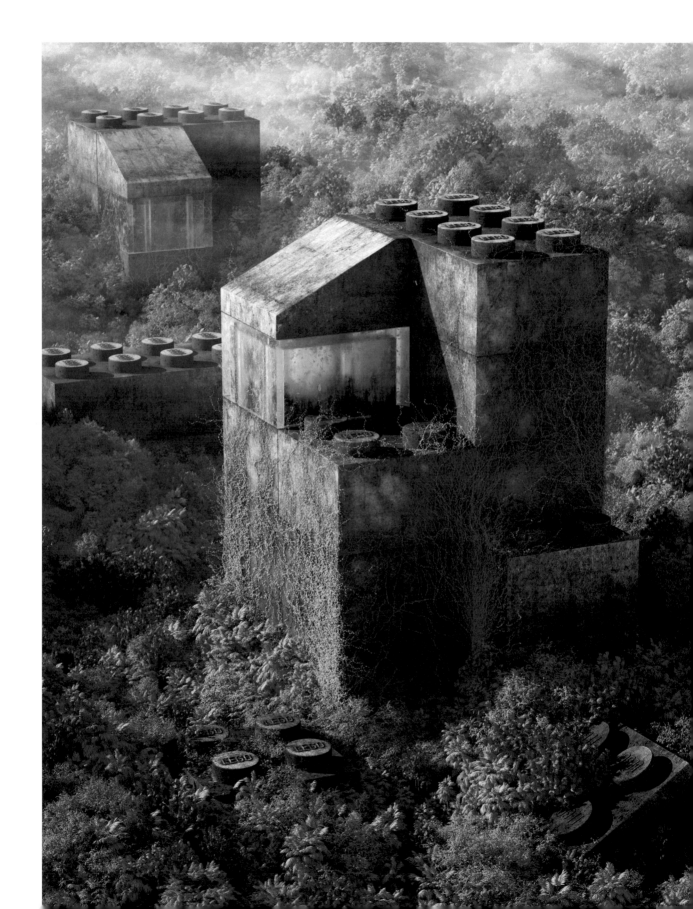

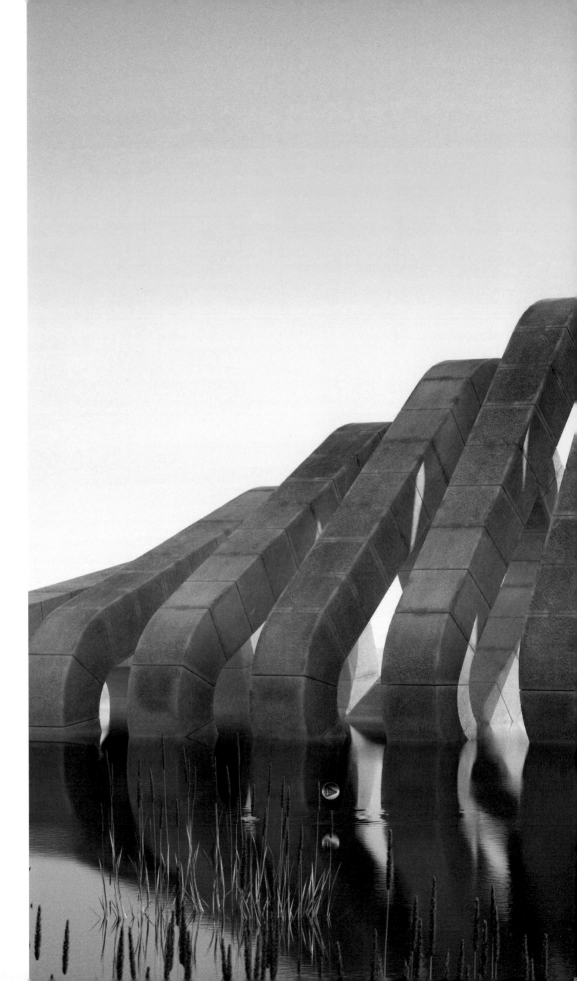

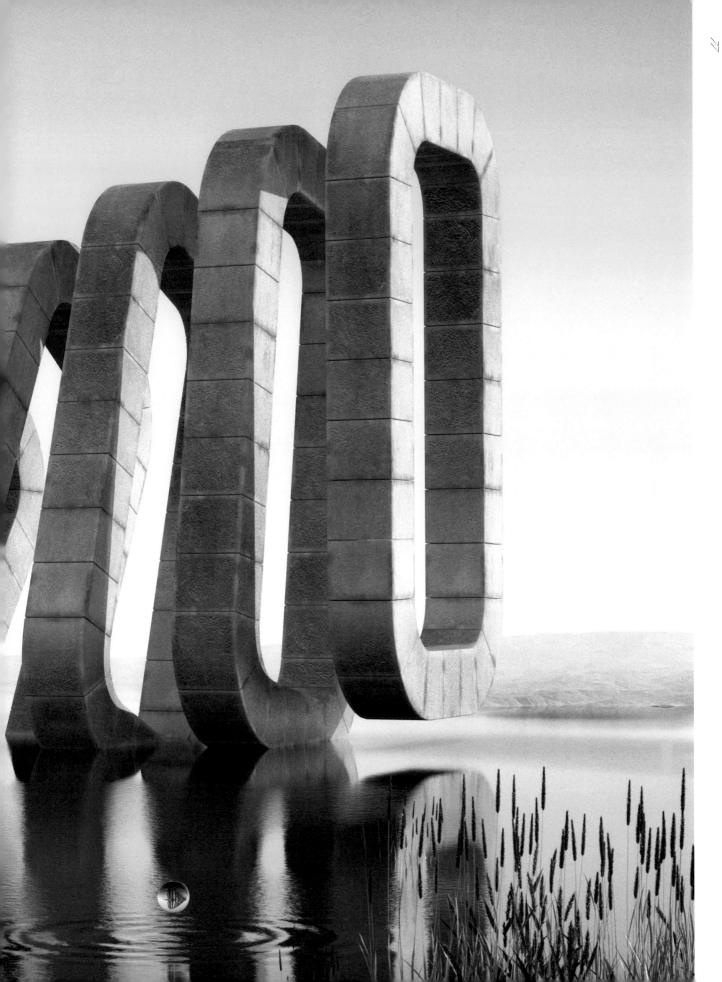

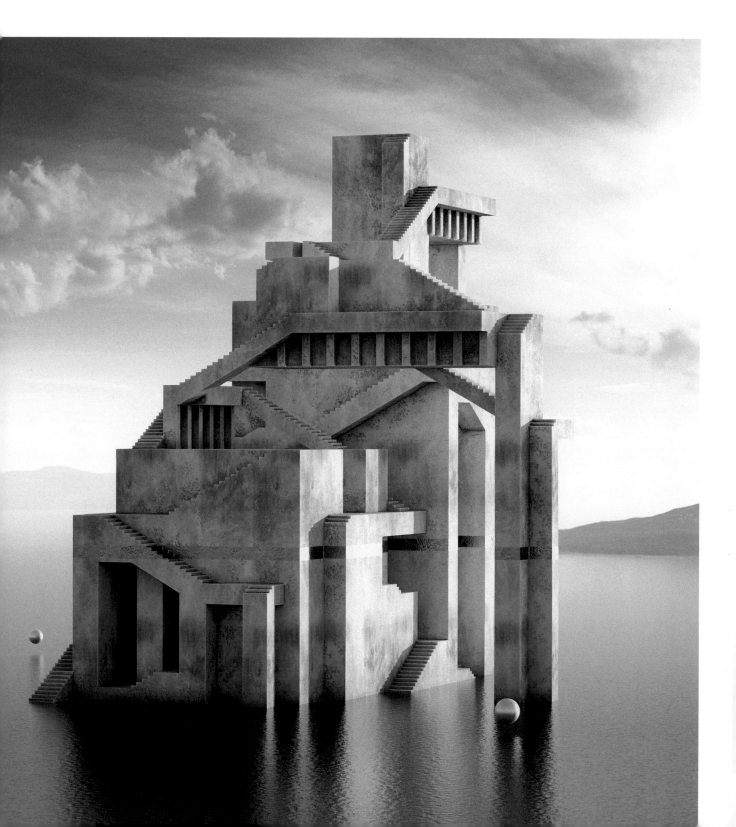

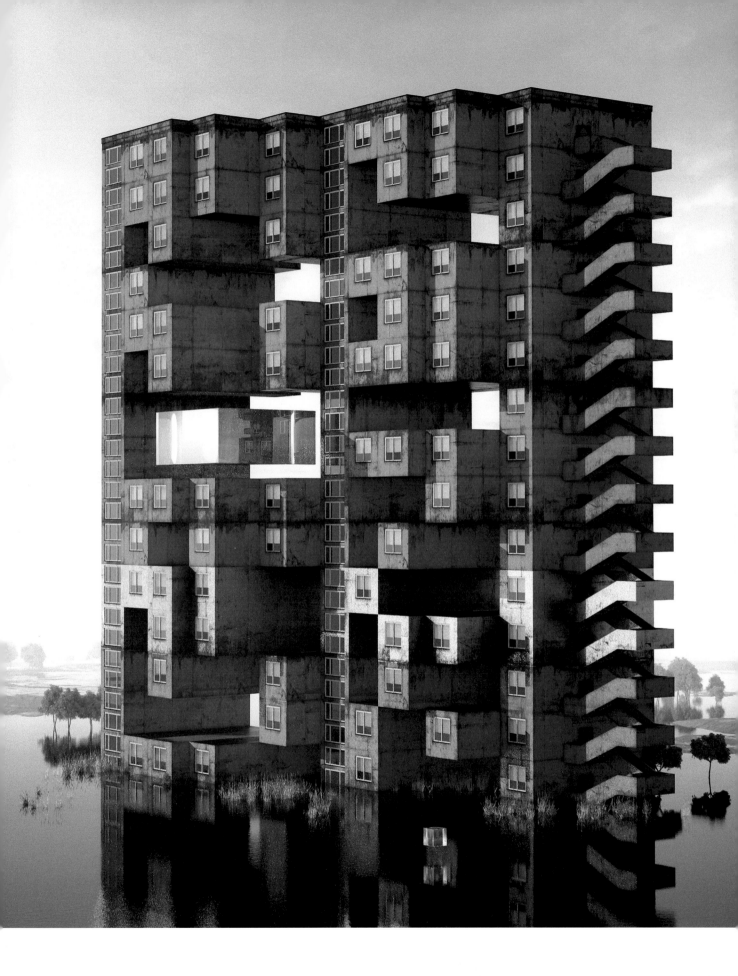

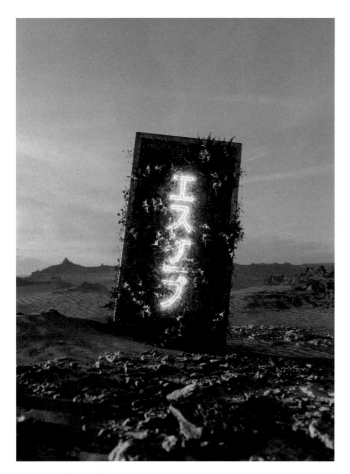

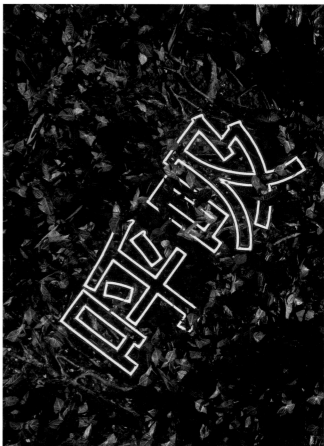

CAMERON BURNS
Minneapolis, MN
USA

Cameron Burns's 3D renders lie on the nightmarish end of the dream spectrum, often populated by barren gravestones and ghostly apparitions. Post-apocalyptic and dystopian, his darkened vistas are lit by artificial sources like car headlights or neon signs. He got his start after being inspired by other 3D artists and now has his own following under the pseudonym Captvart. ✦

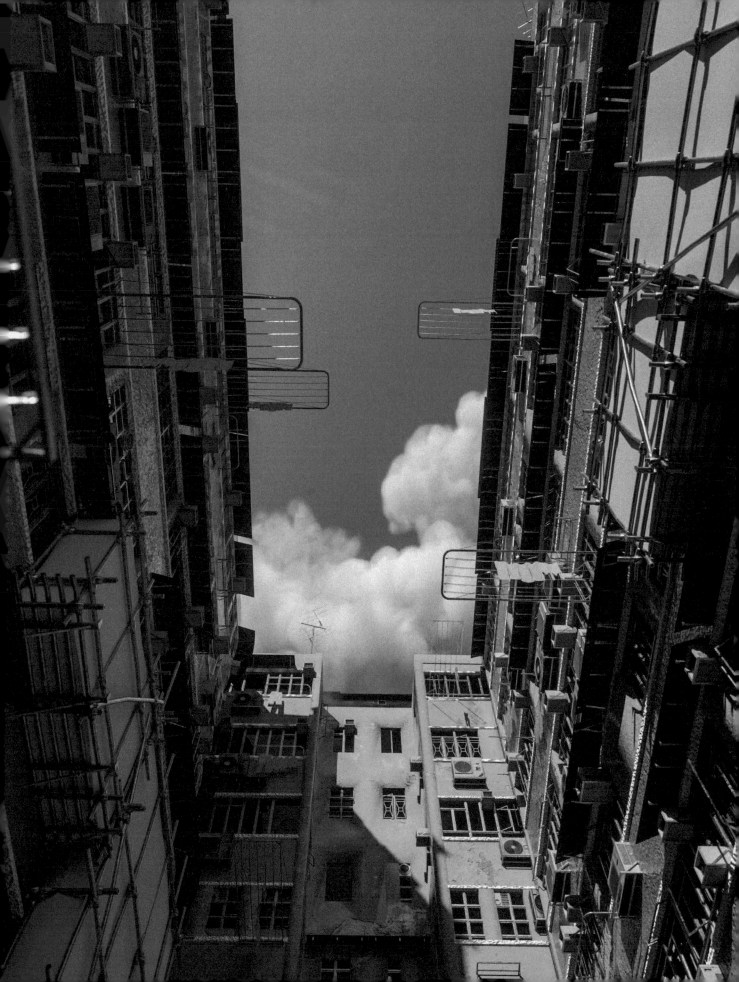

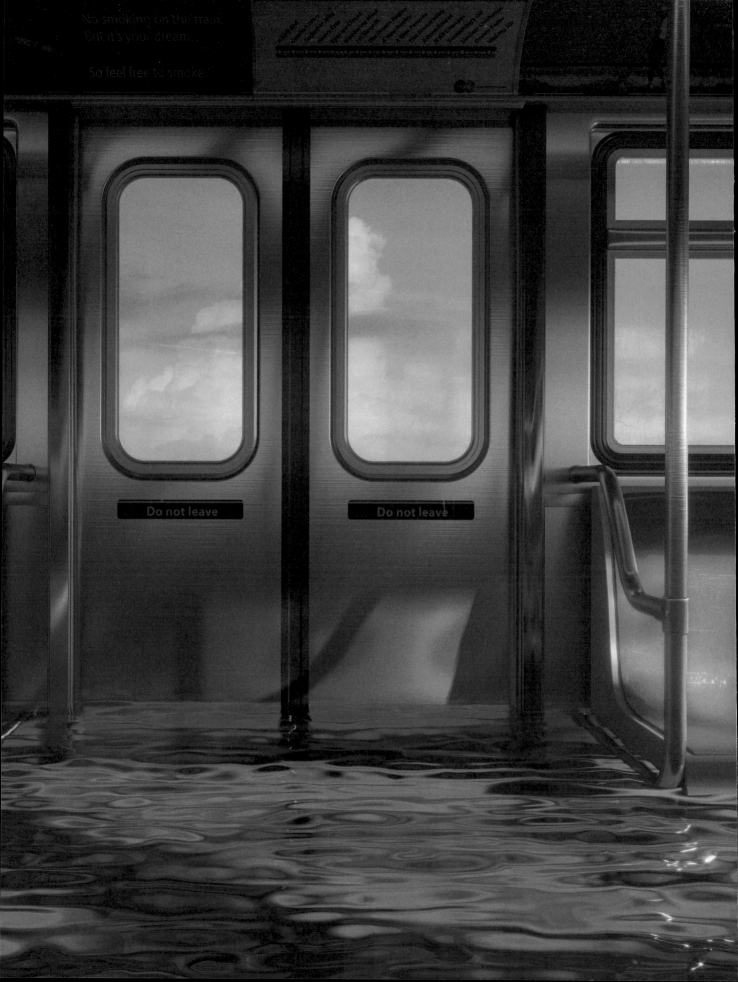

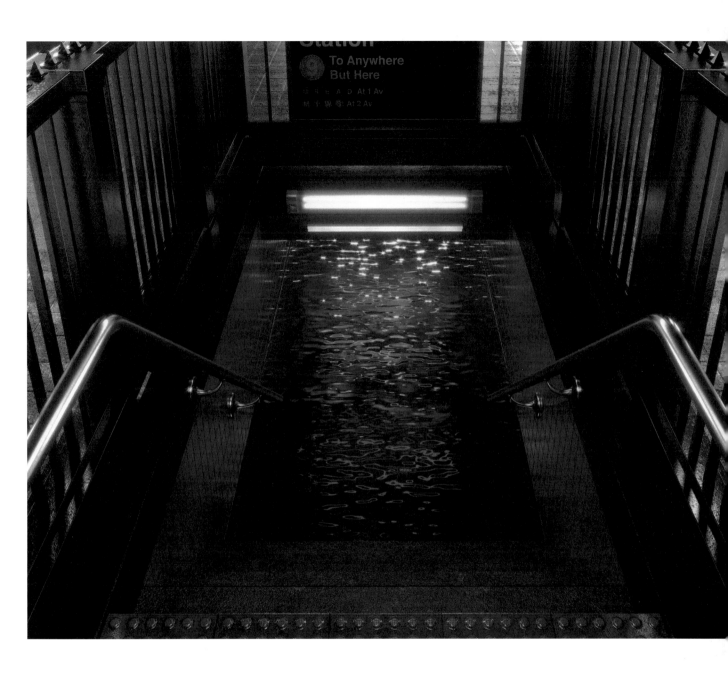

HAYDEN CLAY
Frederick, MD
USA

Having worked as a photographer for many years, creating surreal and dreamy images, Hayden Clay switched mediums one gray, cold winter when he realized he could infuse his work with color and warmth using 3D rendering. Clay's images, flooded with crystal-clear water, evoke a sense of calm and nostalgia combined with a tinge of anxious uncertainty about the future. In his subway series, the seats are modeled after the NYC subway seats, bringing a sense of familiarity to the works. The light that floods into his scenes gives a heavenly quality to works that otherwise signal disaster. ✧

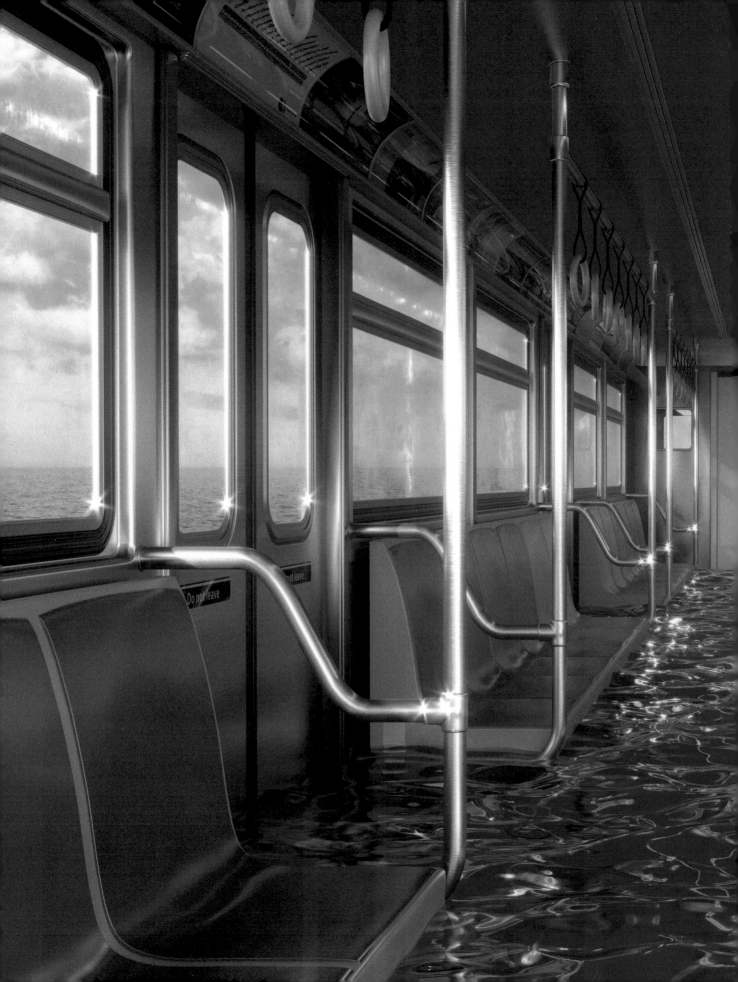

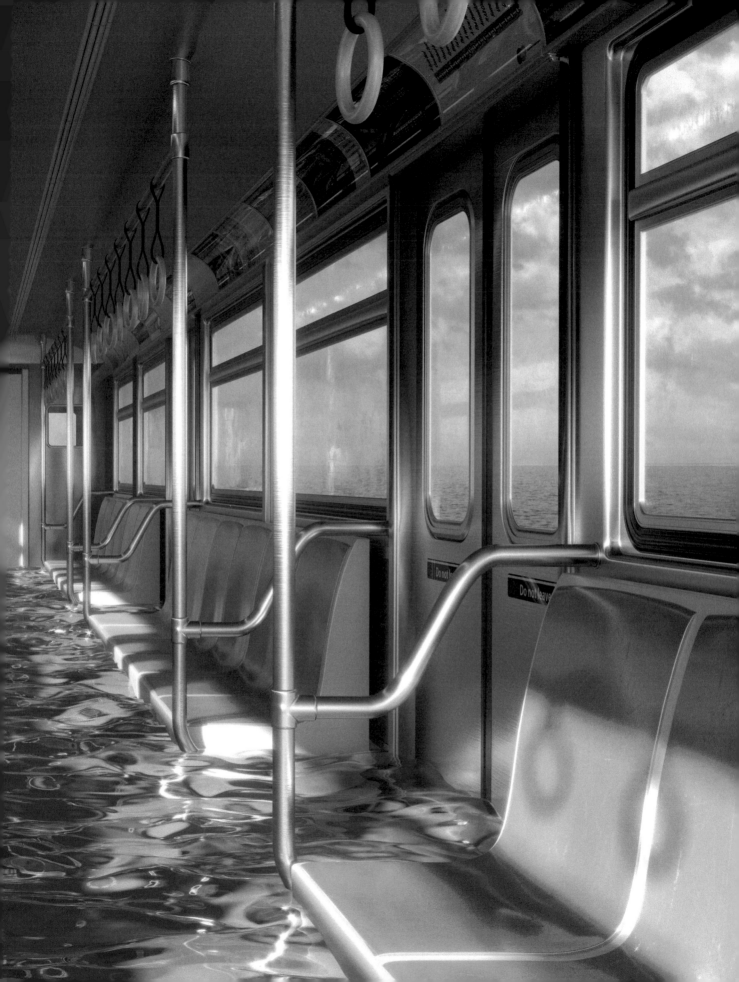

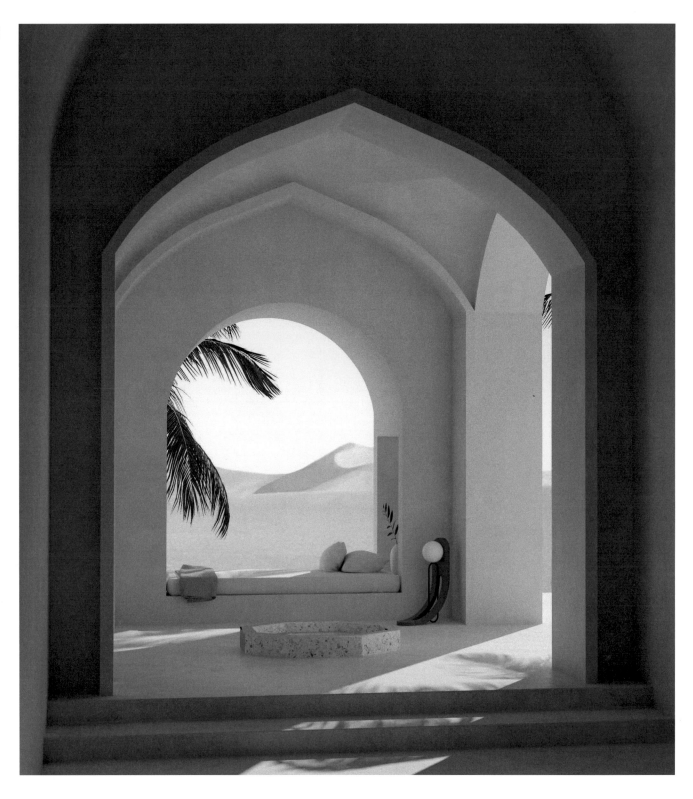

NAREG TAIMOORIAN
Los Angeles, CA
USA

Nareg Taimoorian began creating 3D images in 2018. At first, they were conceived as realistic architectural renderings, but he soon started experimenting with 3D software to envision more surreal spaces. His work blends outdoor and indoor details, and it often contains references to the Middle Eastern architecture he remembers from his youth. Spherical objects are everywhere, with hanging lamps, round mirrors, and circular windows revealing pastel-hued skies. ✧

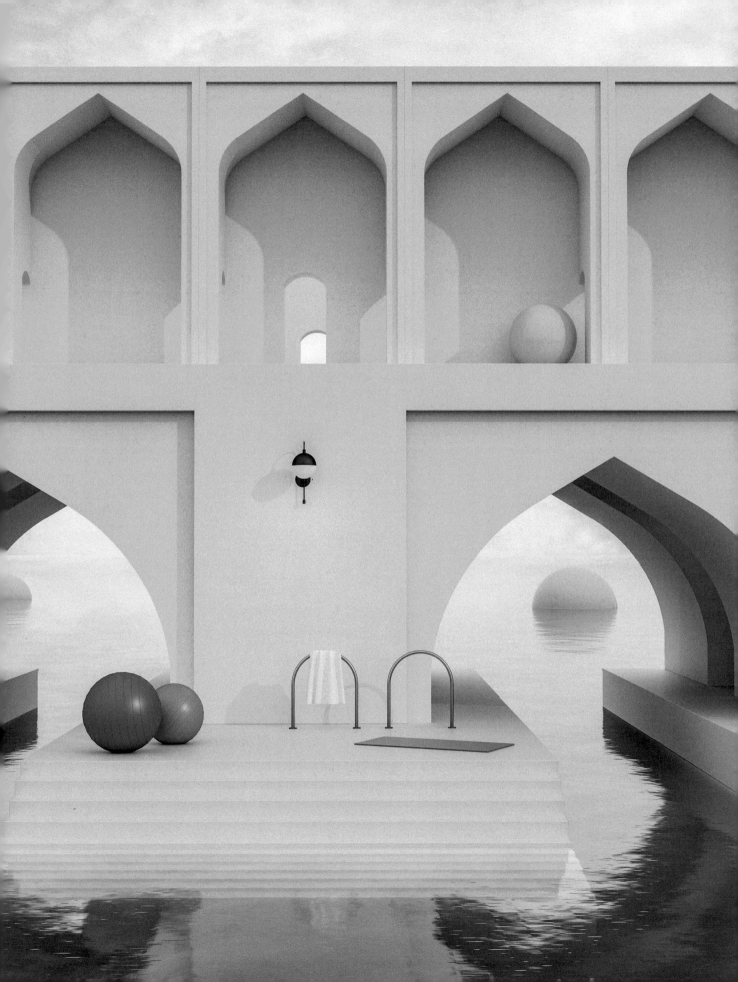

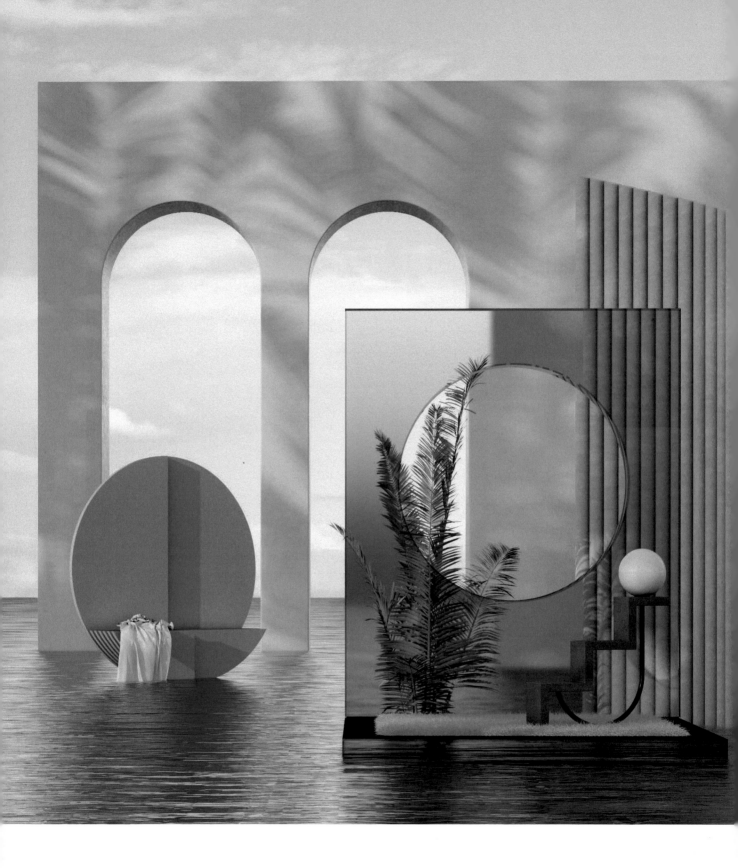

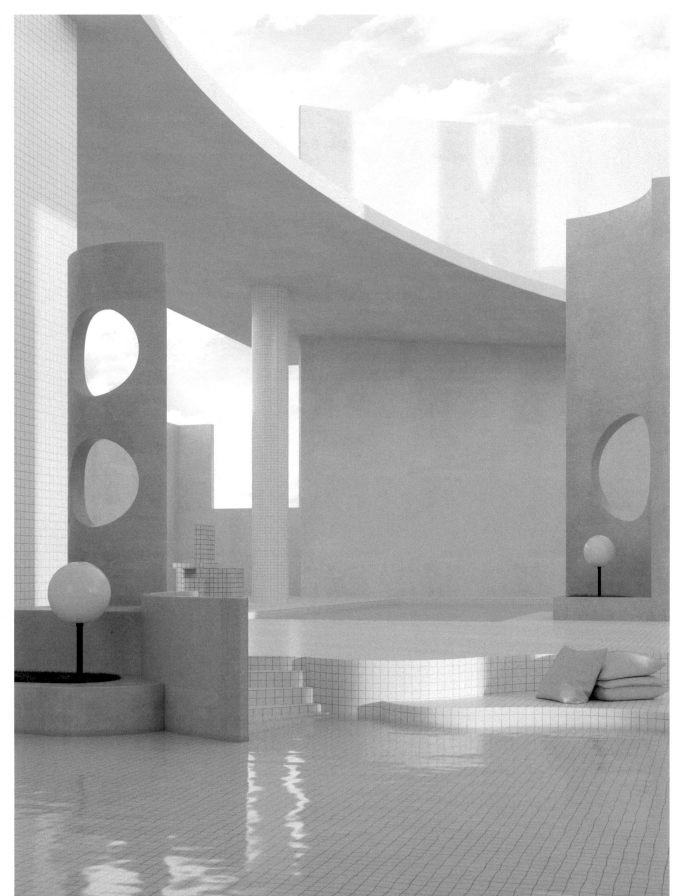

For LONDON-based artist CHARLOTTE TAYLOR, a high-ceilinged, furniture-filled utopia is just a few subtle details away from reality.

Charlotte Taylor has been keeping busy. The London-based artist has made a name for herself for her many fruitful working relationships with other 3D artists, often taking on the role of creative director. Social media, where she has grown a substantial following in the thousands, has been the basis of her more recent collaborations. "The process is collaborative in its nature, with an equal role in creative input and exchange of ideas," she explains.

While the resulting spaces are often fantastical in their settings, with a soft, utopian world view, she hopes one day to realize her designs. "My work is gradually moving towards actual spaces, blurring the line of what is rendered and what is existing. I envisage the spaces to become inhabitable architecture, something I am starting to explore in my practice through interior design projects and retail design."

Taylor recently collaborated with smoking-accessories brand Tetra to create a vision for one of their smoking rooms. The seamlessly curved yellow interior was inspired by a skate-park, the walls and furnishings melting into the surroundings and dissolving the lines into a flowing, limitless space. For Taylor, these kinds of environments work to delicately move our thoughts away from the real world. "Utopia is a notion not too far from reality for me; it lies in the subtle details that push reality from the factual and concrete." ✧

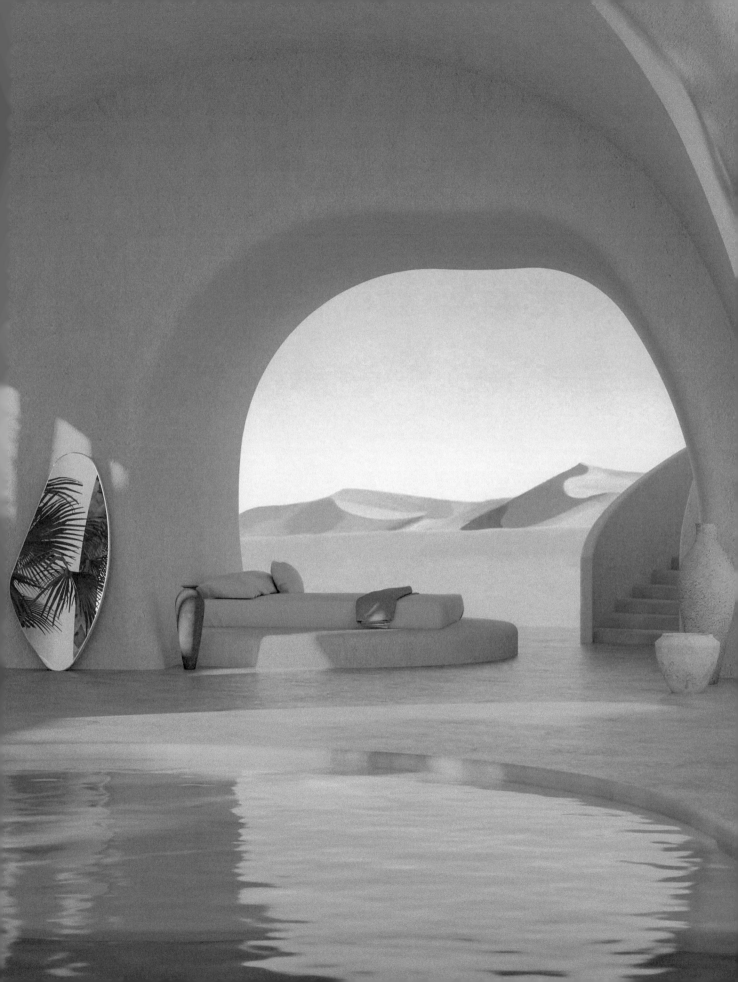

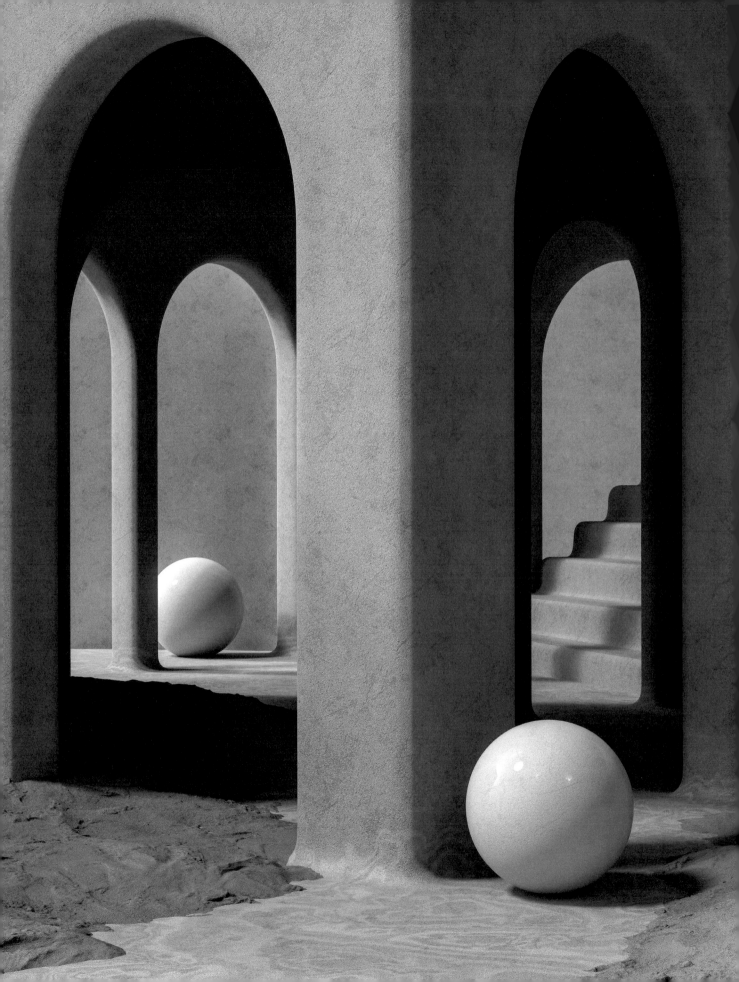

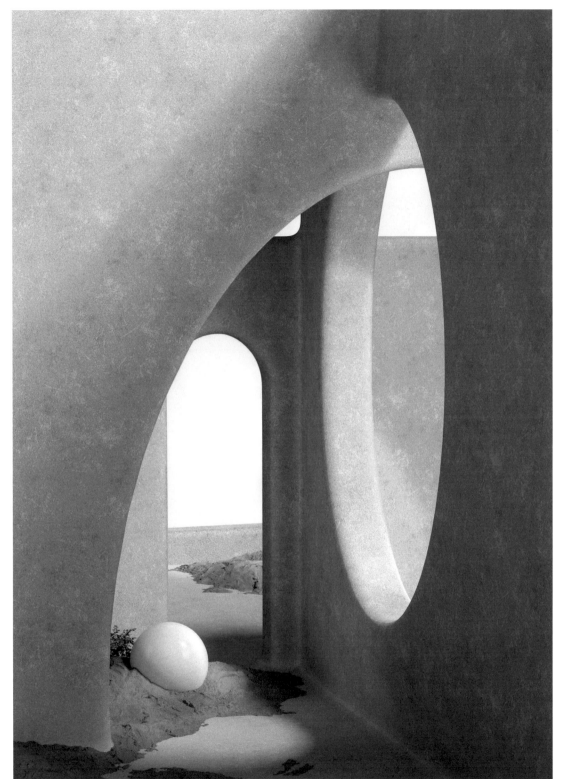

Utopia is a notion not too far from reality for me;
it lies in the subtle details that push reality from
the factual and concrete.

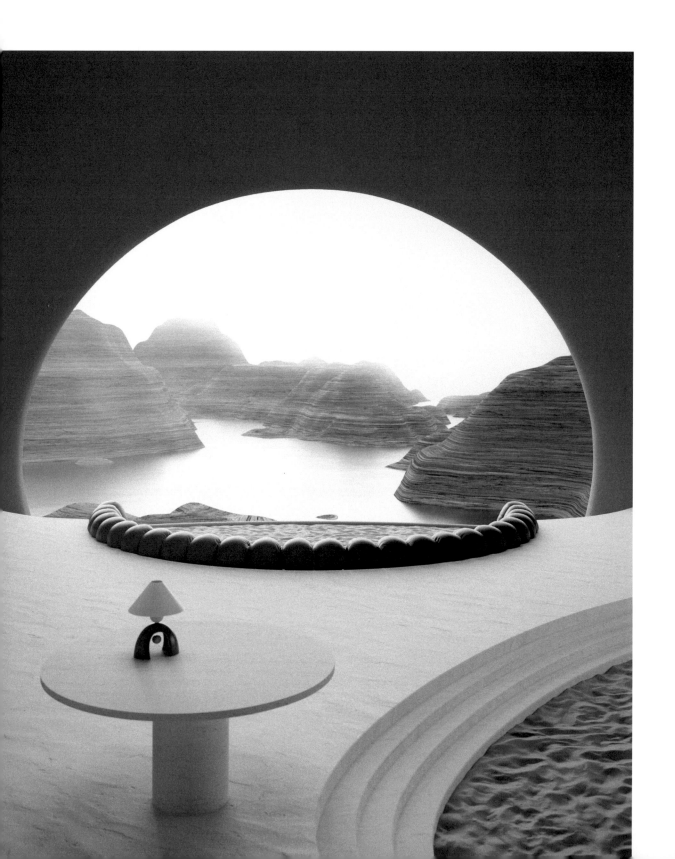

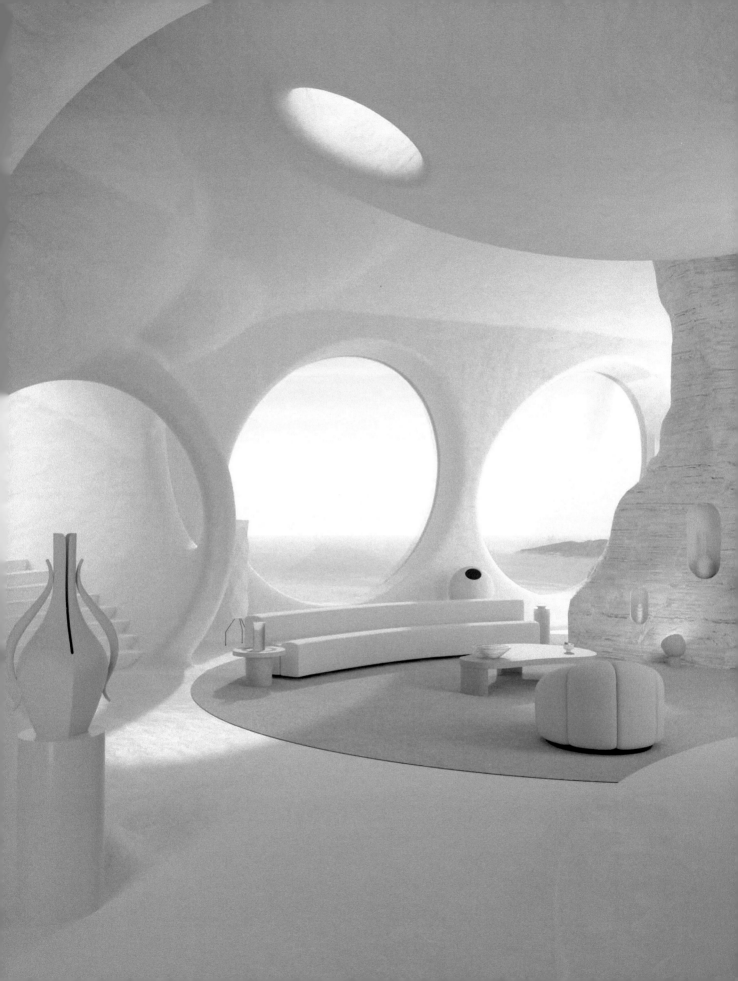

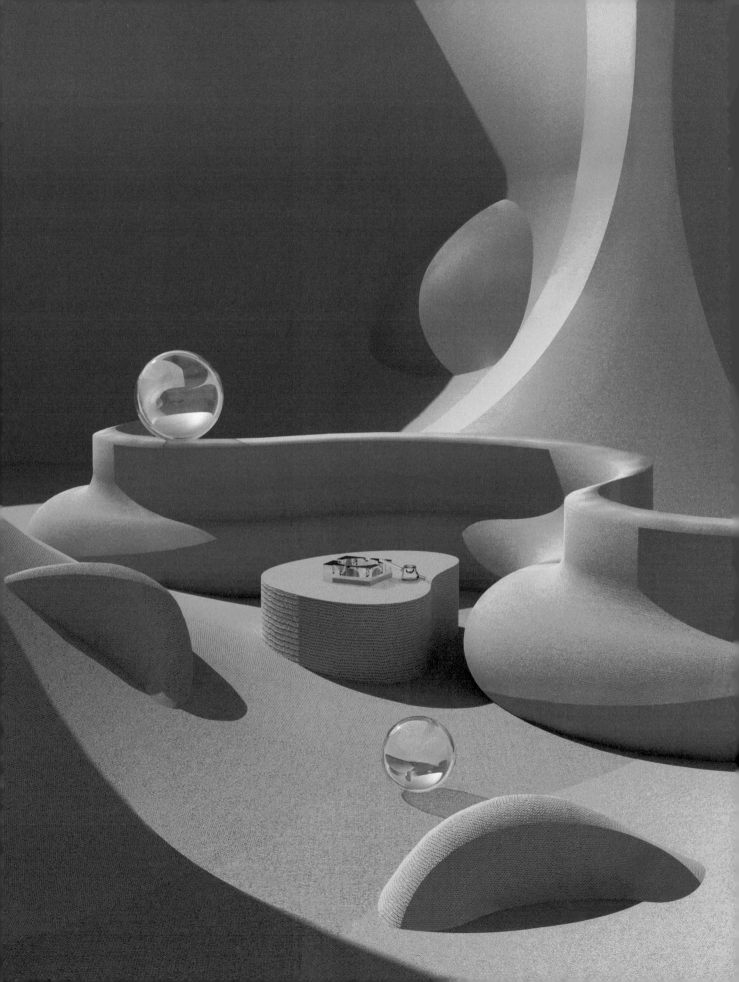

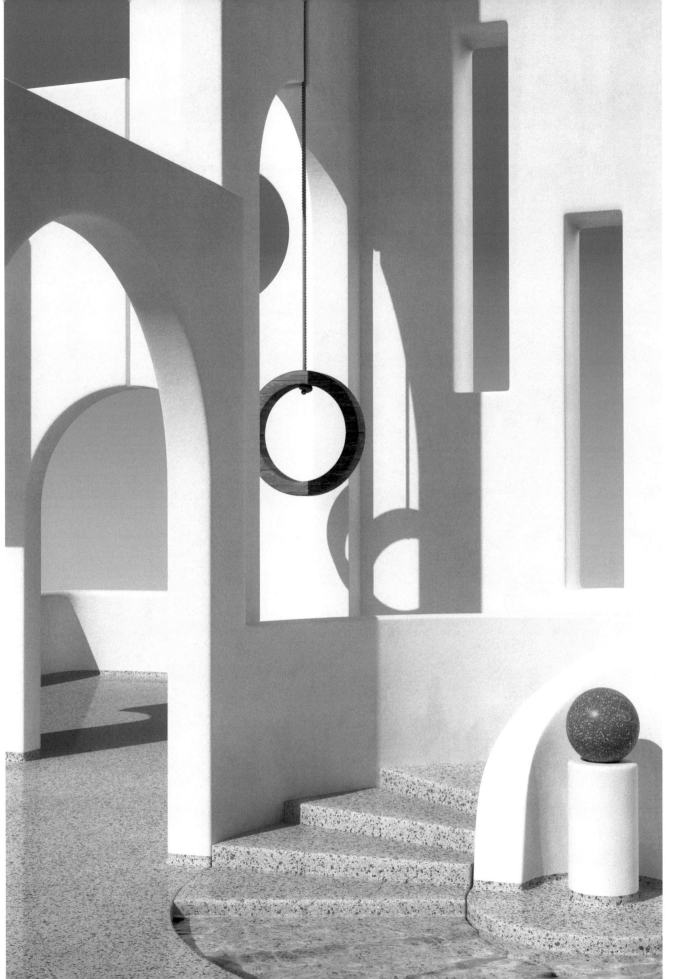

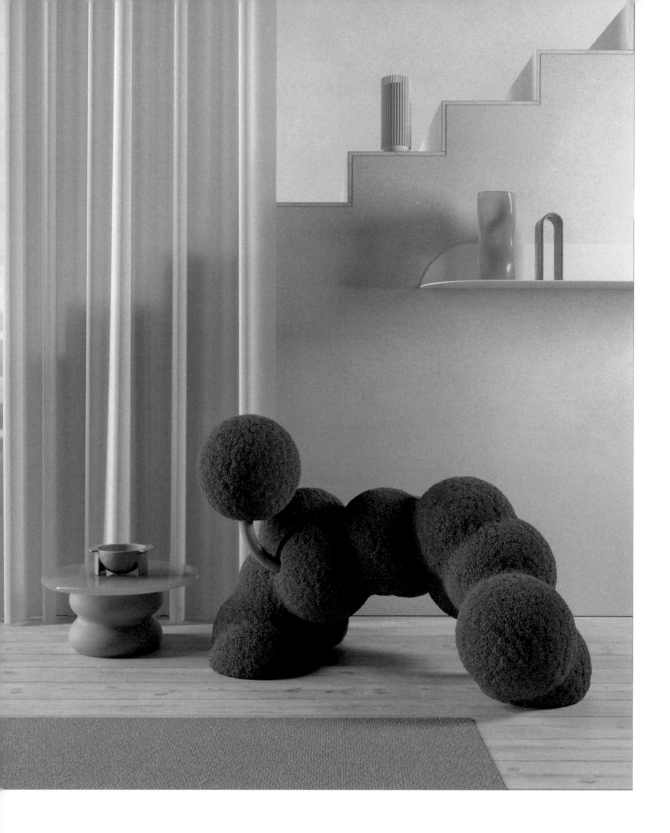

STEFANO GIACOMELLO
Montreal, Canada

Stefano Giacomello was recently commissioned to create a series of illustrations for *Architectural Digest Germany*'s special issue on lighting. With a background in interior design, he progressed naturally to 3D modeling and art direction.

Giacomello's artistic practice draws heavily on his professional experience, but he has branched out to scenography and advertising. He also collaborates regularly with Charlotte Taylor, whose designs have inspired and complemented his own. ✧

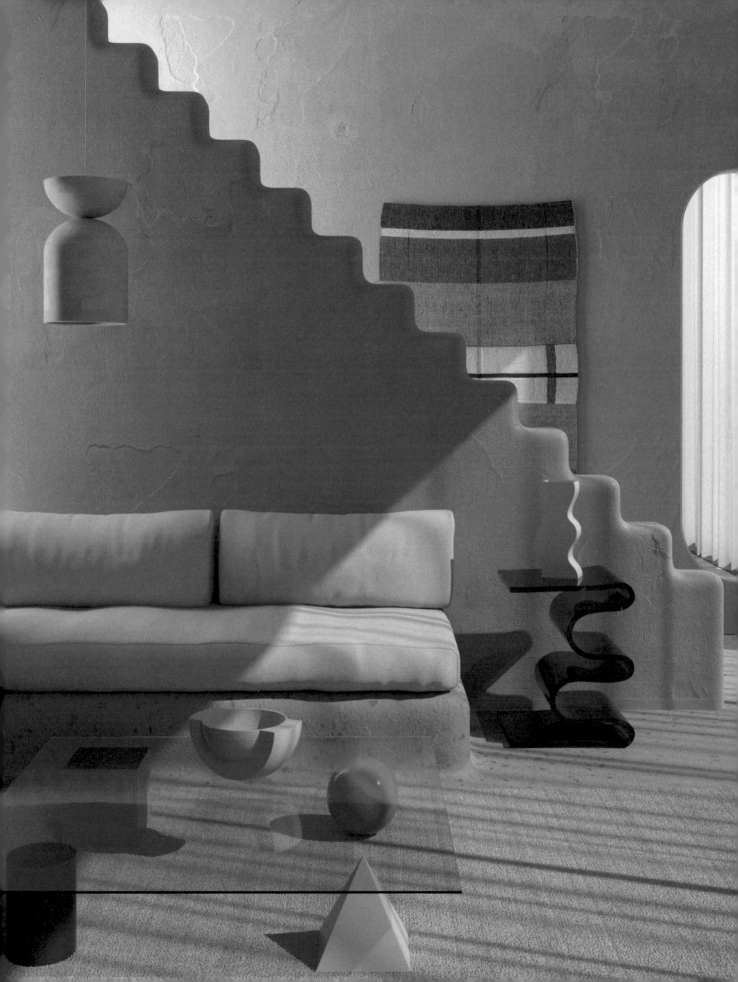

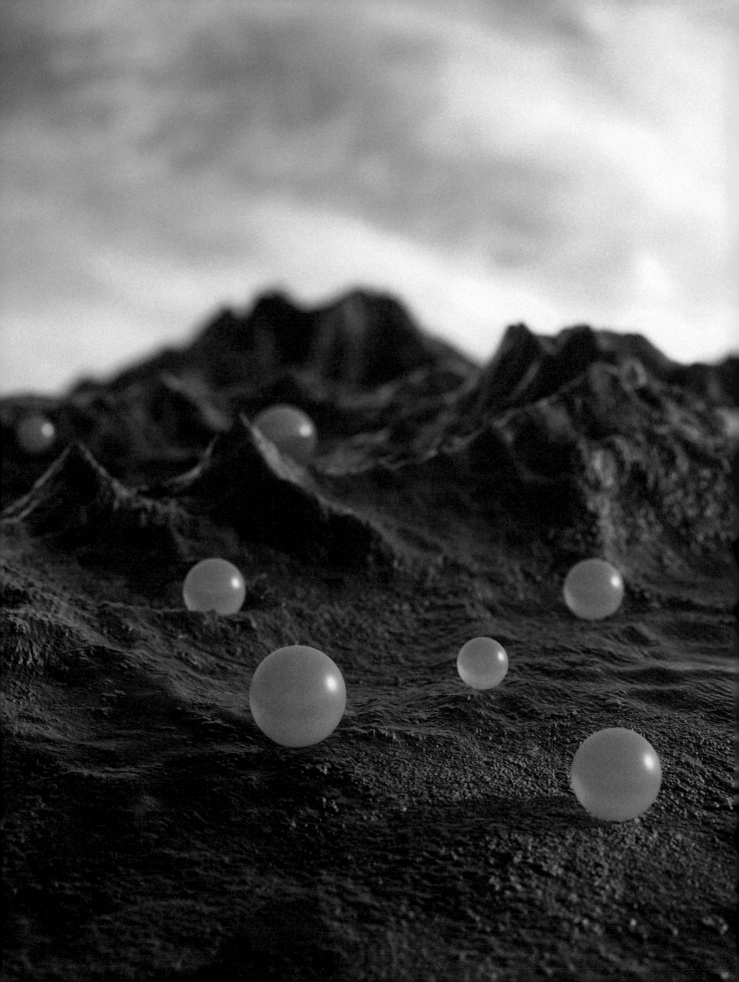

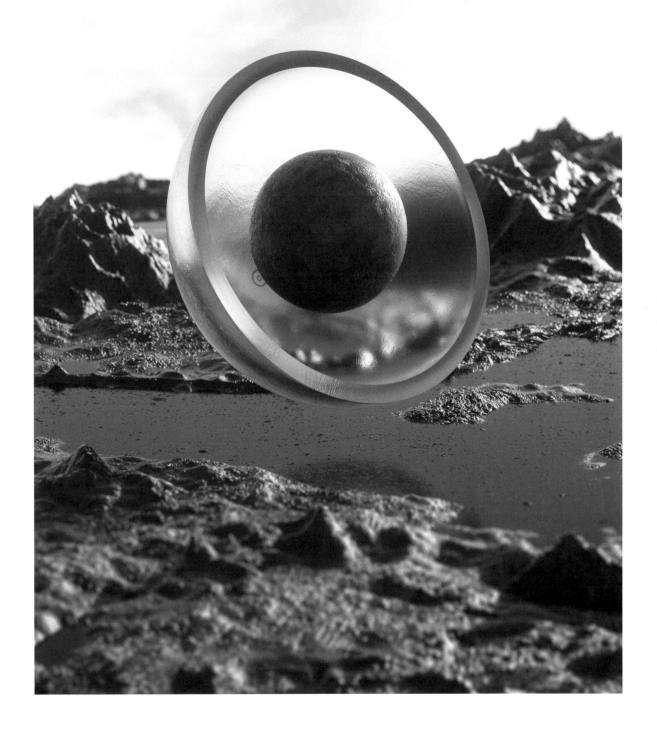

DANIEL URSULEANU
Bucharest, Romania

Daniel Ursuleanu started using 3D tools to create images that reinterpret the places he's traveled to. Whether he is creating barren landscapes populated by alien forms, or vibrant still lifes, Ursuleanu pushes the limits of his software to envision complex worlds. He has designed an app for Cabber and produced digital art for cybersecurity firm Bitdefender Technologies. ✧

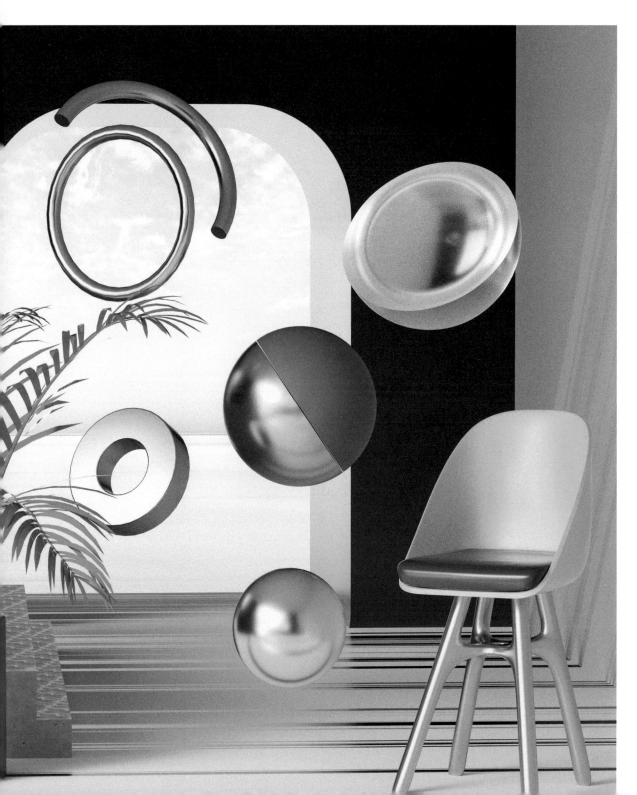

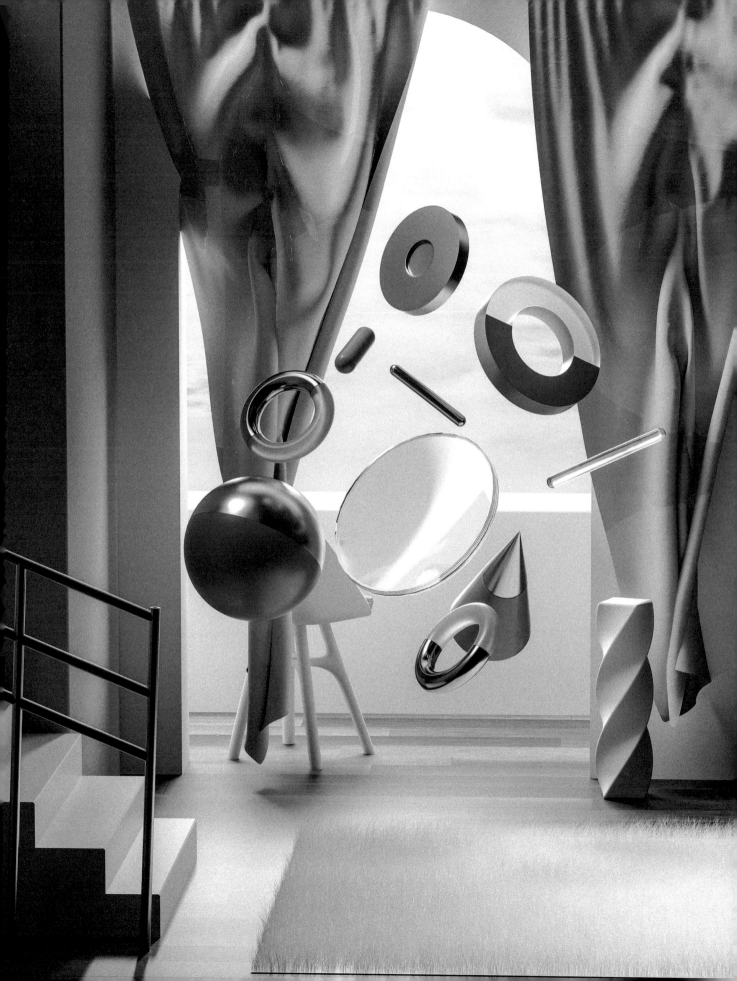

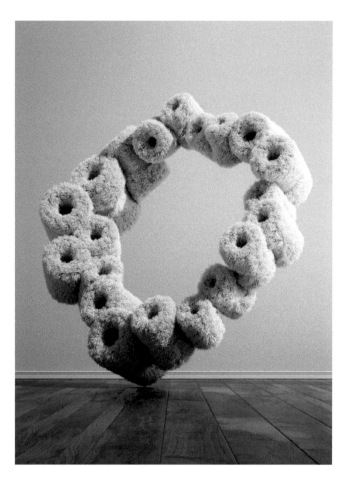
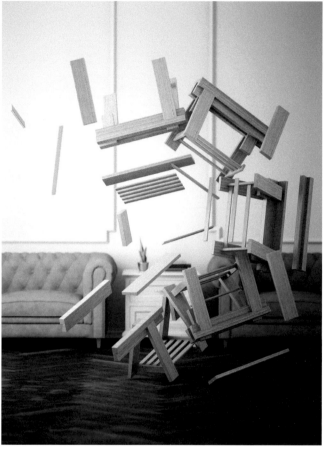

FRIEDRICH NEUMANN
Leipzig, Germany

Friedrich Neumann's 3D compositions and abstract artworks encompass all the elements of interior design renders but defy physics in their arrangement. The sculptural forms stand at impossible angles, some even seemingly suspended in mid-air.

Neumann's aim is to escape rational design principles with his 3D works, freeing his creative expression and creating harmonious images that combine the abstract and the everyday, the realistic and the absurd. ✧

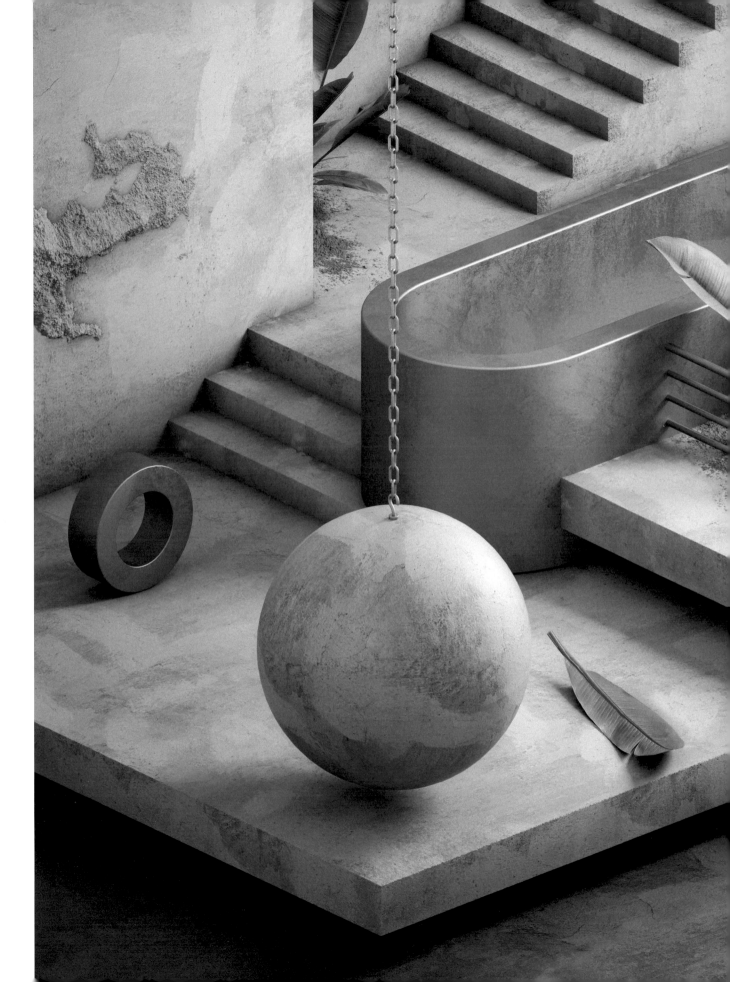

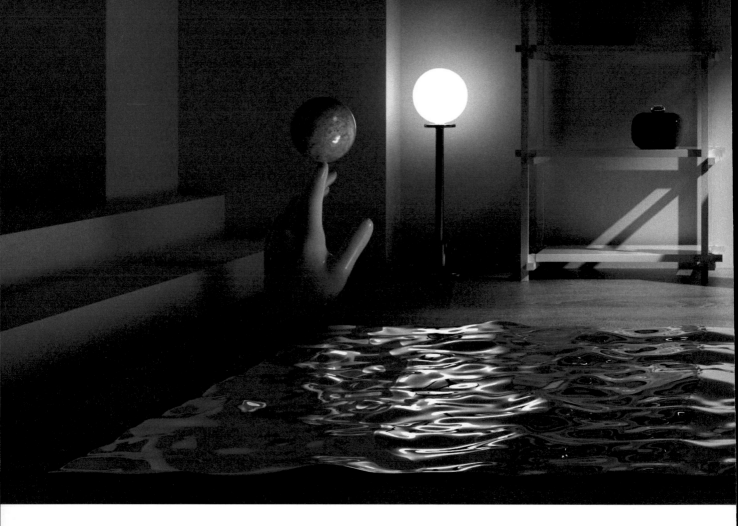

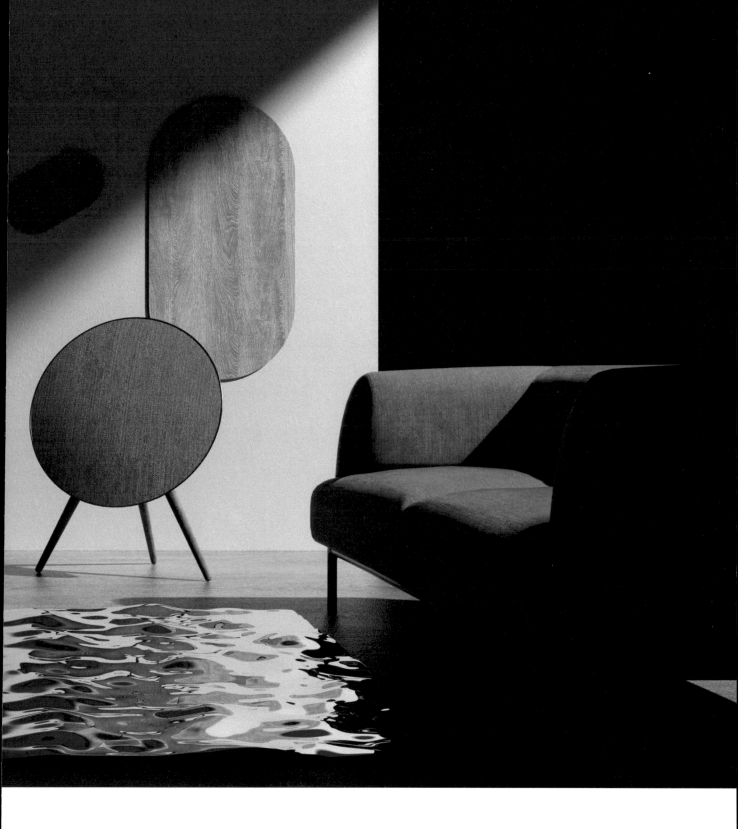

SANTI ZORAIDEZ
Buenos Aires, Argentina

Santi Zoraidez worked in Copenhagen and Berlin before returning to his native Buenos Aires, where he previously studied communication design. As an independent art director and designer, Zoraidez draws inspiration for his compositions from outside the screen, translating conceptual thinking and movement into simple, bold images with a focus on interior and industrial design. His interest in motion graphics led him to work with Argentinian studio Punga, where he learned about animation and design while working with major brands. ✧

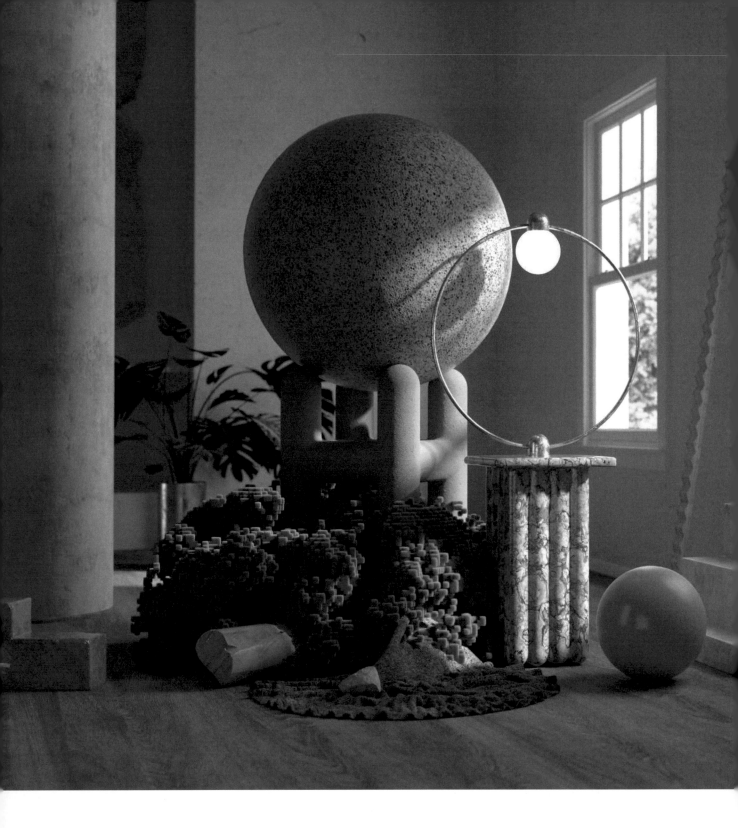

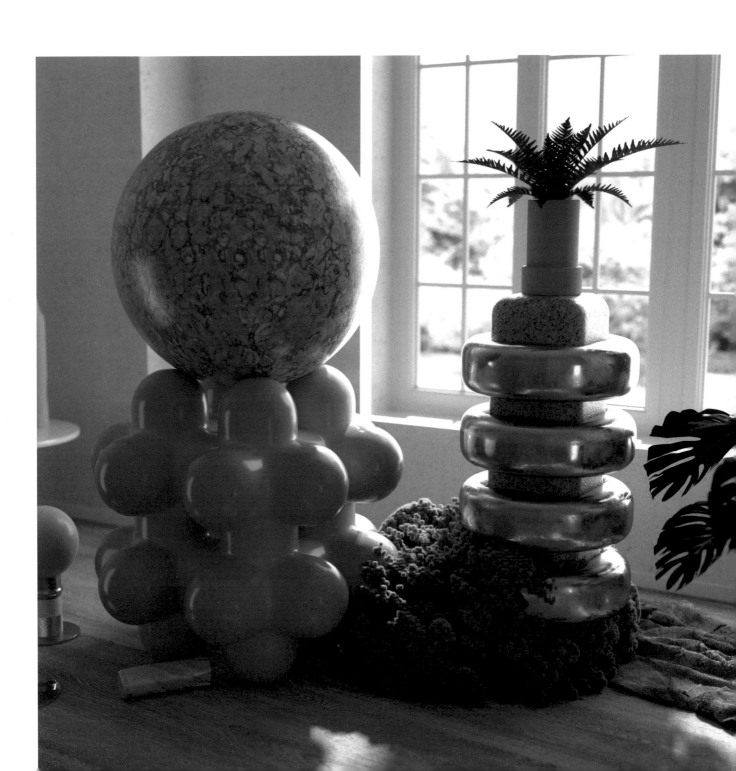

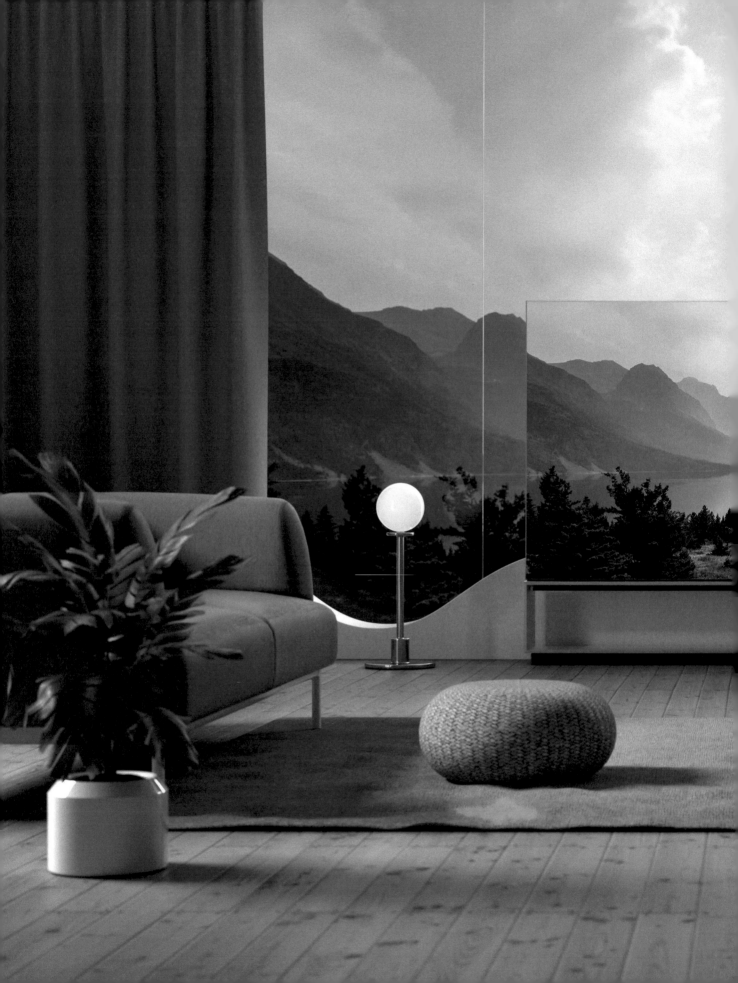

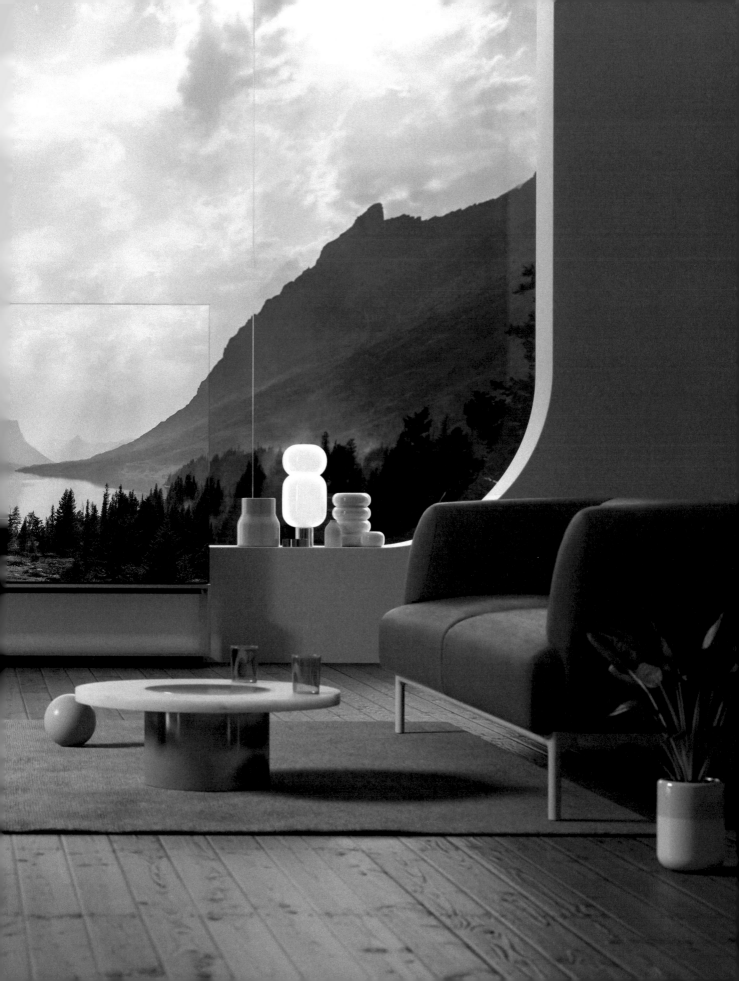

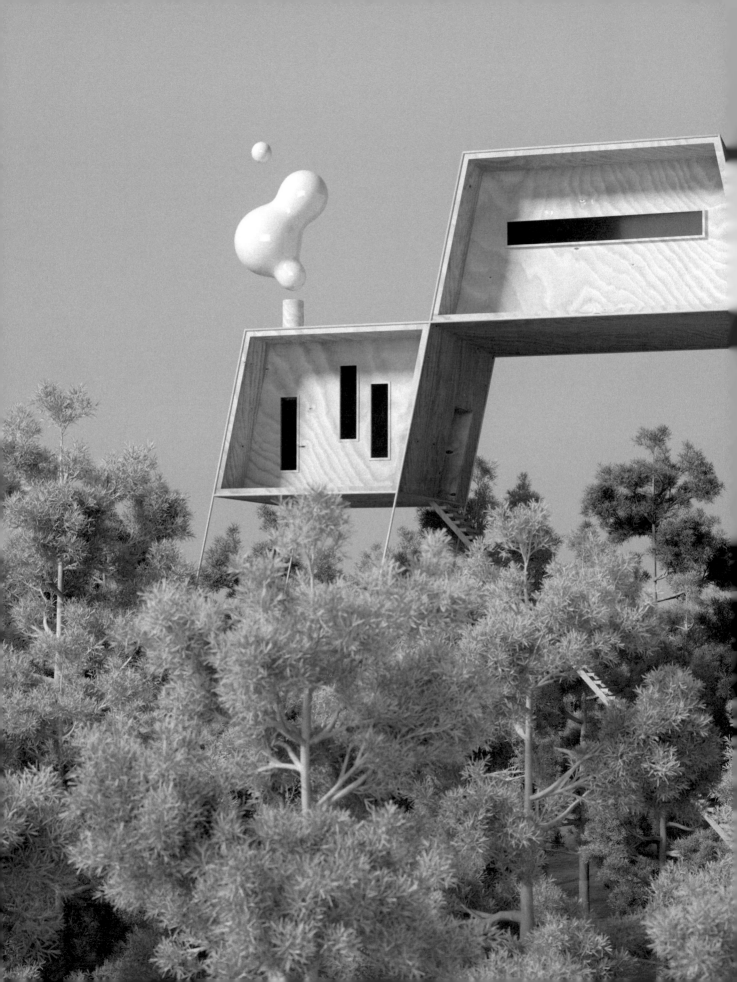

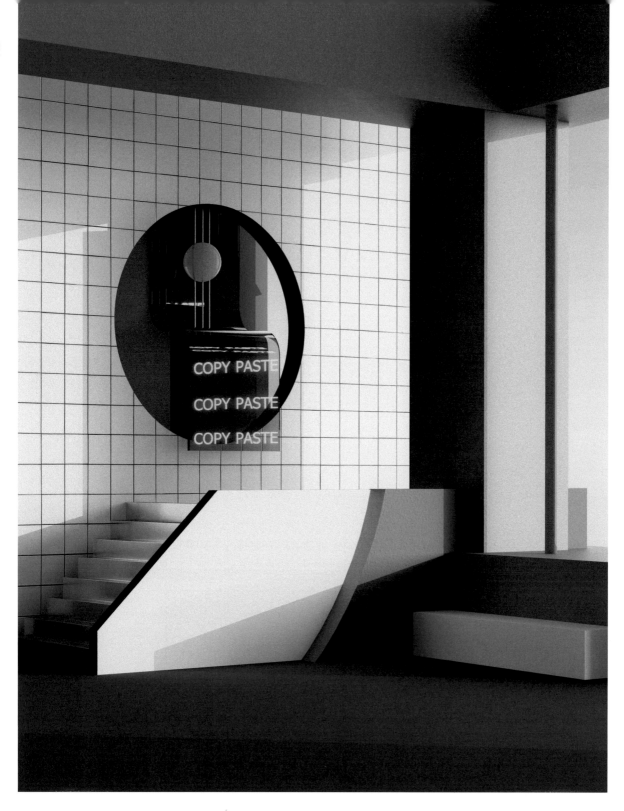

OUUM
Lviv, Ukraine

OUUM is a design studio that specializes in CG architecture visualizations, interior design, and post-production. Inspired by 1960s and 1970s designers like Verner Panton and the Swinging Sixties movement in London, the studio launched its *Technicolor Dream* series to imagine wildly colorful interiors—spaces that could be considered art in themselves. The images pop with vibrant yellows, hot pinks, and Egyptian blues and make use of elements from Spanish modern architecture, such as Ricardo Bofill's famous housing project *La Muralla Roja*. ✧

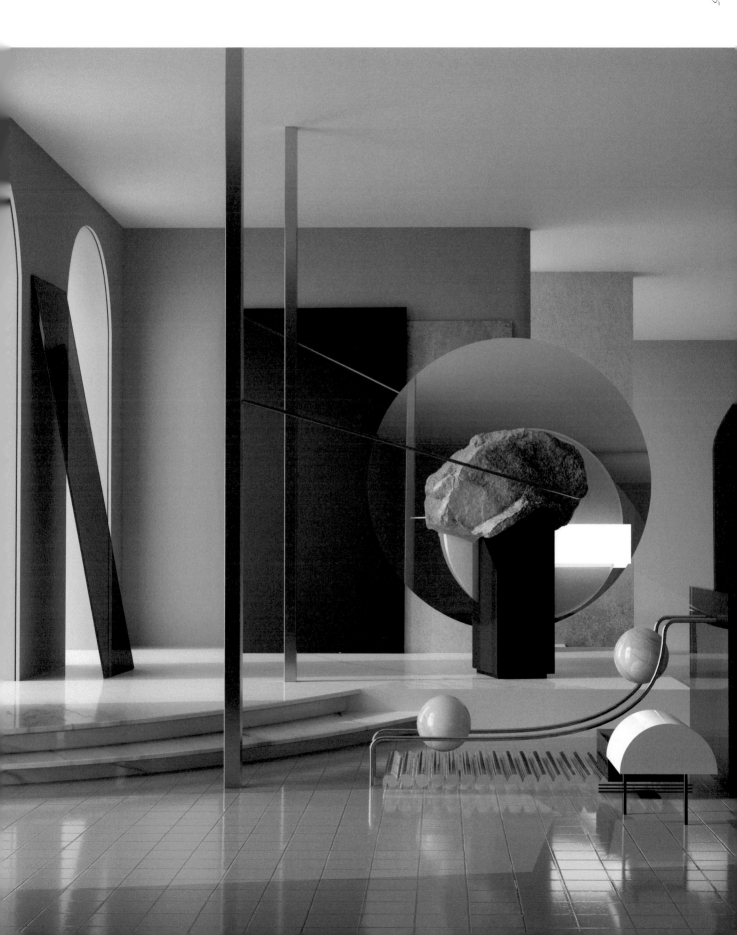

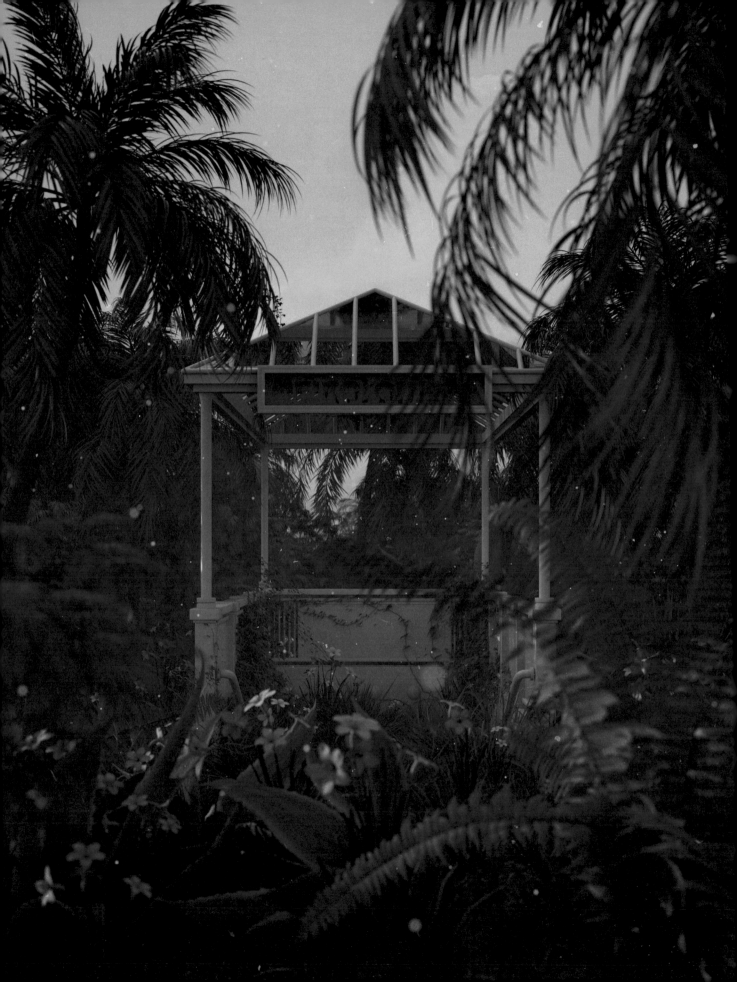

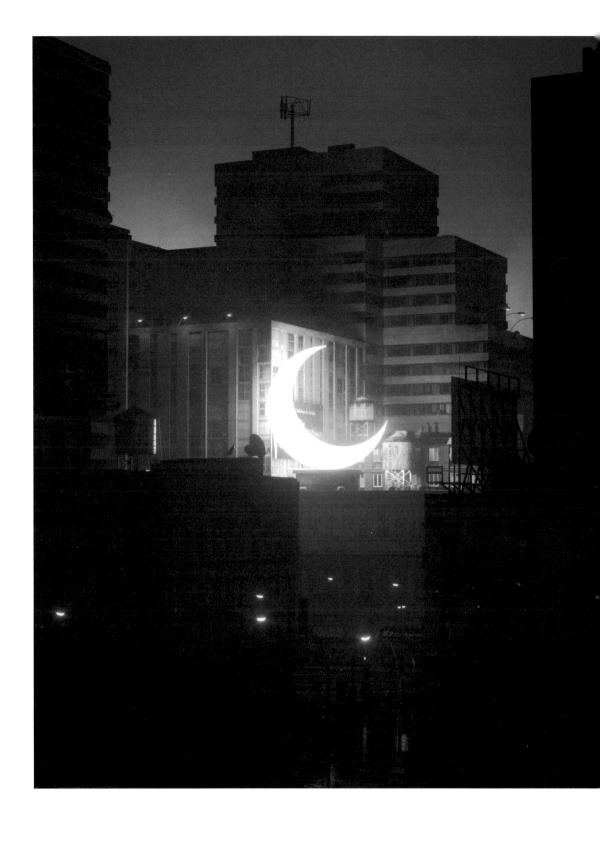

JULIEN MISSAIRE
Annecy, France

Julien Missaire wants his images to translate a feeling of peace. His dimly lit, sunset-infused 3D visuals aim to harness that perfect light at just the right time of day that we only rarely experience in person. He creates moods by exploring the use of buildings in his images. Architecture is used to access feelings and memories, whether through a busy cityscape, or an isolated home in the forest. As well as his 3D images, he creates visuals for music videos and augmented reality. ✧

PZZZA STUDIO from BARCELONA, SPAIN offers a surreal slice of life— but they don't want to make it too easy on the viewer.

When Boldtron—the alter ego of Xavi and his twin Dani, founders of PZZZA STUDIO—began creating 3D renders, they were mostly in the form of sculptures and still lifes. After a few collaborations with other 3D studios, they began to push their work into the realm of architecture and interior design. "Working next to big studios like Serial Cut or Six N. Five helped us to evolve this sense of space and scale."

With PZZZA STUDIO, Boldtron created a production house to work on bigger projects with skilled collaborators, whom they refer to as "satellites." Today, they enjoy working with lifestyle brands such as Nike, Lacoste, Nautica, and Reebok, as well as in the video game industry. Their move to virtual reality was a natural progression. "VR changed our perception and creative process in a very innovative way," they explain. "And, nowadays, video games are equal in importance to cinema, especially in narrative and effects."

Cinema optics have also played an important role in PZZZA STUDIO's work. But the duo aren't interested in making their work straightforward or user-friendly. Their work contains skewed structures that complicate the viewer's perspective. This is a reaction to what they see as a certain complacency in modern life. "Disorientation also comes from our personal point of view. We live in a digital era filled with grids, patterns, and intelligent guides; everything becomes very boring if we just click on them." Instead, PZZZA STUDIO wants to push us out of our comfort zones and encourage us to rethink the physical realm. ✦

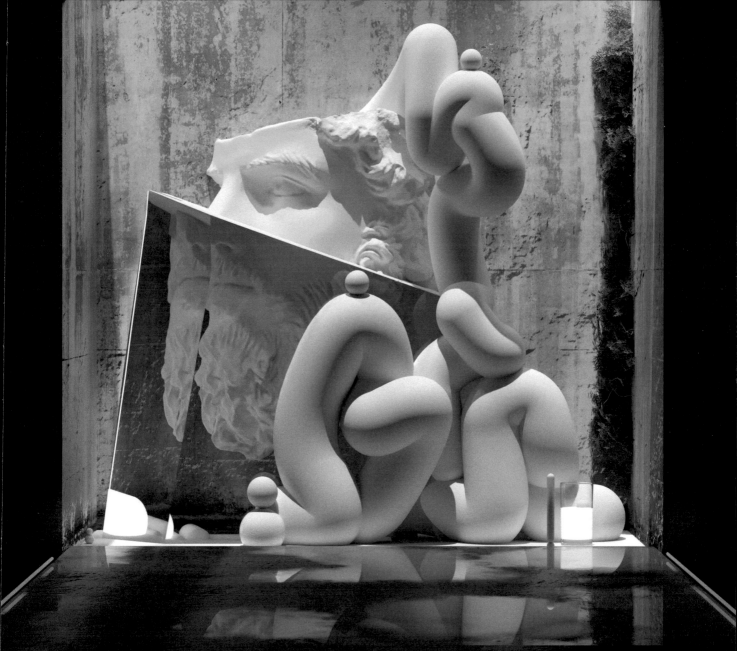

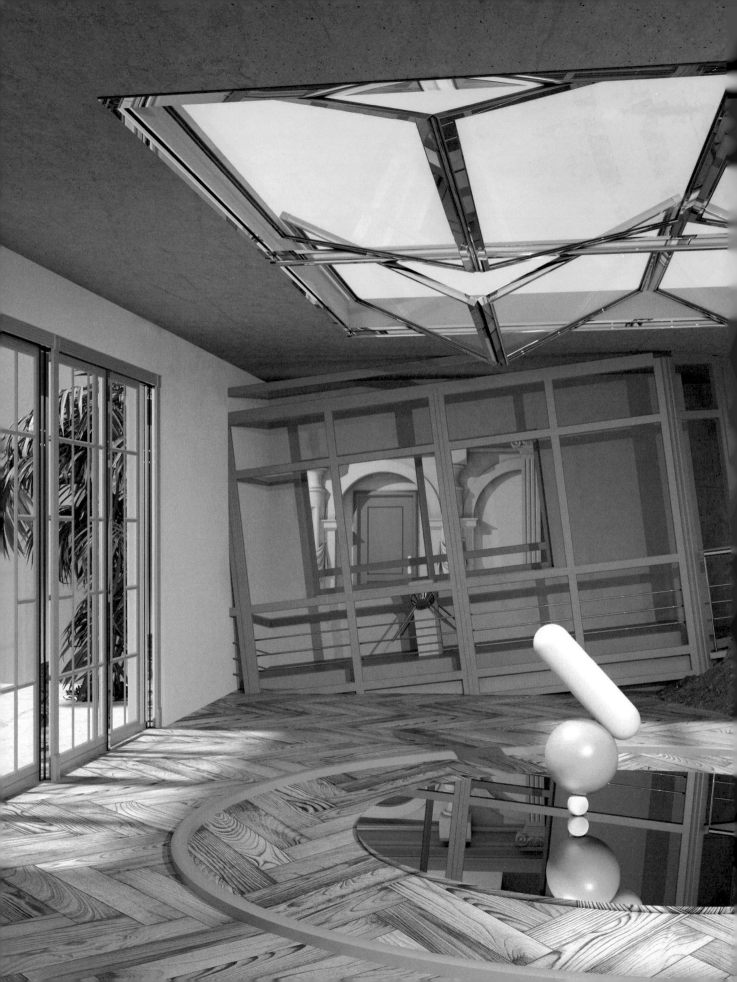

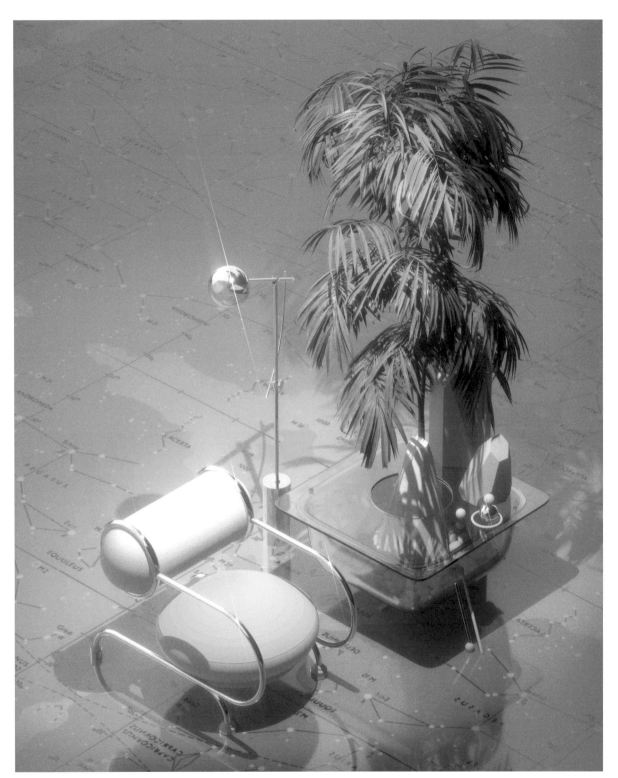

We live in a digital era filled with grids, patterns, and intelligent guides; everything becomes very boring if we just click on them.

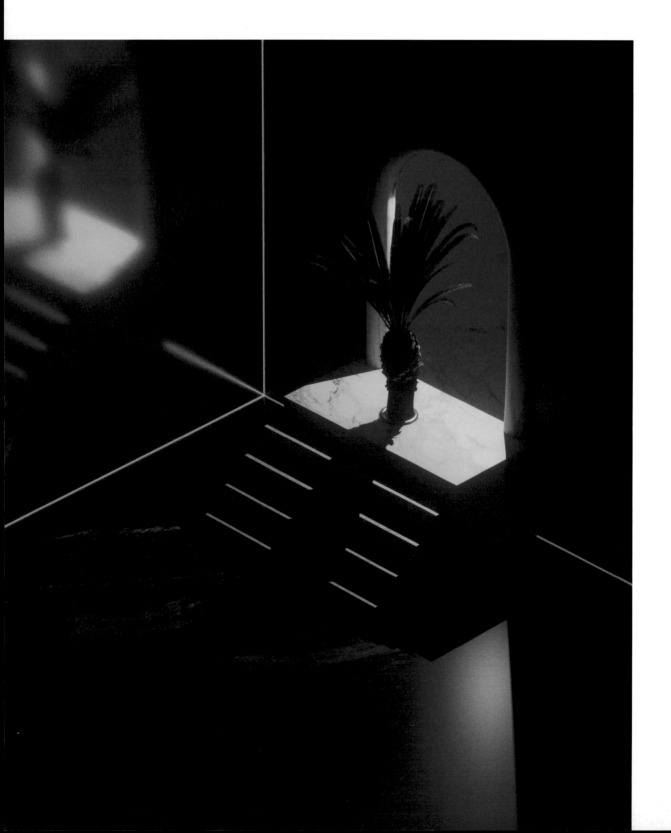

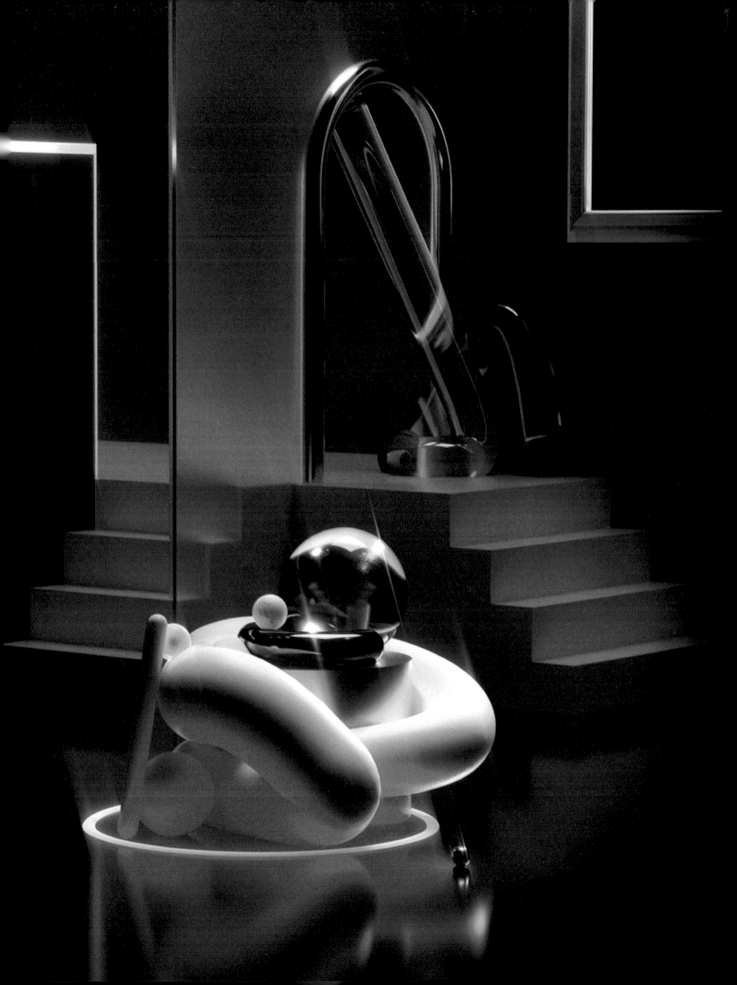

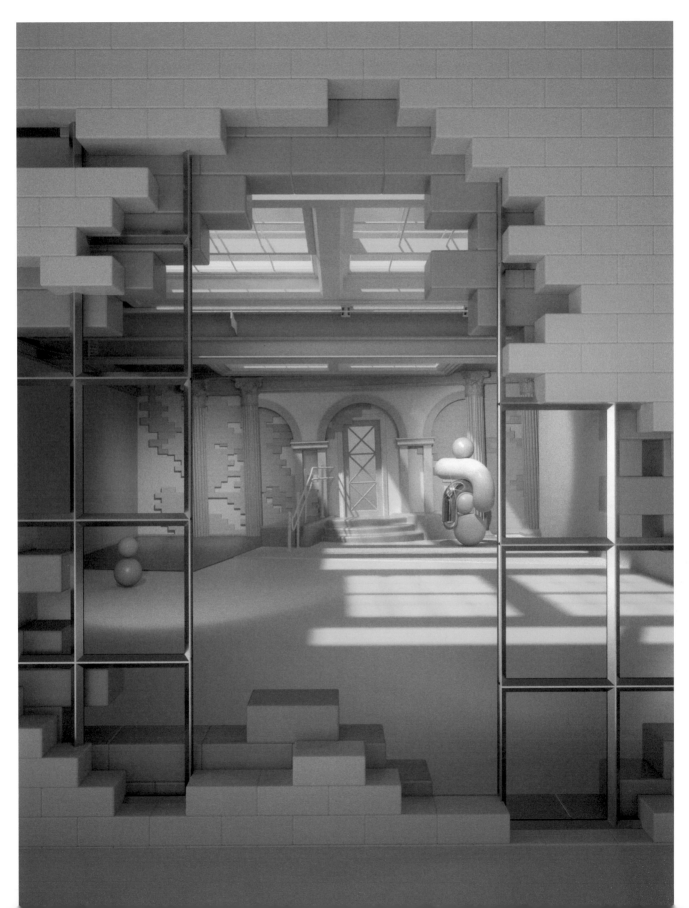

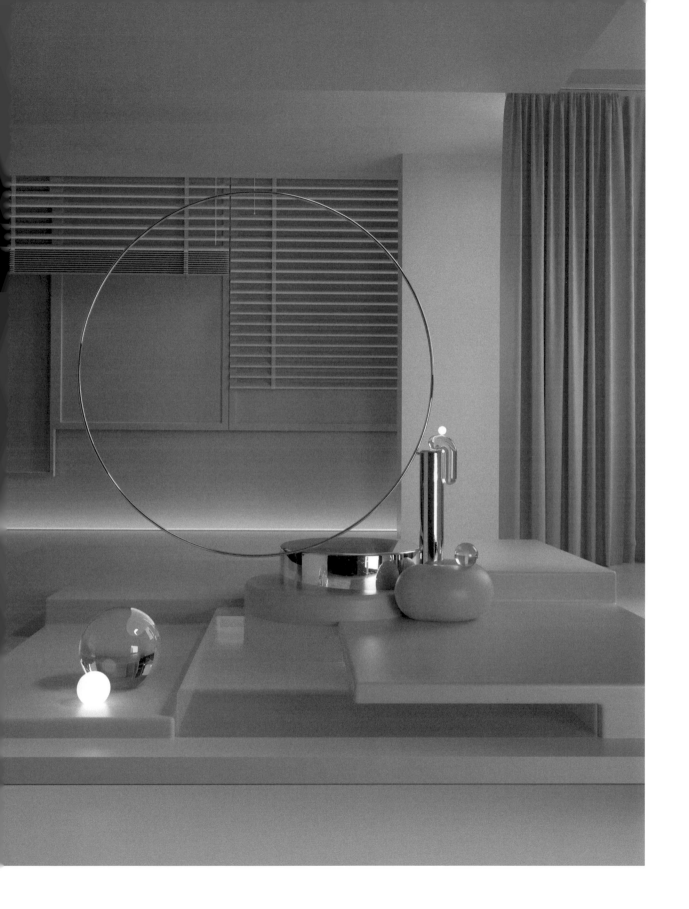

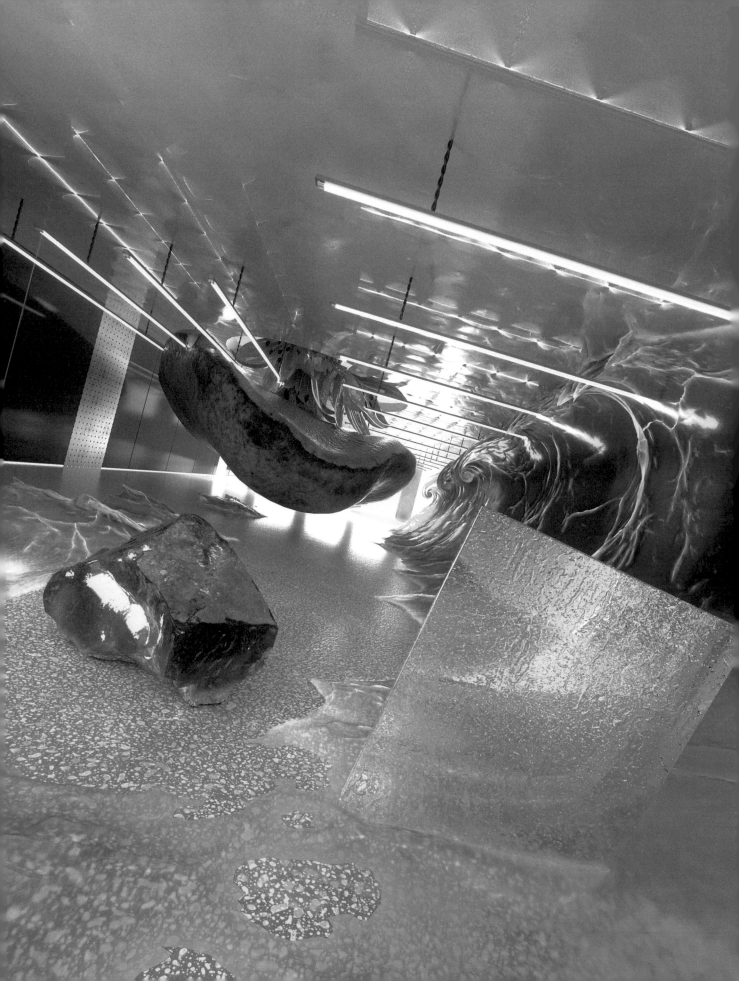

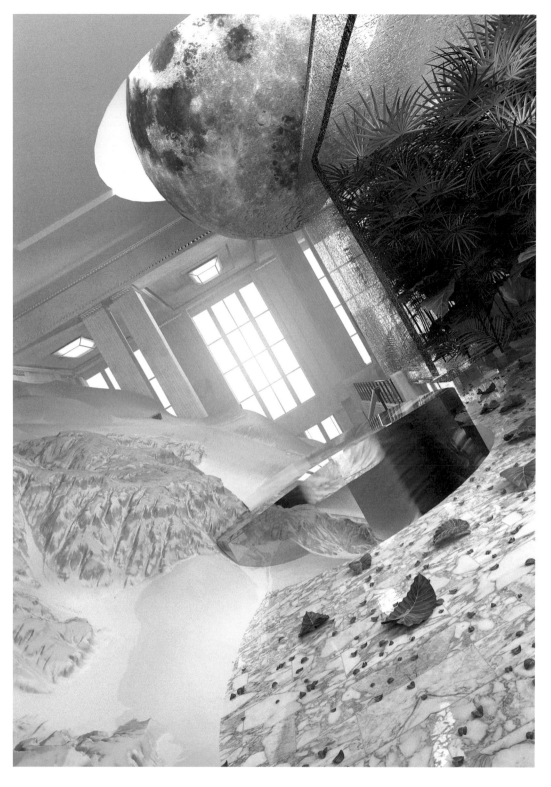

THOMAS TRAUM
London, U.K.

Thomas Traum is a pseudonym that describes the kind of work the artist does, "Traum" meaning "dream" in German. The 3D worlds he creates are an alternative to the one in which we live, but the landscapes often verge on the chaotic and catastrophic. The projects that Traum and his team of five at TRAUM INC have worked on a range from animations for fashion brands such as Kenzo, Estée Lauder, and Issey Miyake to music videos and interactive exhibitions. ✧

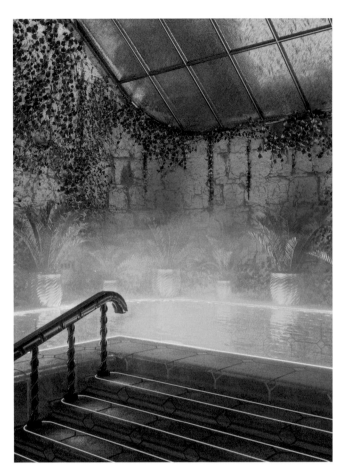

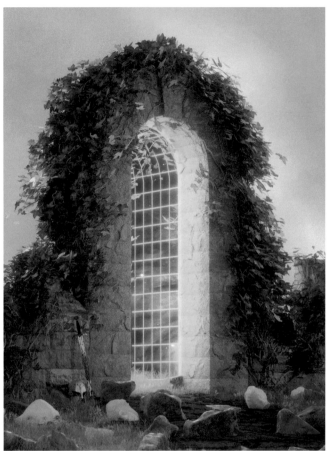

BLUNT ACTION
New York City, NY
USA

Blunt Action has always had an appreciation for psychedelic art, ancient aesthetics, and diverse cultures. In 2017, they began creating 3D worlds that reflected these interests, combining them with their own contemporary influences. The result has a timeless quality, mixing the ancient and the futuristic to evoke a sense of reminiscence and familiarity. The studio strives to show that there are no limits to the imagination when envisioning alternative futures. ✧

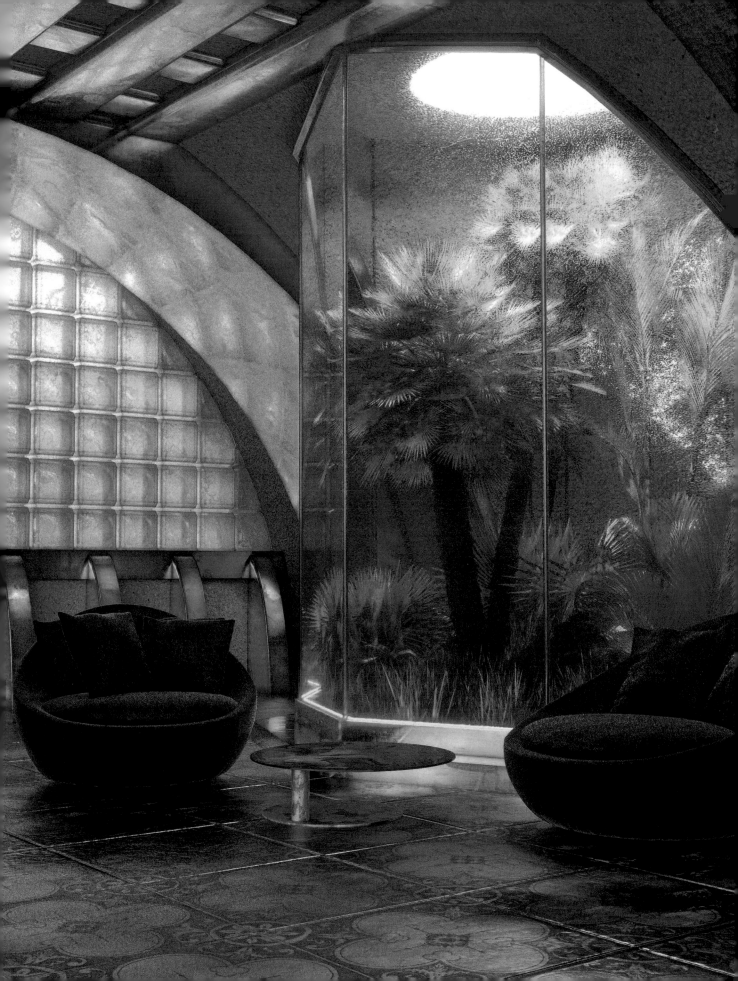

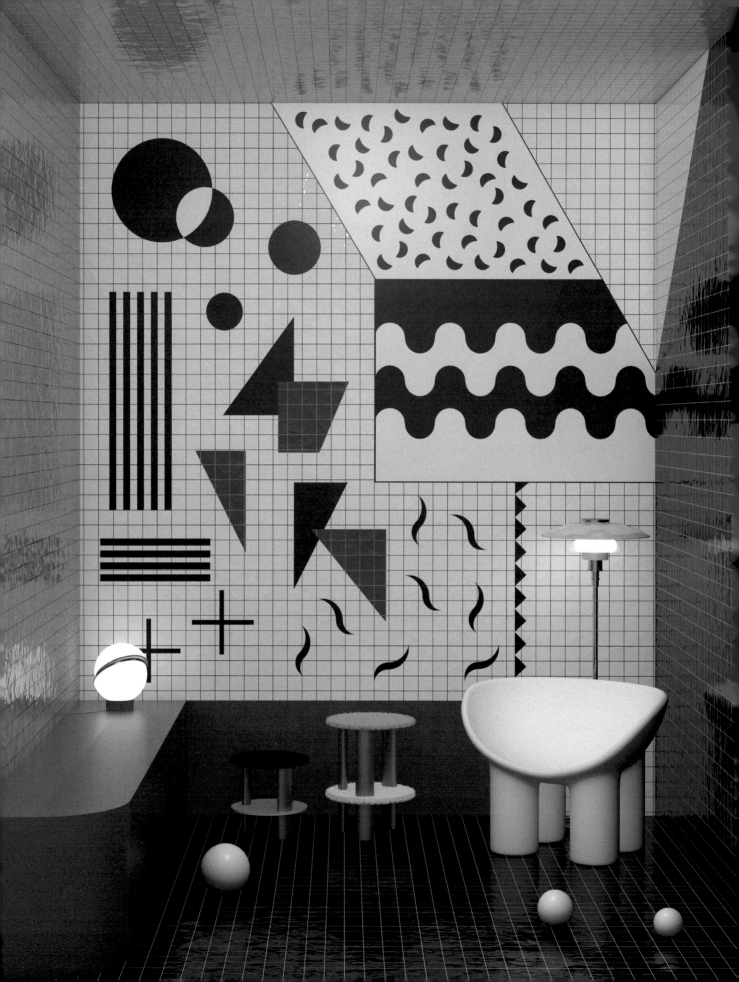

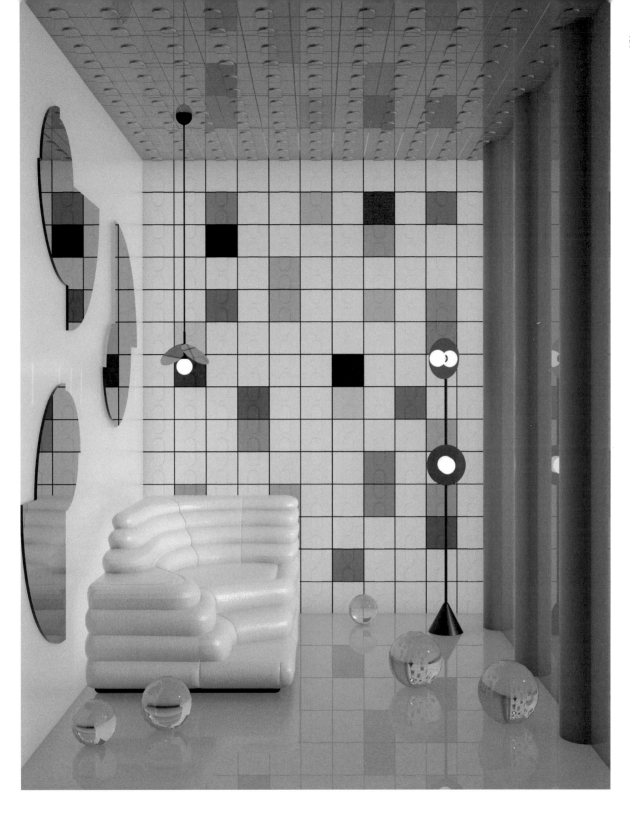

ANA DE SANTOS DÍAZ
Madrid, Spain

Ana de Santos Díaz is an interior designer and visual artist. A self-described dreamer, she wants to create images of places she'd like to inhabit or visit. Colorful tiled geometries and patterns mixed with curved and bubbled furniture give a retro-futuristic feel to her sites, which are often dotted with famous furniture by modernist masters such as Eames or Breuer. ✧

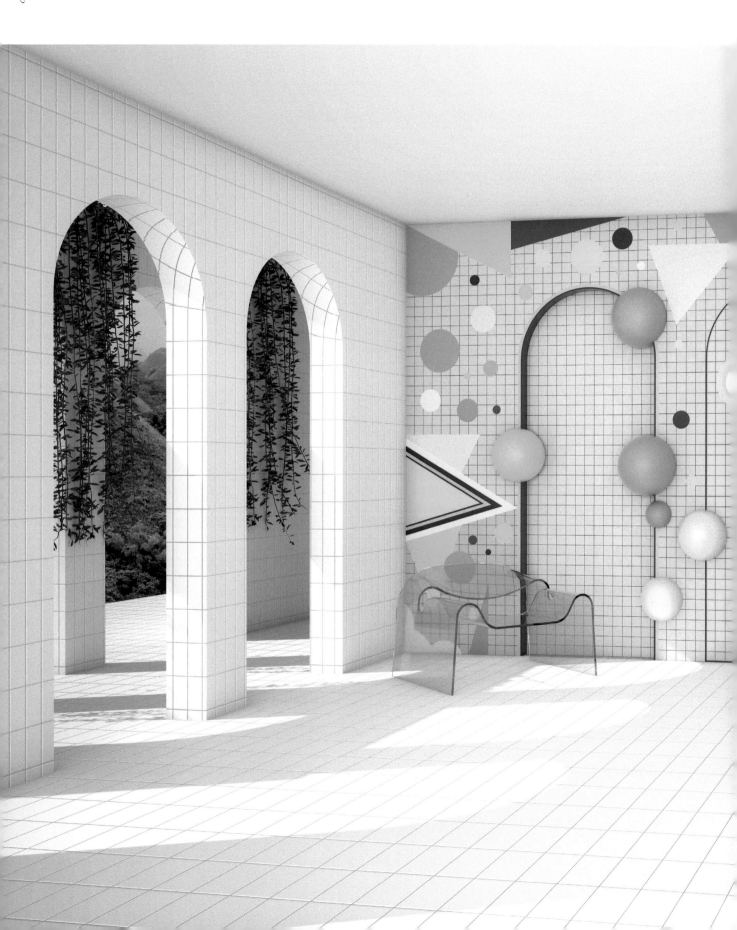

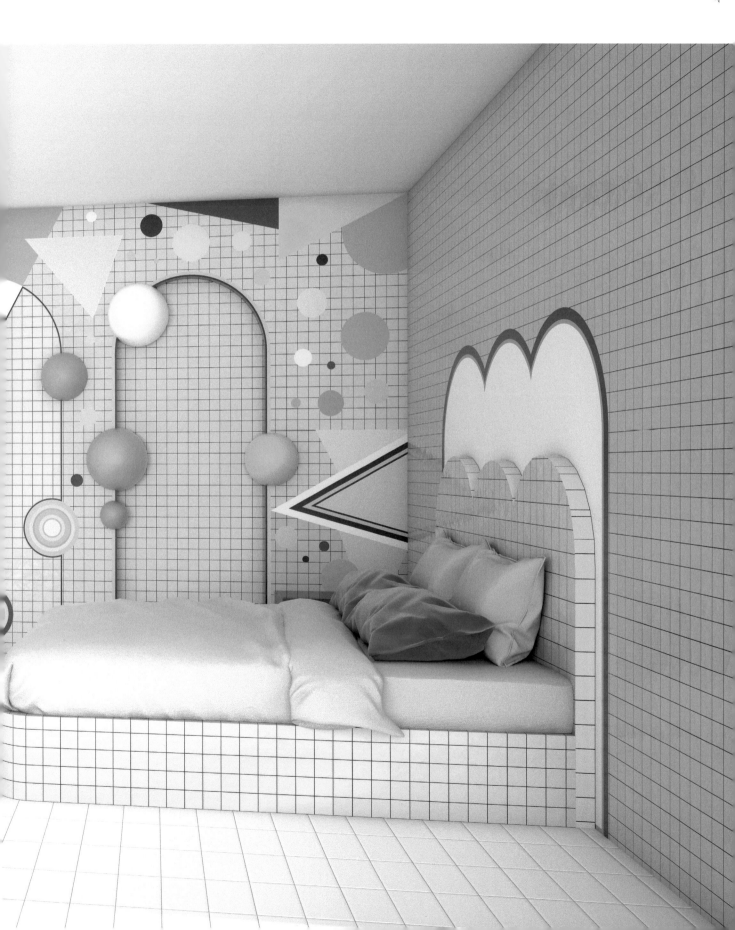

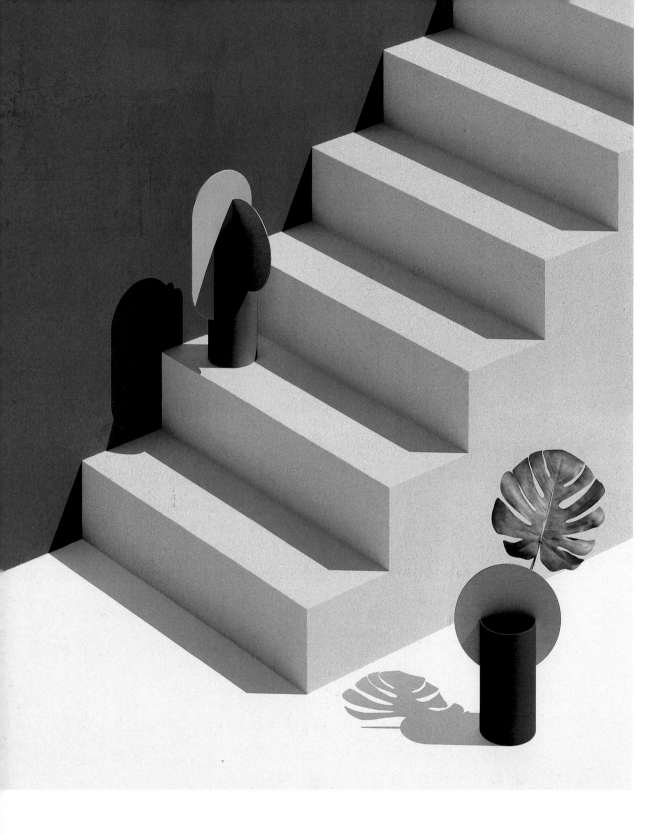

CRISTINA LELLO STUDIO
Venice, Italy

Using a clear and decisive visual language of spaces, lights, shapes, and materials, Cristina Lello draws on her background in theatrical scenography to bring stories to life. Her goal is to create worlds that evoke sensations, rather than a real sense of inhabitability. Lello works with communication agencies, furniture companies, and product designers to transmit their visions using minimalism, geometry, and a strong graphic imprint that is both sharp and playful. ✧

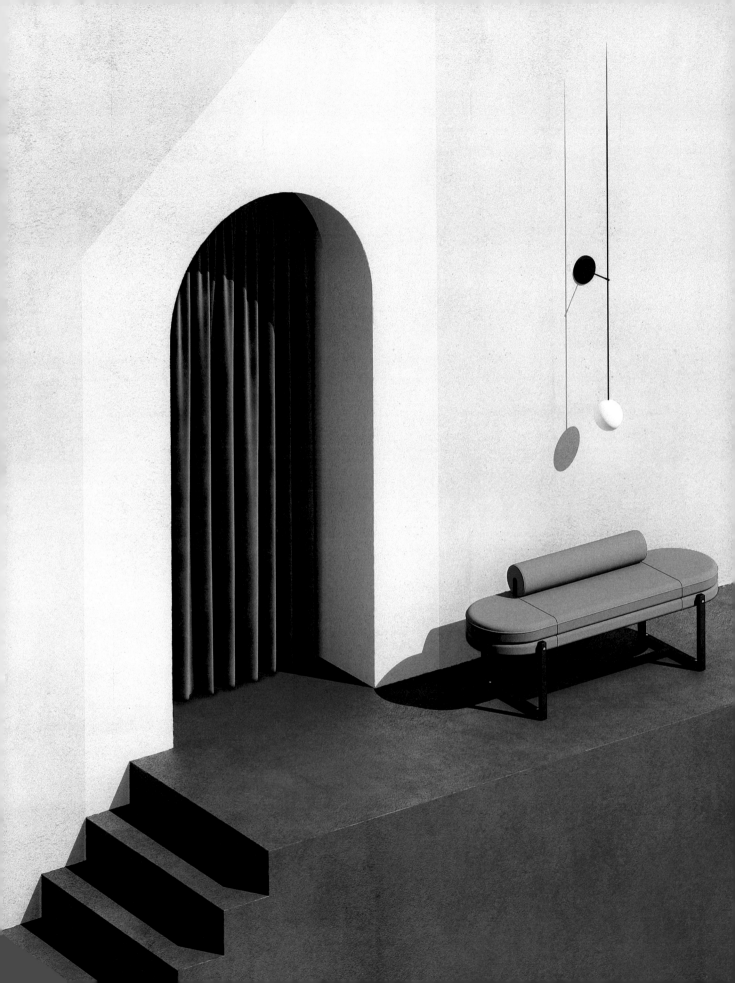

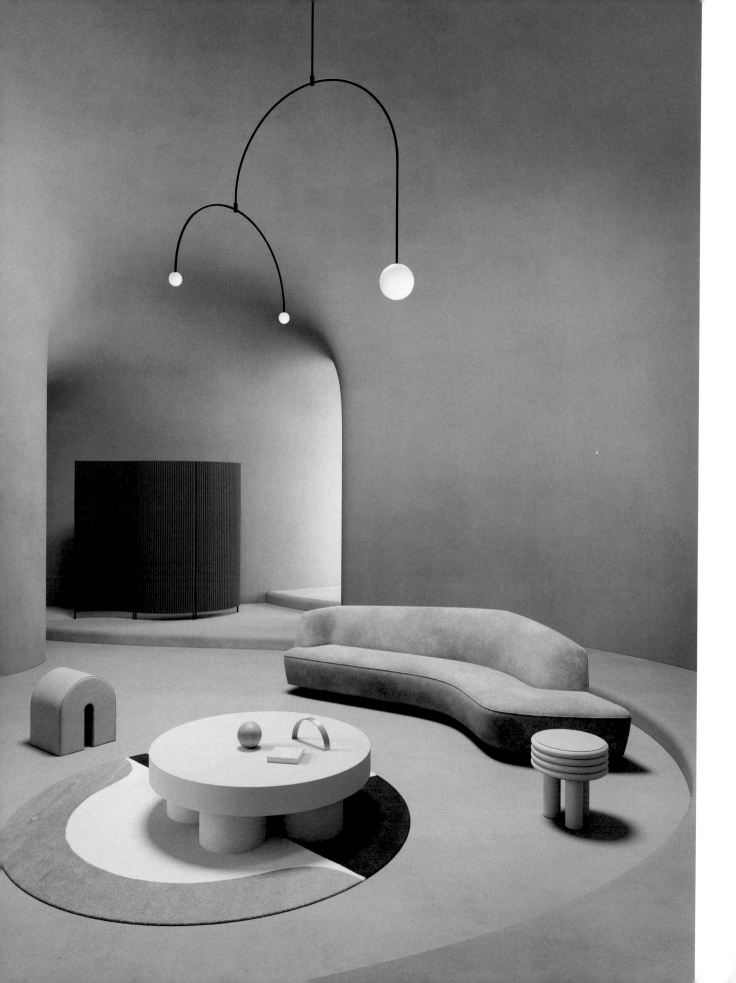

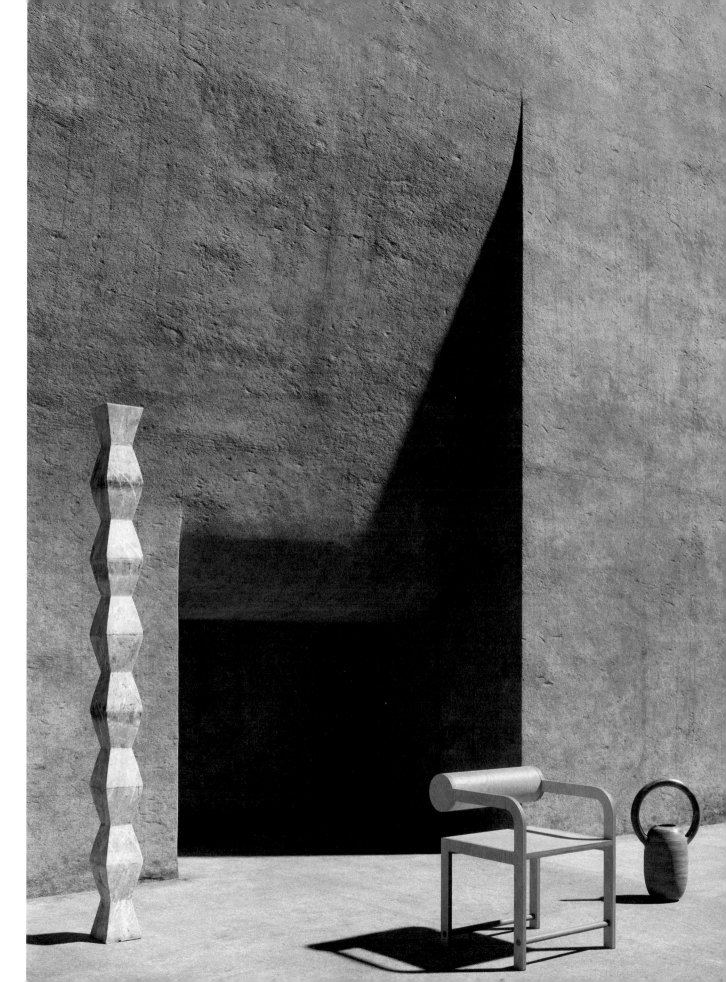

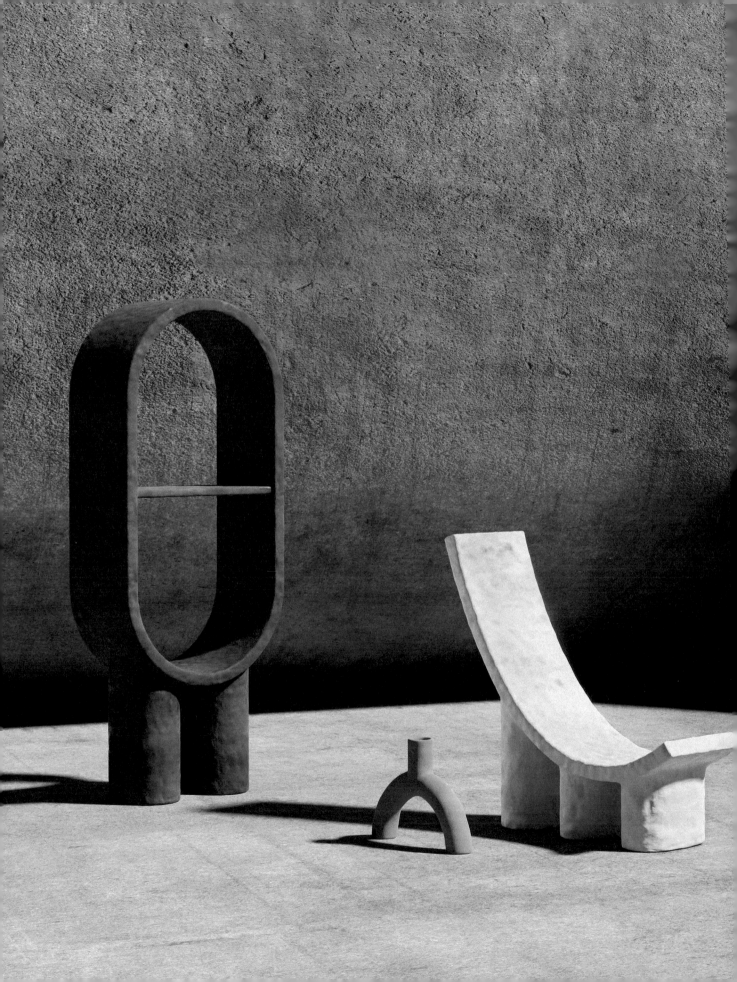

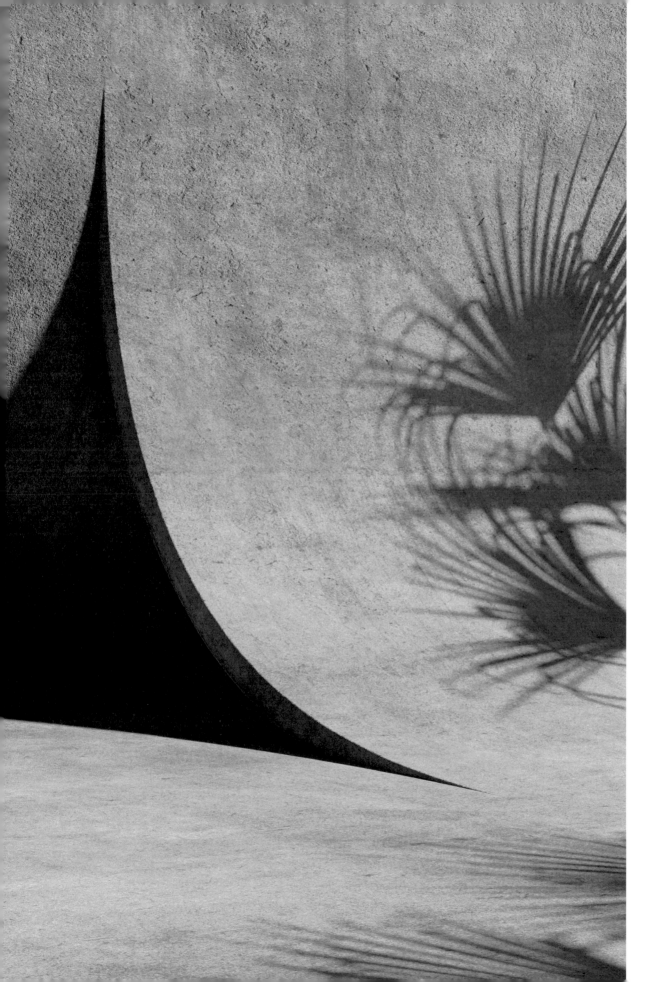

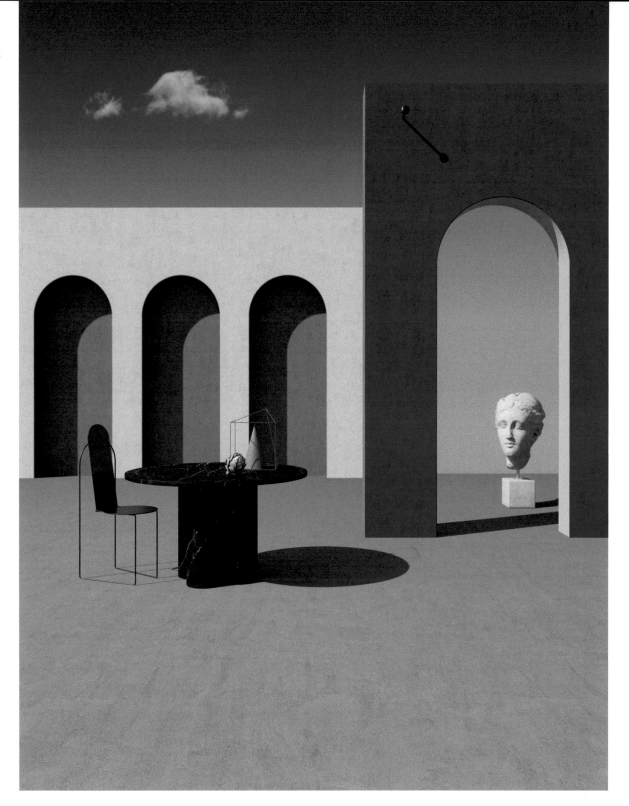

NOTOOSTUDIO
Formigine, Italy

notooSTUDIO reimagines the two-dimensional world of 20th-century masters as hypothetical 3D visualizations. The series InsideArt brings to life the styles, shapes, and colors that inspired great artists such as De Chirico, Mondrian, and Magritte, creating conceptual spaces in which the work interacts with contemporary furniture. When they aren't reimagining the works of surrealist artists, notooSTUDIO is collaborating with a roster of interior designers and furniture brands who turn to the studio to create renders that highlight products and create wonder. ✧

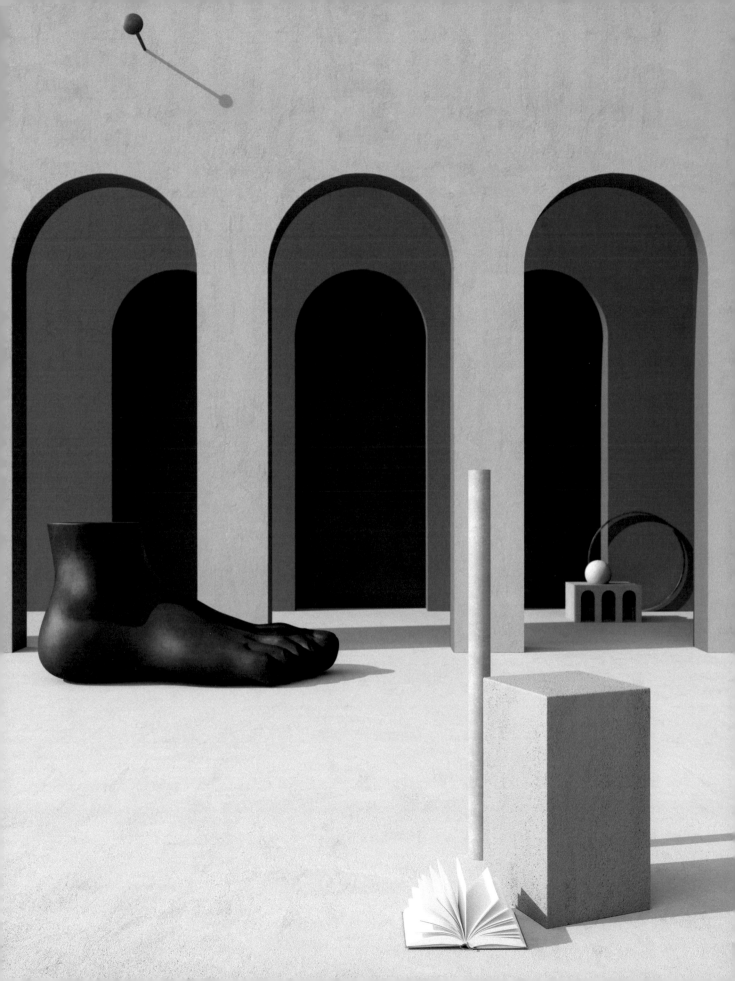

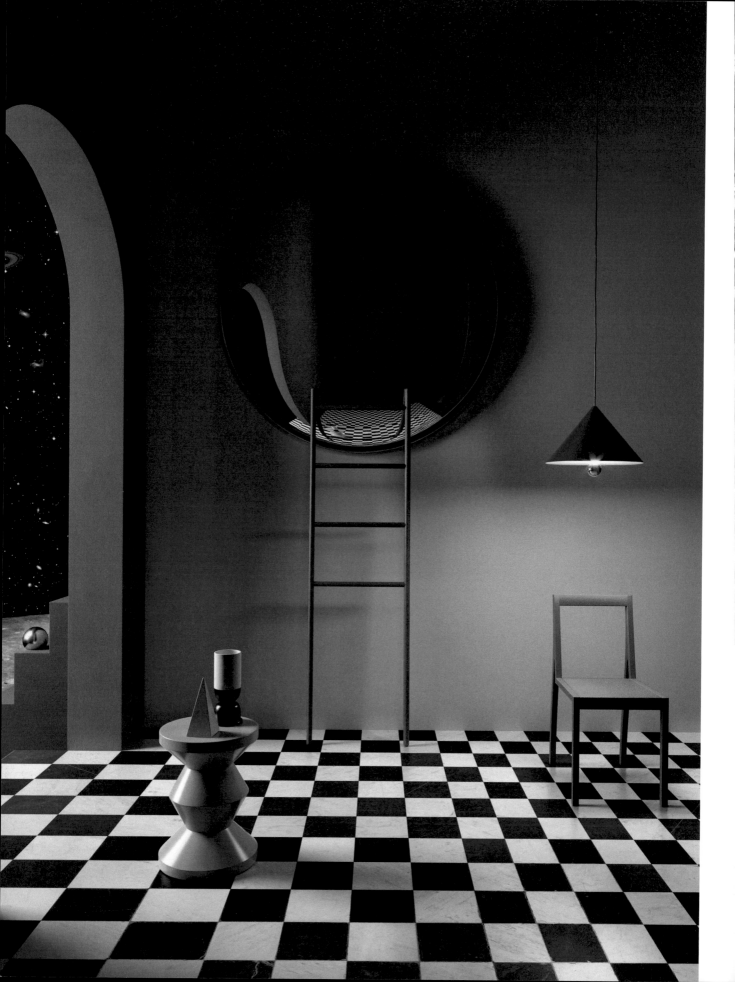

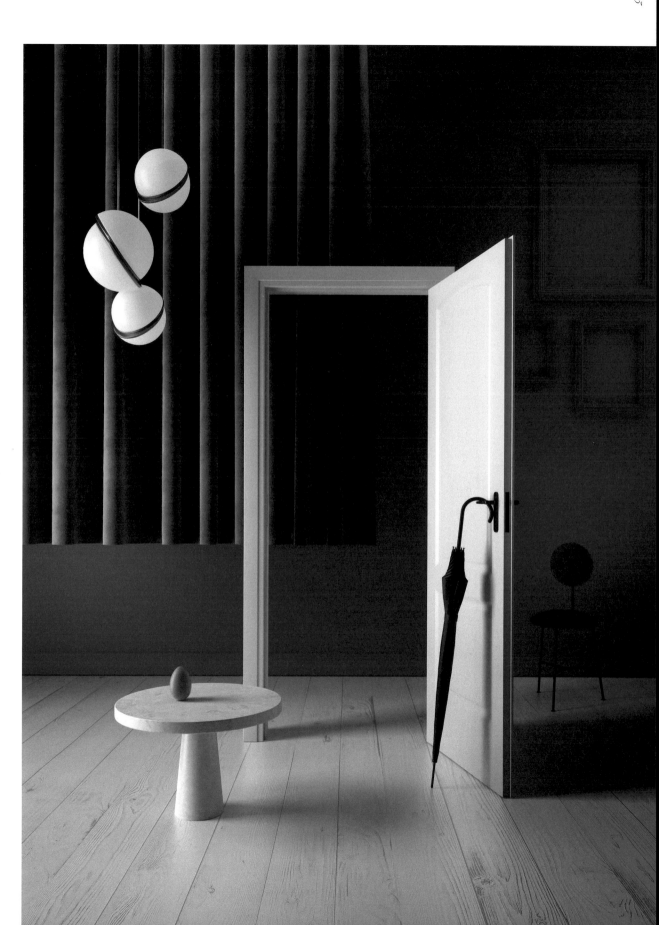

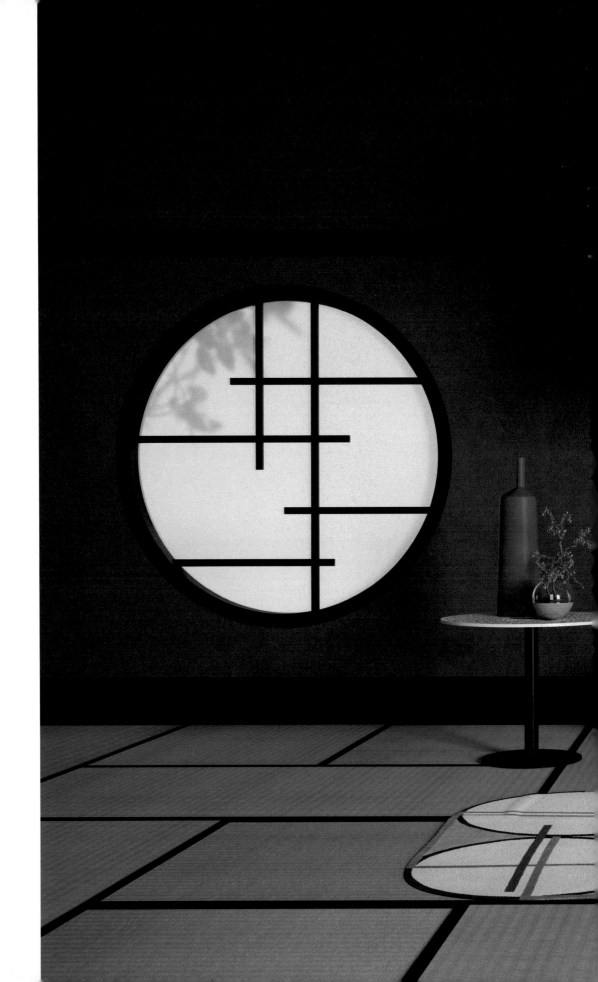

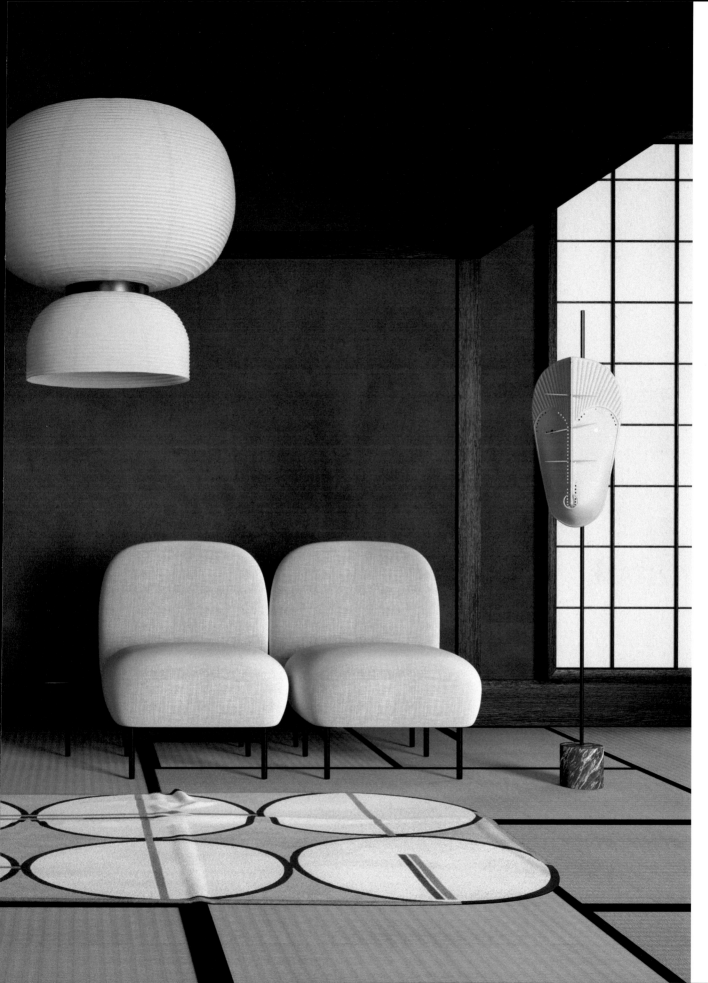

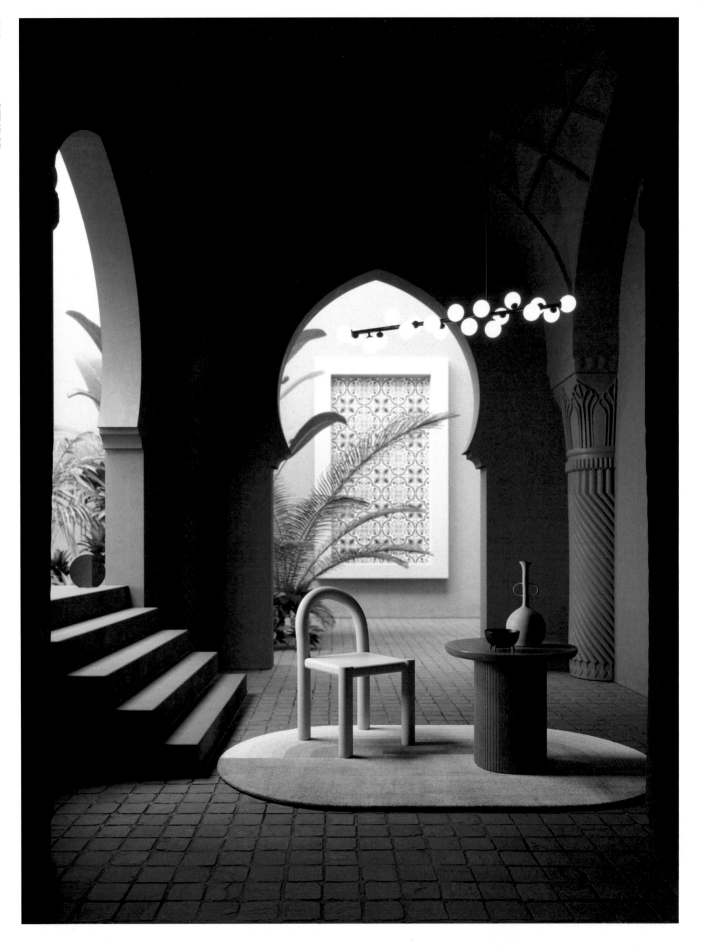

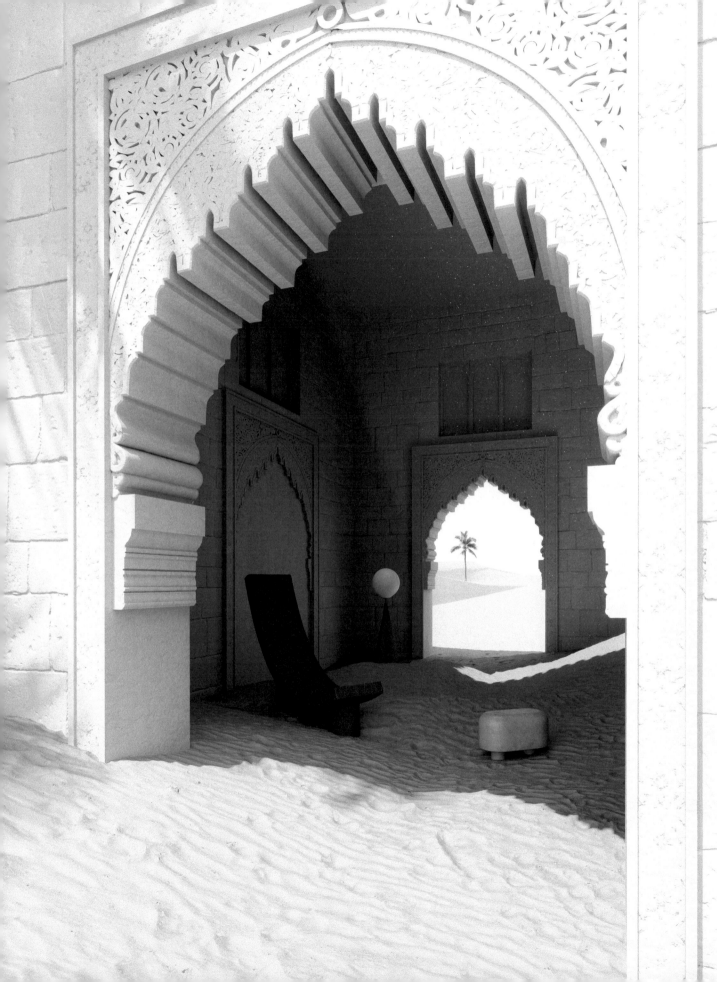

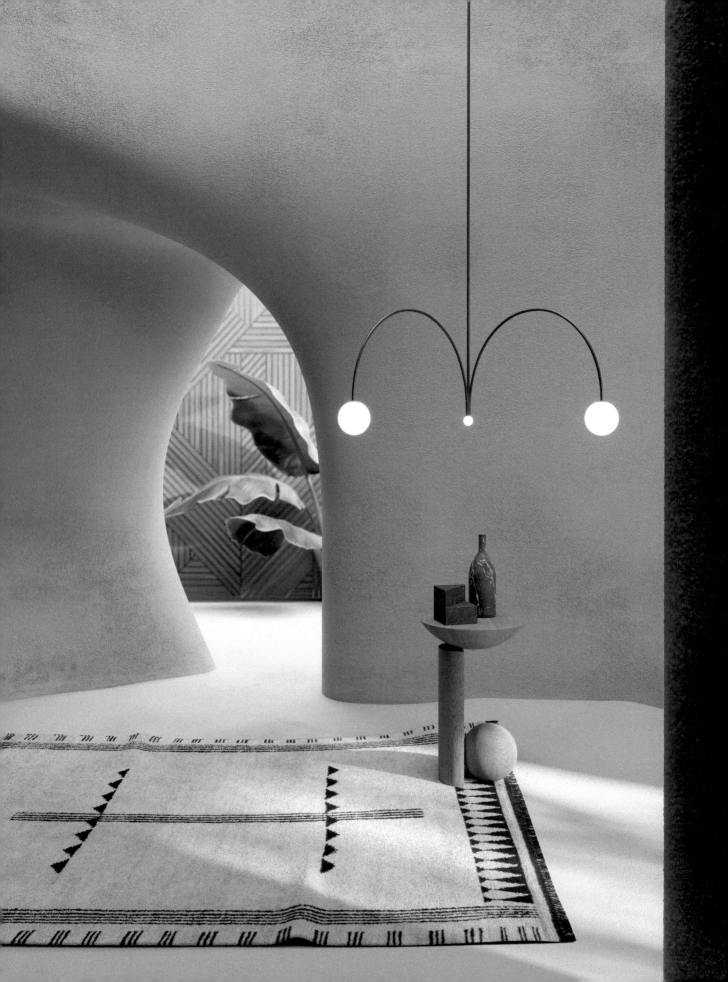

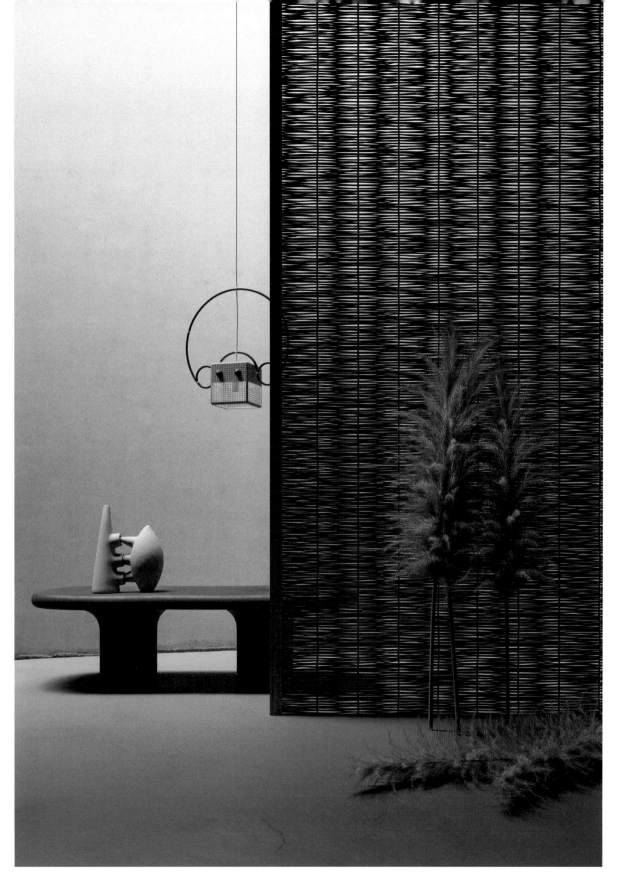

MASSIMO COLONNA from SCANDIANO, ITALY makes vibrant stone buildings the protagonist of his work—that, and flocks of birds flying in puzzling formations.

Massimo Colonna's surrealist works are influenced by both his upbringing in the mountainous province of Reggio Emilia in Italy and his early love of photography. Before he branched out into 3D, Colonna worked in post-production and retouching in a photography studio. His work is inspired by contemporary Italian photographers Luigi Ghirri and Franco Fontana, known for their blurring of fiction and reality and their abstract color landscapes.

In his own playful renders, Colonna captures imagined scenes from urban and suburban life, but with a twist or detail pushing them into the extraordinary. "From a compositional point of view, architecture plays a big role in my images," he says. "Architecture is often a co-protagonist together

with the subject." Architectural follies grace nearly all of his scenes, which are sometimes focused around a thematic idea. In his series *Migration*, for example, a flock of birds amasses in unusual geometries, announcing a seasonal or paradigmatic shift. Another series, *Apathy*, relies on local views of post-industrial landscapes that bring out the absurd in the everyday, with a potent sense of indifference.

In 2019, Colonna collaborated with design retail platform the Cool Hunter and with studios MUT Design and Six N. Five. His commercial commissions have a similar aesthetic to his personal works, many of which play with open-air architecture. Colonna's images open viewers up to the unseen, through his use of artful perspectives and trompe l'oeil techniques. ✧

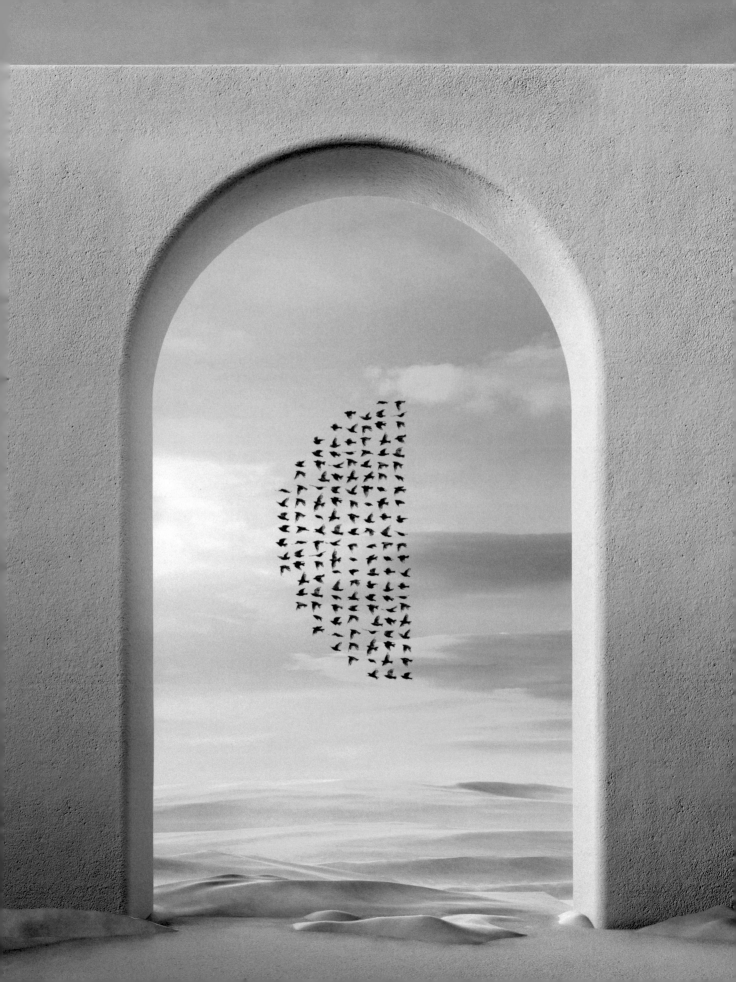

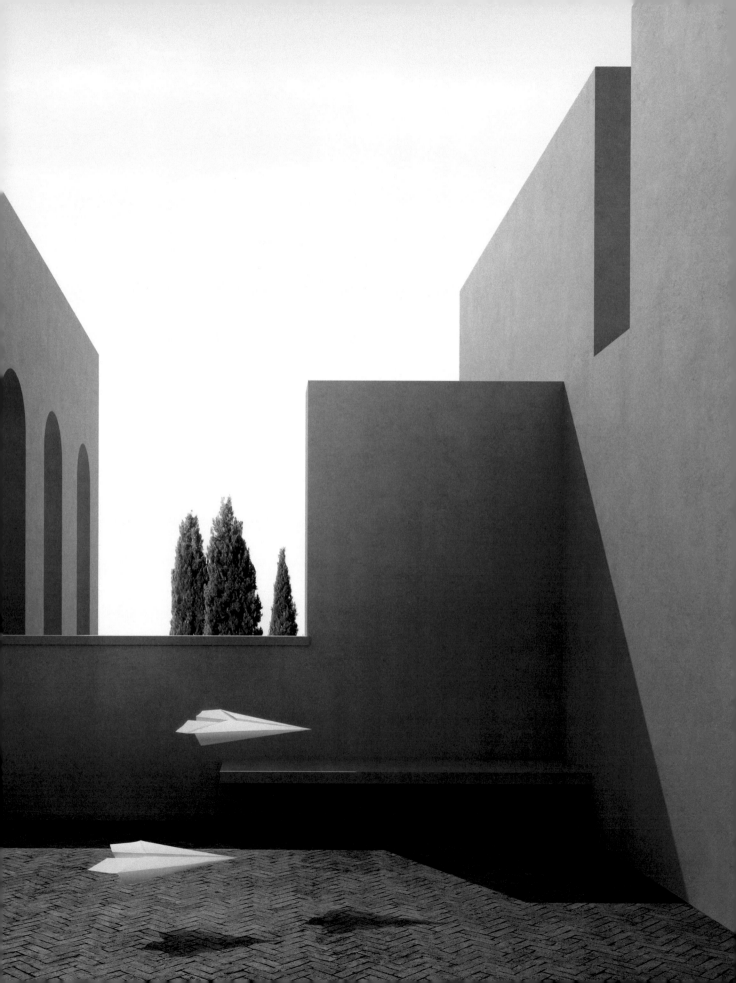

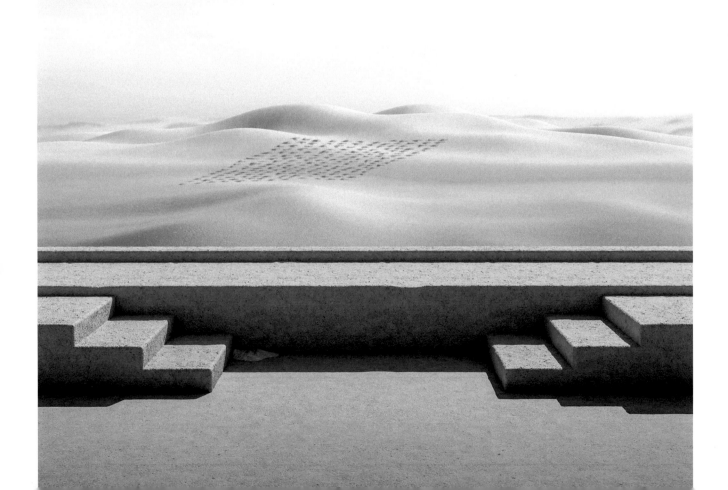

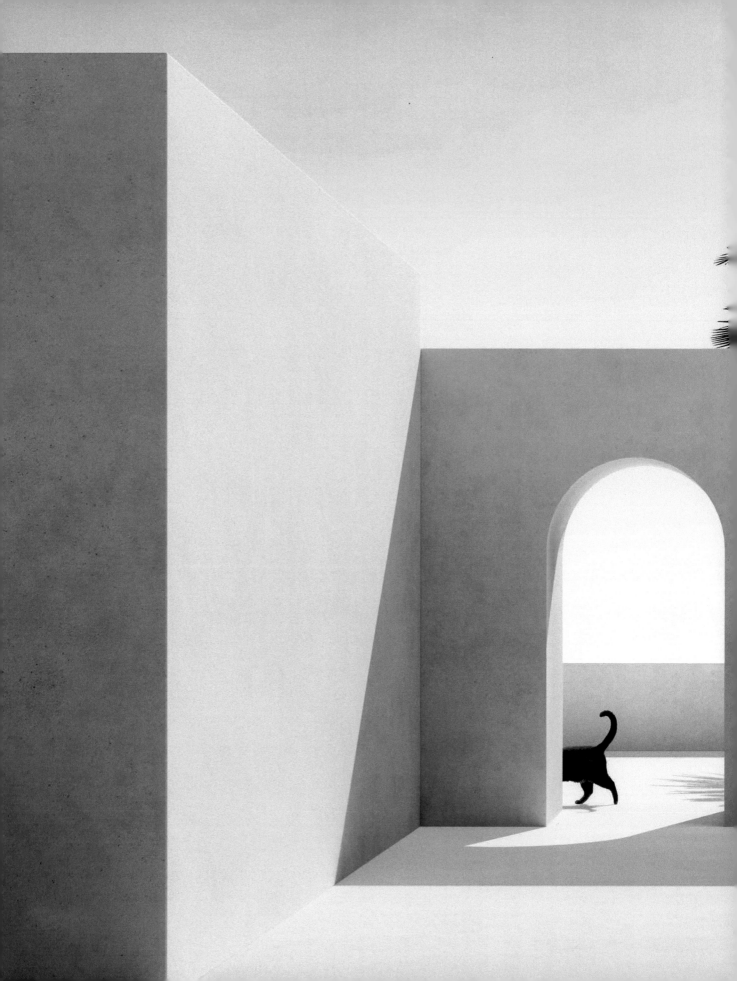

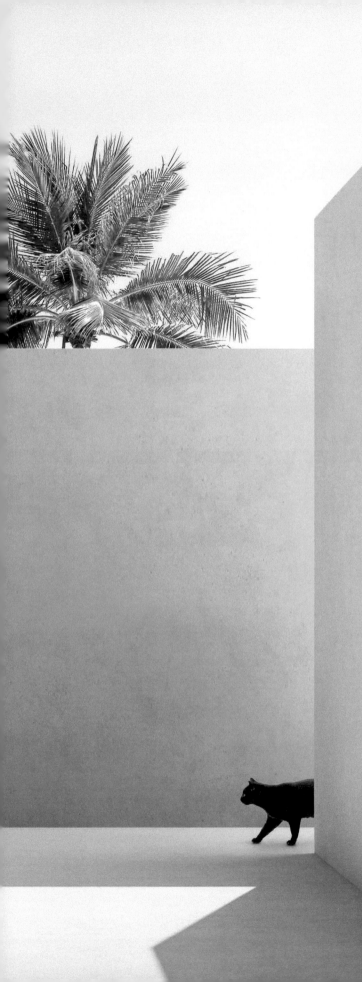

Architecture is often a co-protagonist together with the subject.

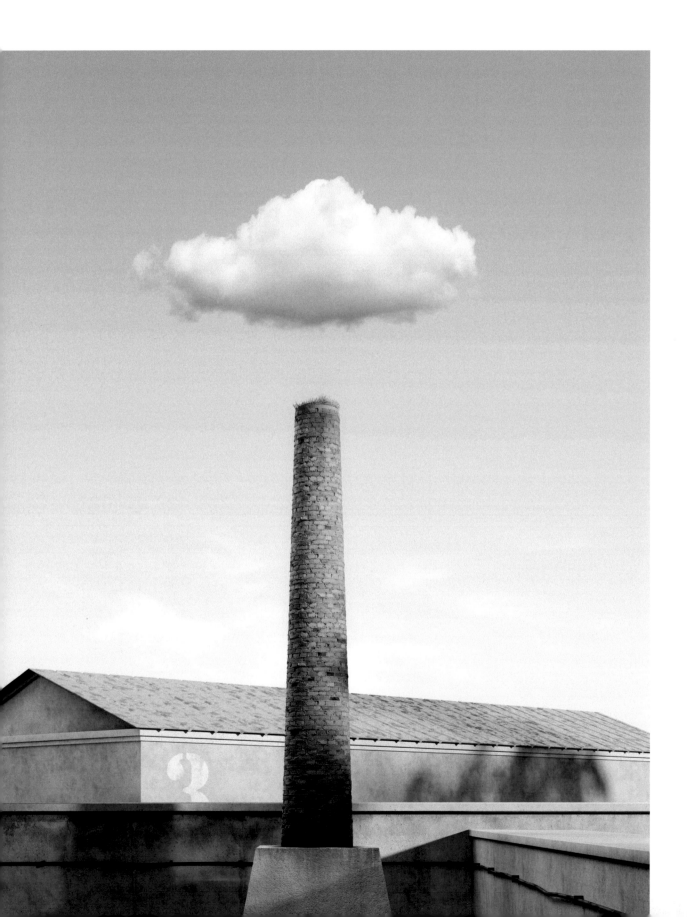

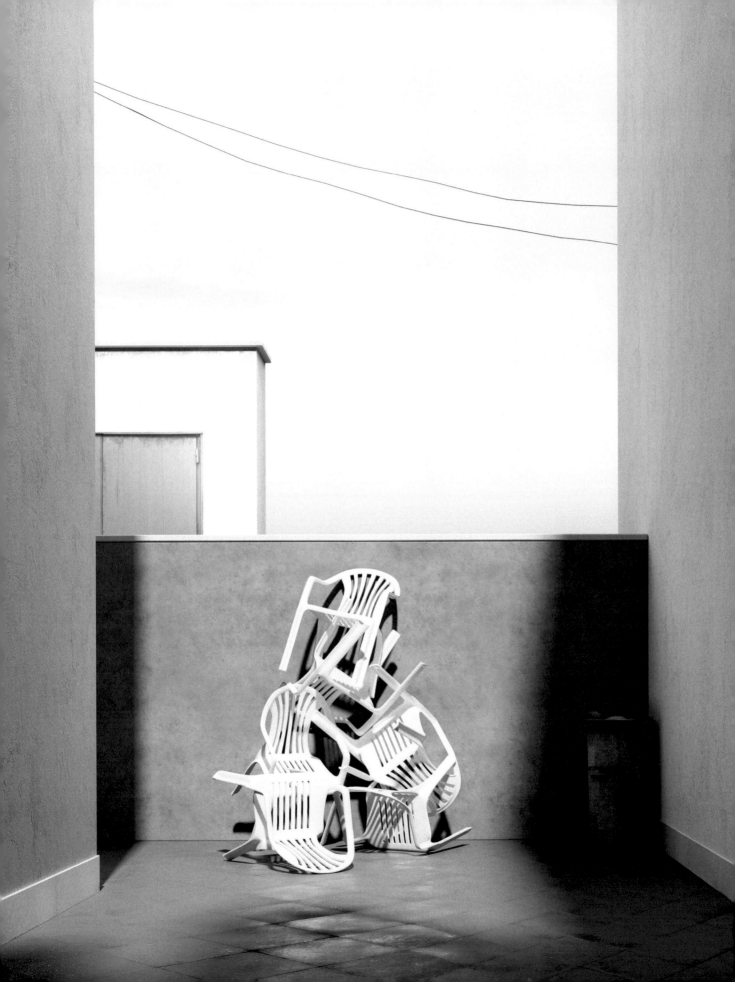

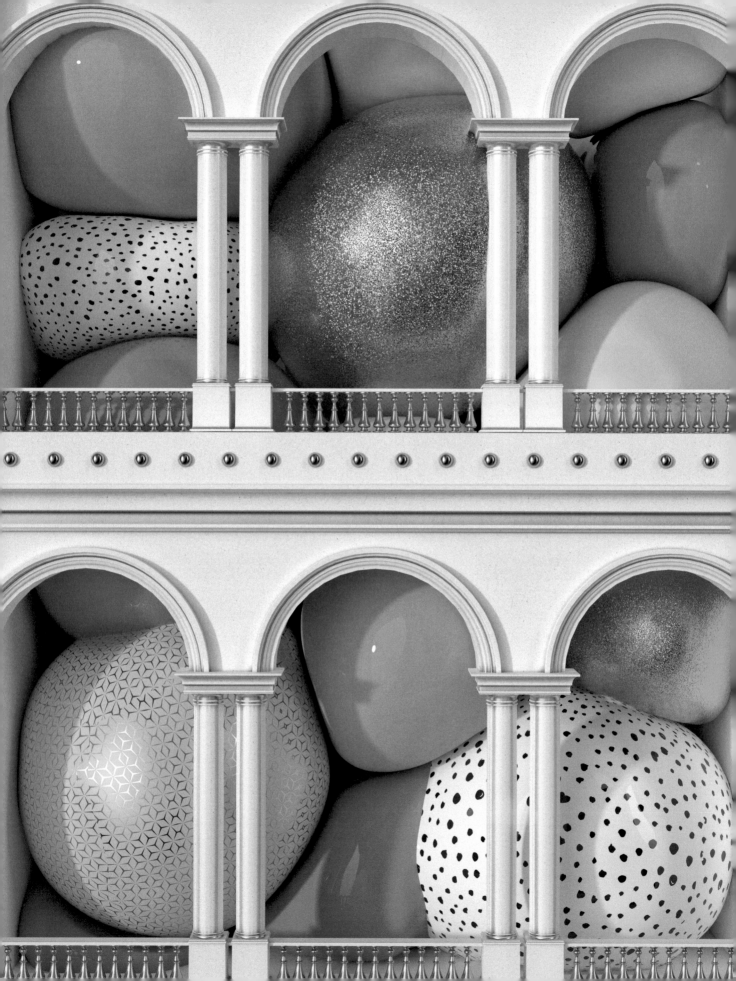

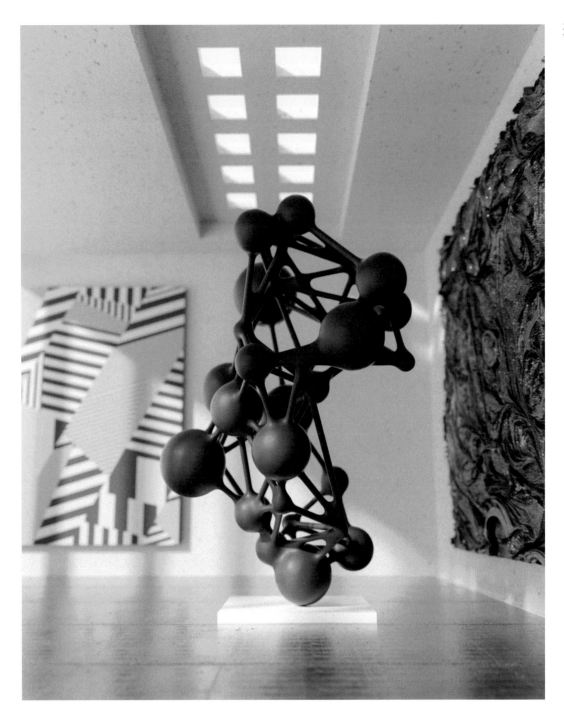

ROMAN BRATSCHI
Zurich, Switzerland

A 3D illustrator and animation director, Roman Bratschi often found himself having to rein in his ideas for his clients. As a creative outlet and a complement to his corporate work, he began a series of compositions titled *Nonsense in 3D*, through which he expanded his creative practice to artmaking. Using elements such as fruit and vegetation, he combines objects and shapes into pleasing arrangements that push the boundaries of the natural and the artificial. Bratschi's keen eye has landed him clients such as Swarovski, Victorinox, Lindt, and Ray-Ban. ✧

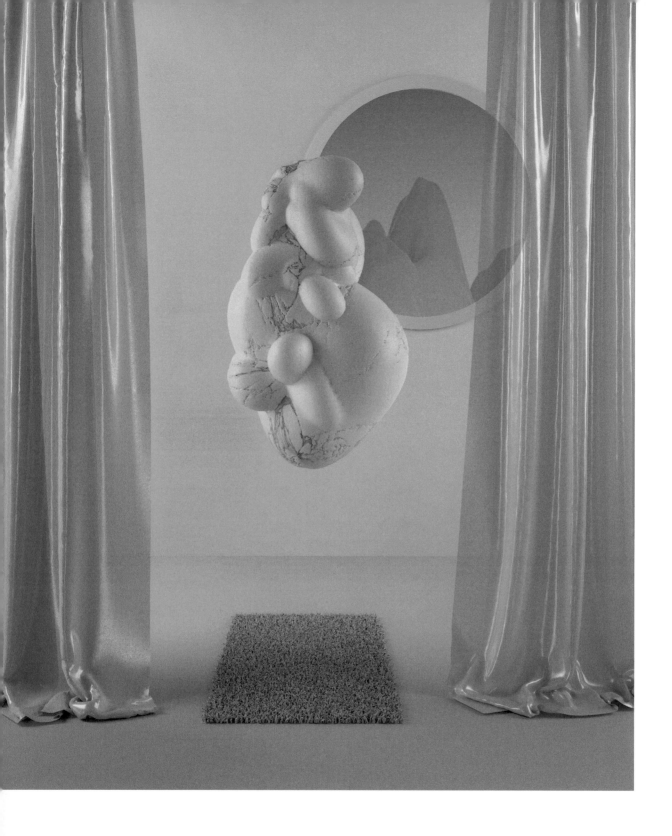

STUDIO MANÈGE
Montreal, Canada

Renée Lamothe of Studio Manège is an experimental filmmaker turned designer and 3D illustrator. She uses her artistic practice as a playground where she aims to connect with abstract impressions in a deeply introspective way. Exploration of the human psyche is integral to her work.

She mixes the organic with the synthetic, the real, and the eerie to create a space where nothing is ever certain. Previous collaborations include a series of 3D illustrations for the Montreal magazine *Figures de style*, and a campaign for high-end women's clothing brand, Lachapelle Atelier. ✧

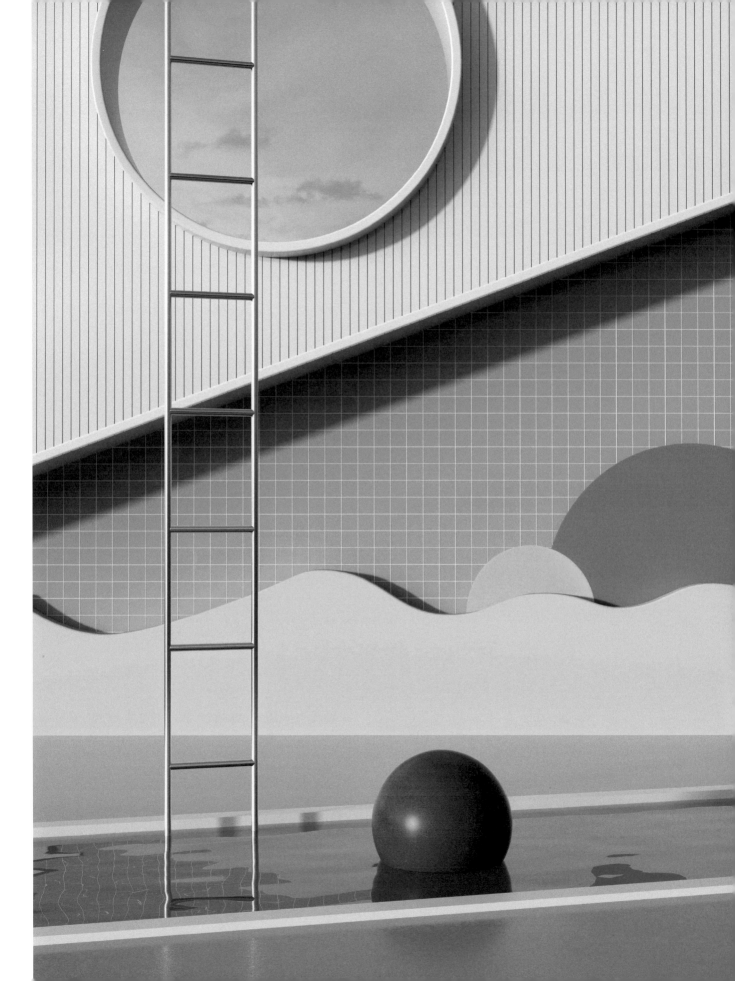

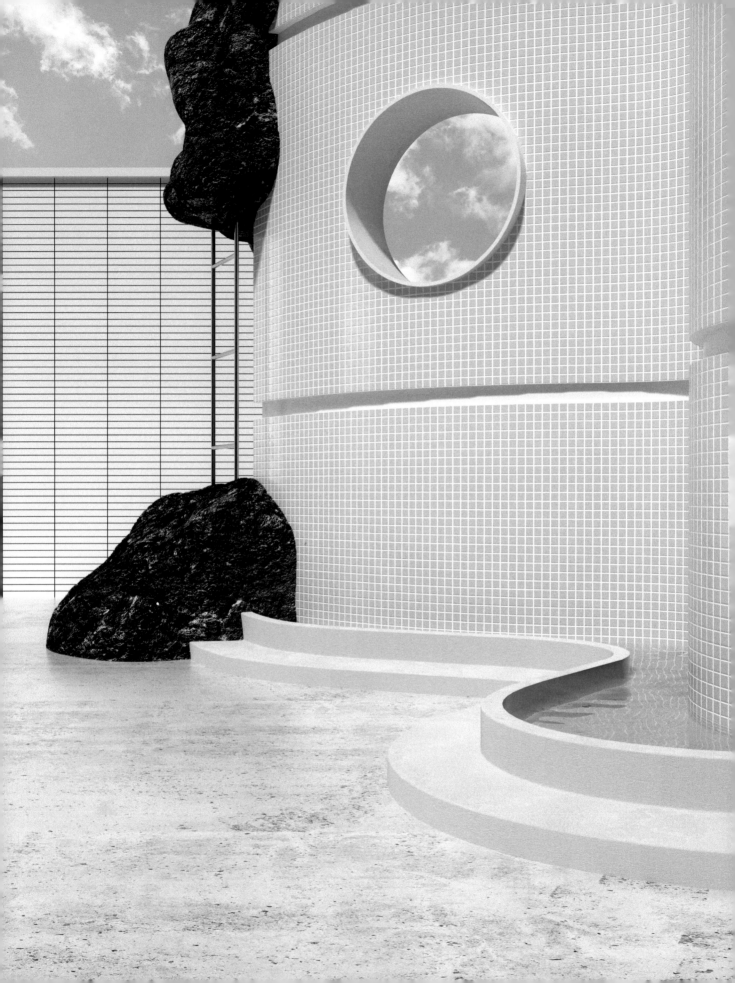

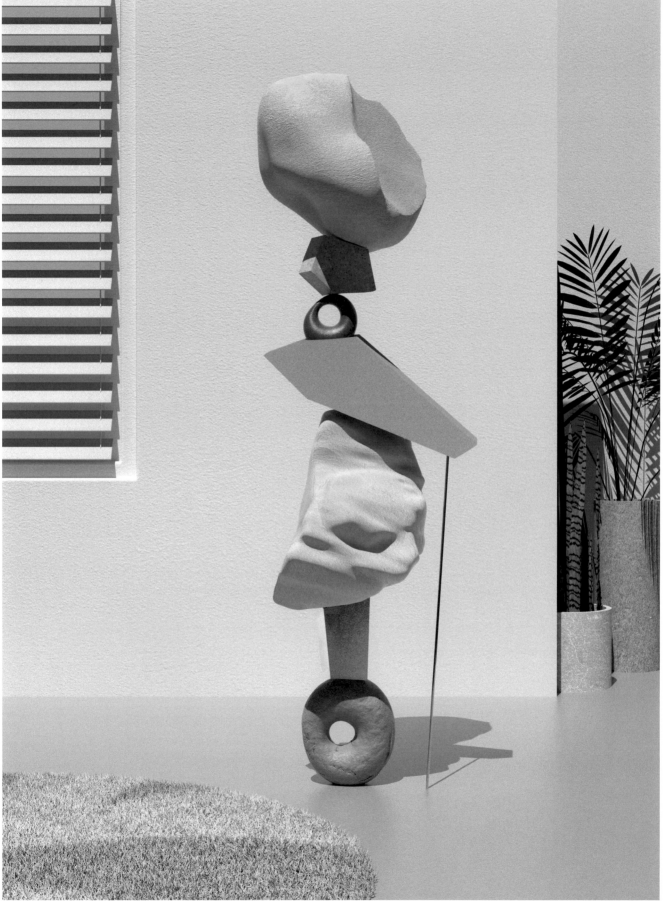

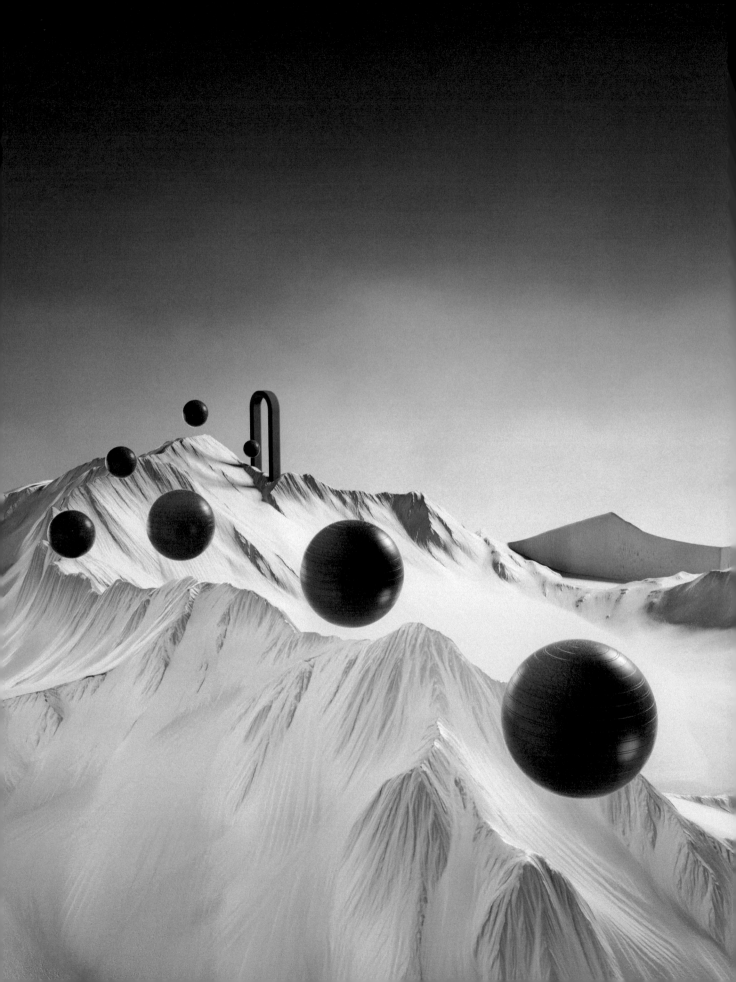

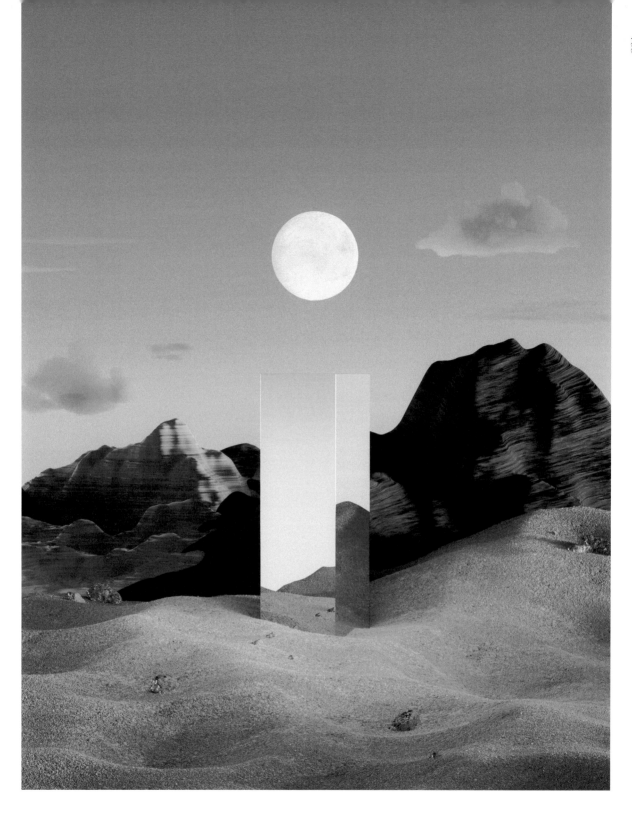

BÜRO UFHO
Singapore

BÜRO UFHO opened as a visual design studio in 2008. The studio began creating dreamscapes as simple studio backdrops that eventually evolved into full outdoor landscapes in 2018. Devoid of people, the environments evoke different responses depending on the viewer; they can either be a peaceful utopia or an intensely lonely world. BÜRO UFHO has worked with brands including Adobe, Apple, Facebook, and Mastercard. Yana and Jun, the artist couple behind BÜRO UFHO also set up an illustration outfit, kittozutto, which produces art for Nike, Esquire, HBO, and more. ✧

CAPE TOWN-based ALEXIS CHRISTODOULOU creates spectacular visions inspired by 1960s art movements and the tiniest observed details.

Alexis Christodoulou wants to cut through the noise of every-day life. But rather than succumbing to complete escapism, he describes his visualizations as momentary "digital sanctuaries" amidst the social media landscape. "I try to make my scenes as neutral as possible," he says. "No comments, no buy in. I just want someone to look for five seconds longer than they usually look at something."

Christodoulou began devising his fictional oases eight years ago as a creative outlet while he was working as a copywriter in advertising. Recently the self-taught 3D artist has been developing his artistic practice more seriously. Now, he has a cult following on Instagram—and the attention of the international design press.

From the beginning, Christodoulou's "imaginary architec-ture" was inspired by neo-futuristic design movements from the 1960s, like Superstudio's gridded furniture, or the circular geometry in Aldo Rossi's drawings and sketches. He likes to keep the materials simple. "I really love the small white bricks you find all over Tokyo," Christodoulou explains, "so I often try to mimic them in my scenes."

Christodoulou, who is based in South Africa, laments that growing up he didn't see any modern, clean aesthetics reflected in the 3D visuals he encountered, primarily in video games. The serene settings that he stages in his work offer an antidote to these gritty and hyper-real environments, and they add a new range of contemporary possibilities to the realm of fantasy. ✦

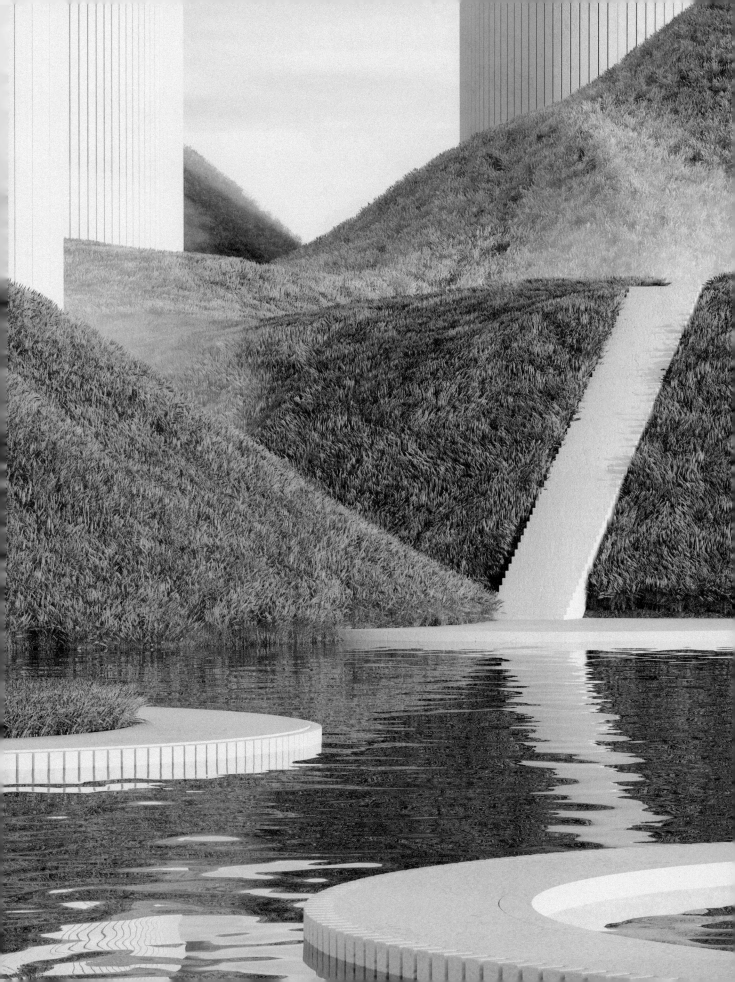

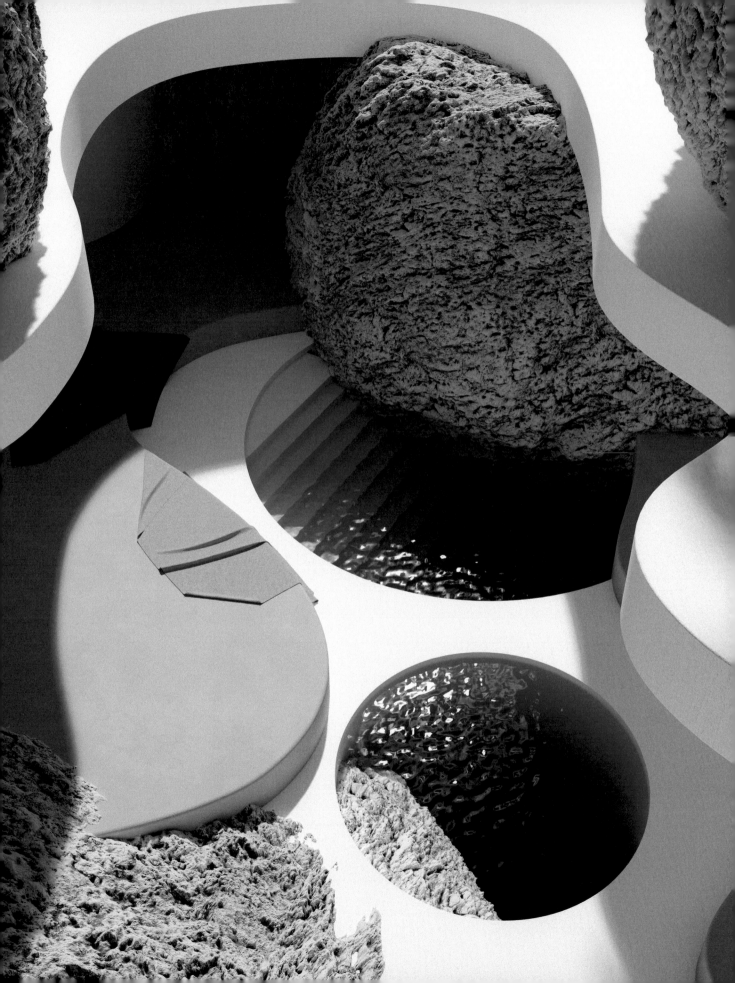

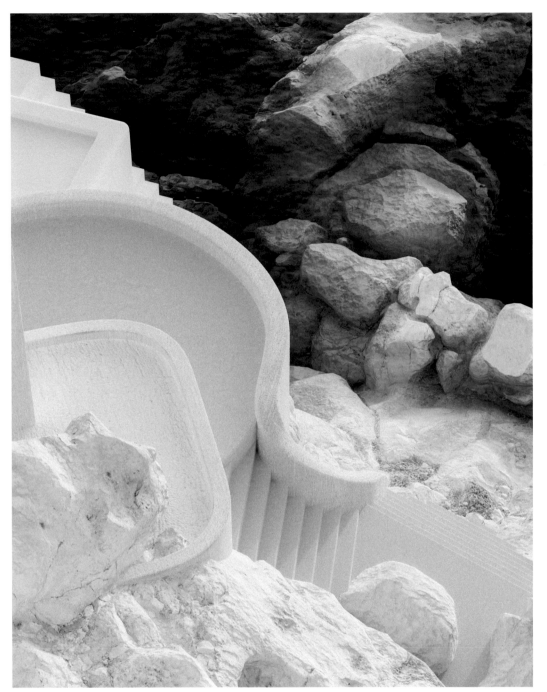

I just want someone to look for five seconds longer than they usually look at something.

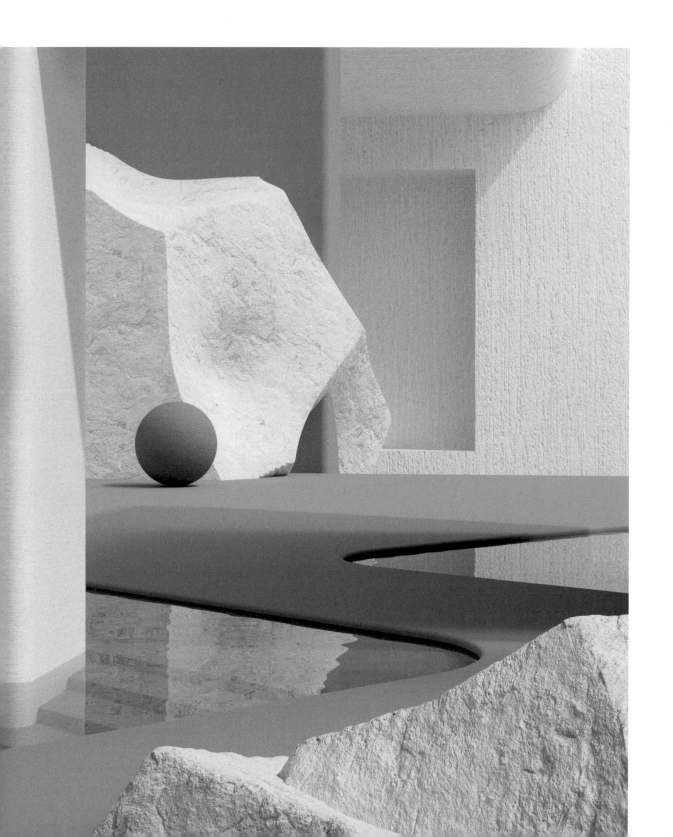

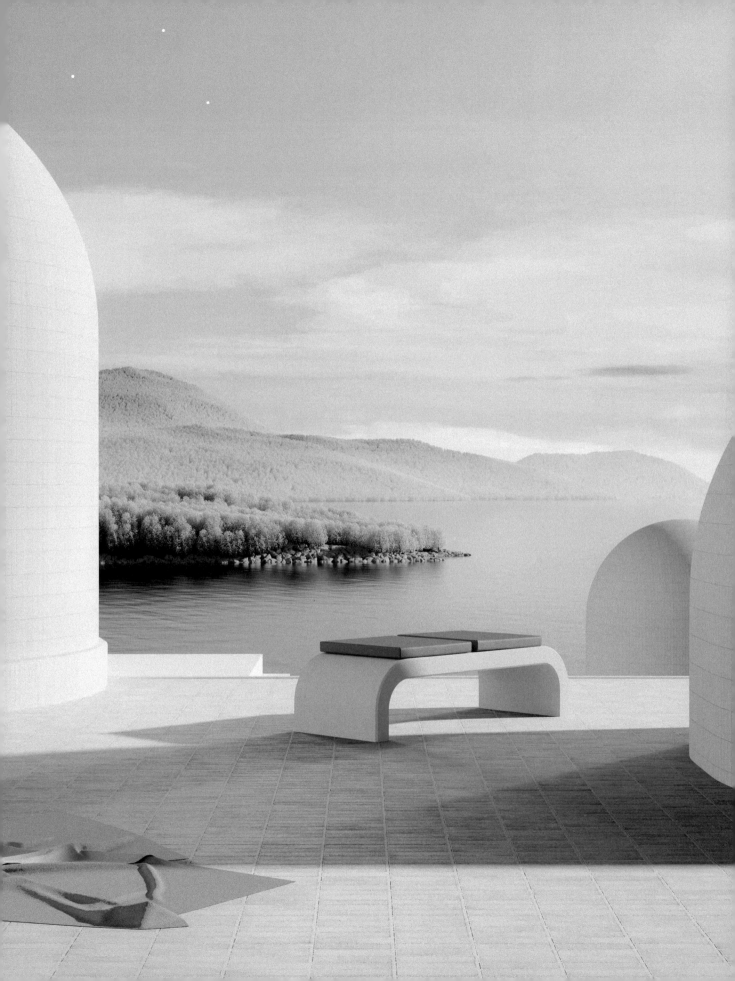

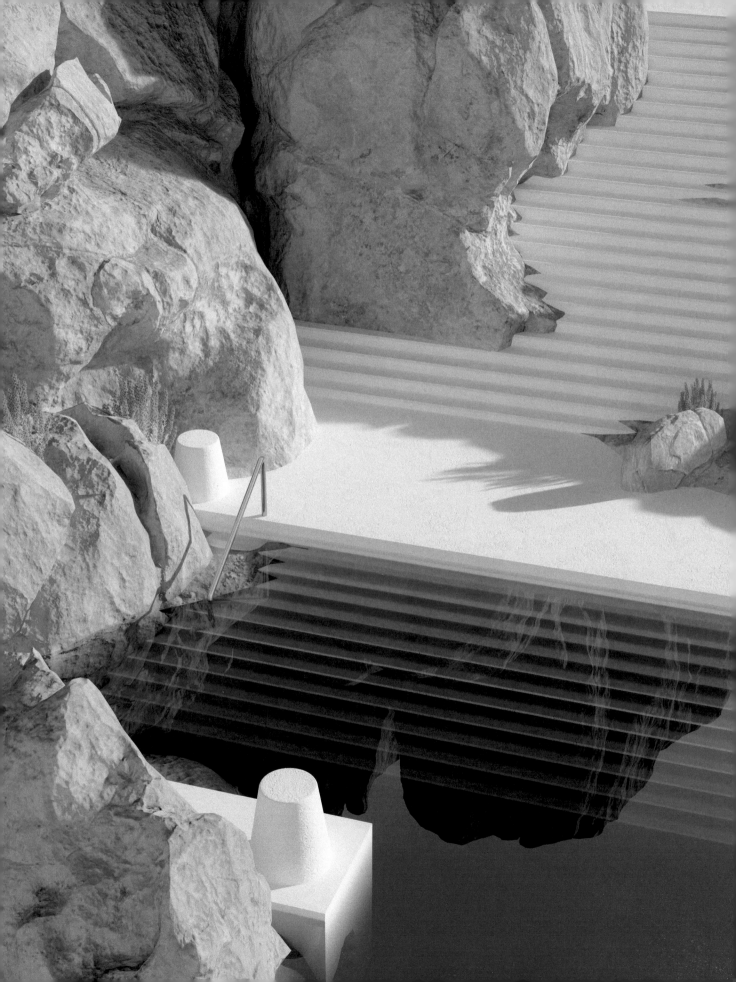

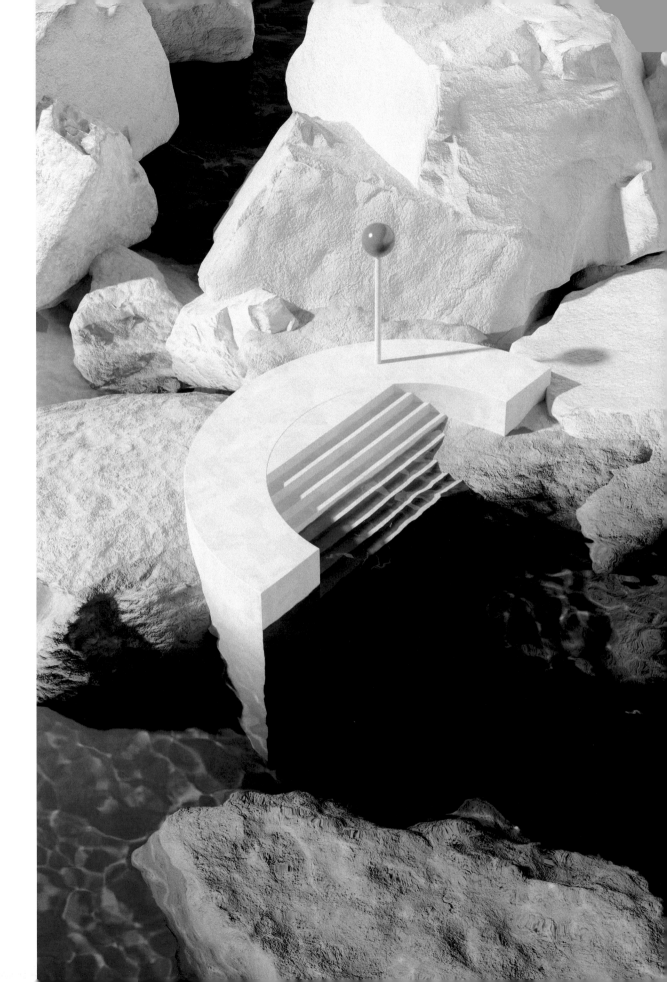

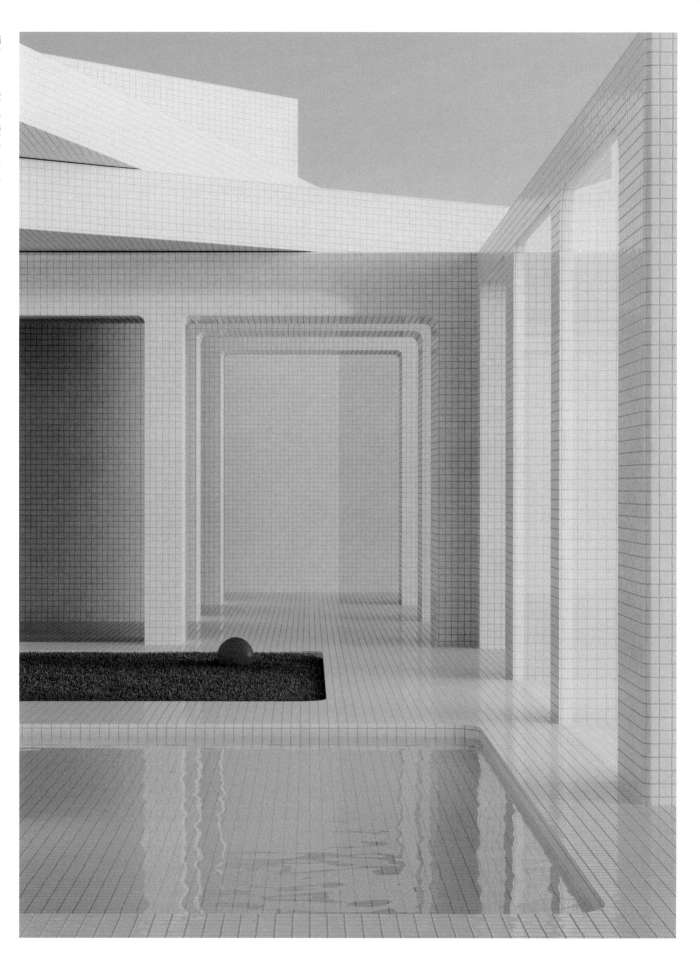

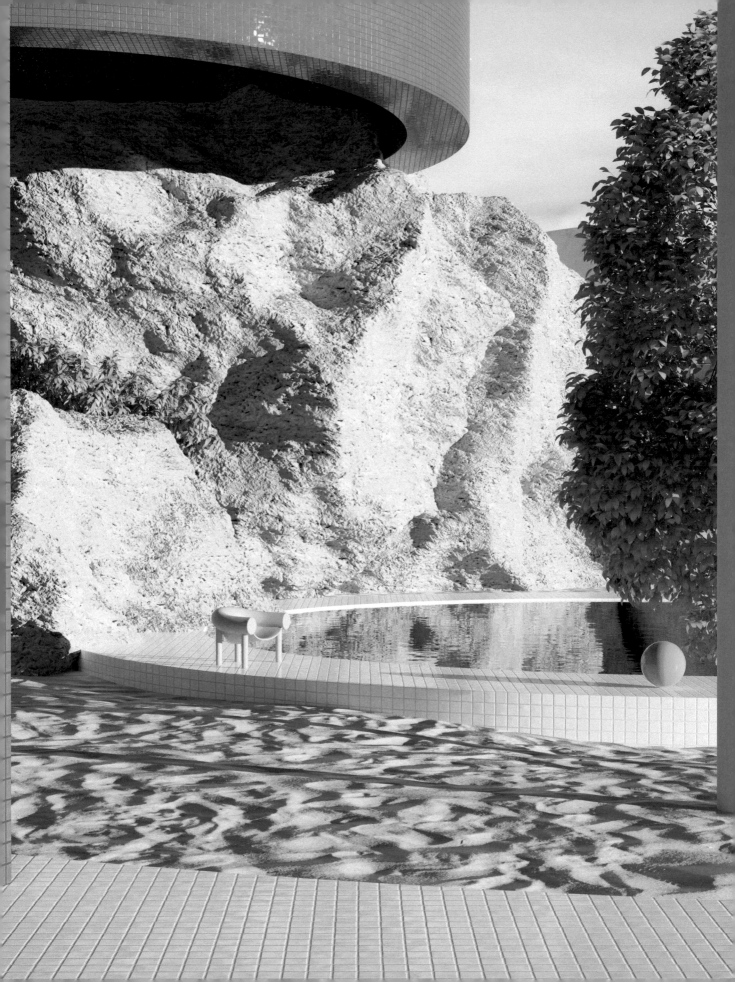

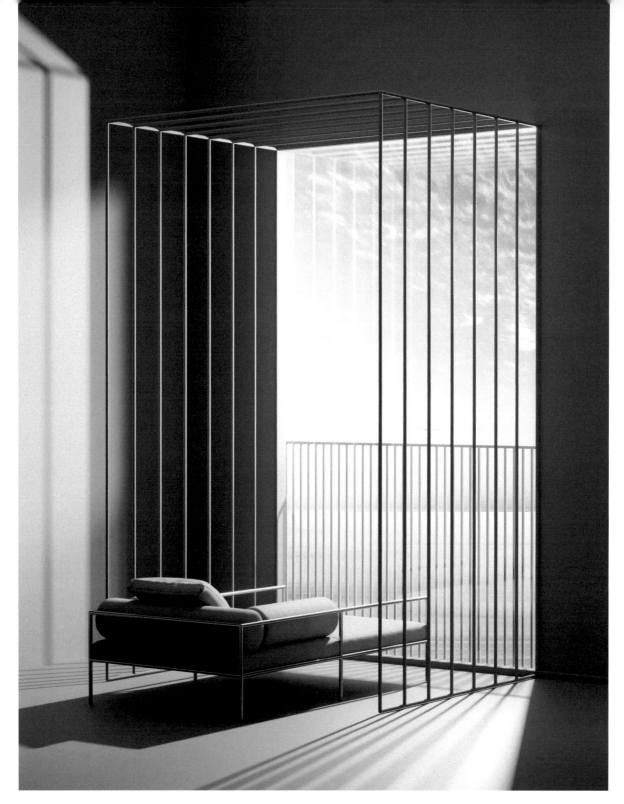

PETER TARKA
London, U.K.

With thousands of followers on social media, and clients that include Apple, Nike, LG, and Google, Tarka's 3D visualizations are hard to miss. Moving away from hyper-realistic and sci-fi trends, Tarka takes an illustrative approach to his work. Many of his compositions, which often look like scale models or miniatures, use architecture and design elements to construct complex worlds within themselves. Mixing colors and textures, Tarka highlights products within stylized universes. ✧

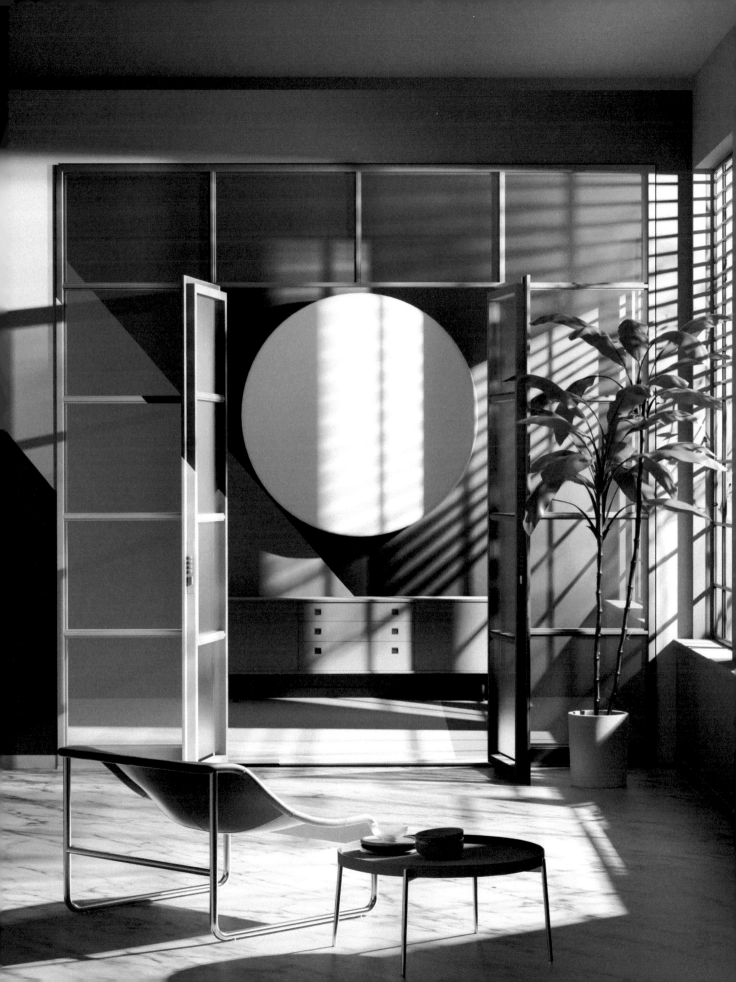

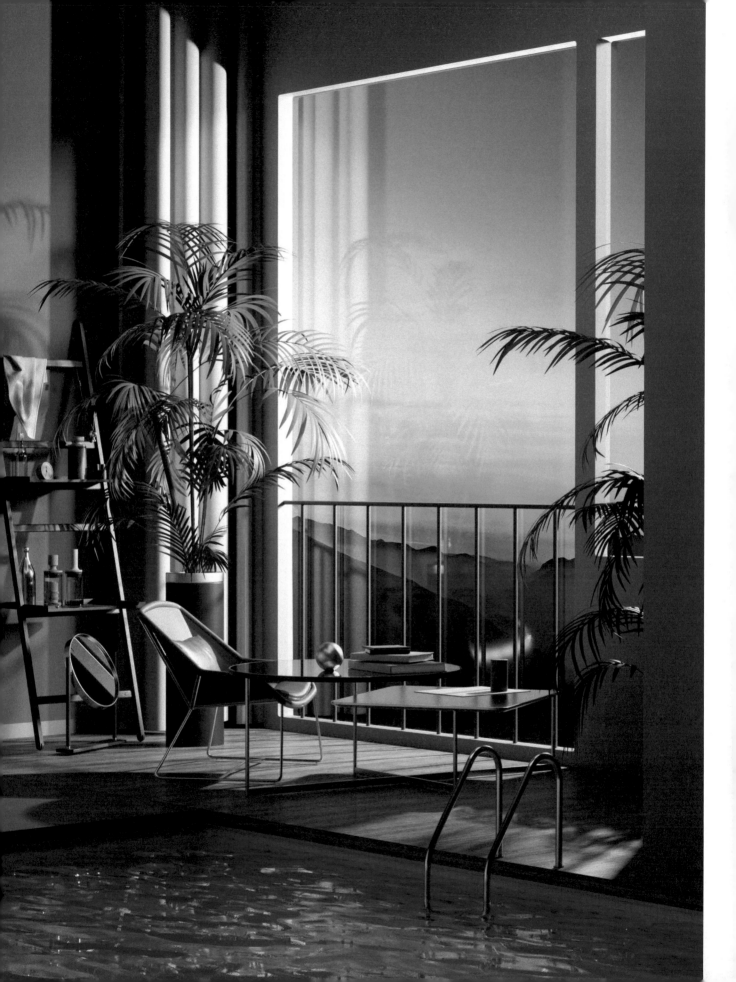

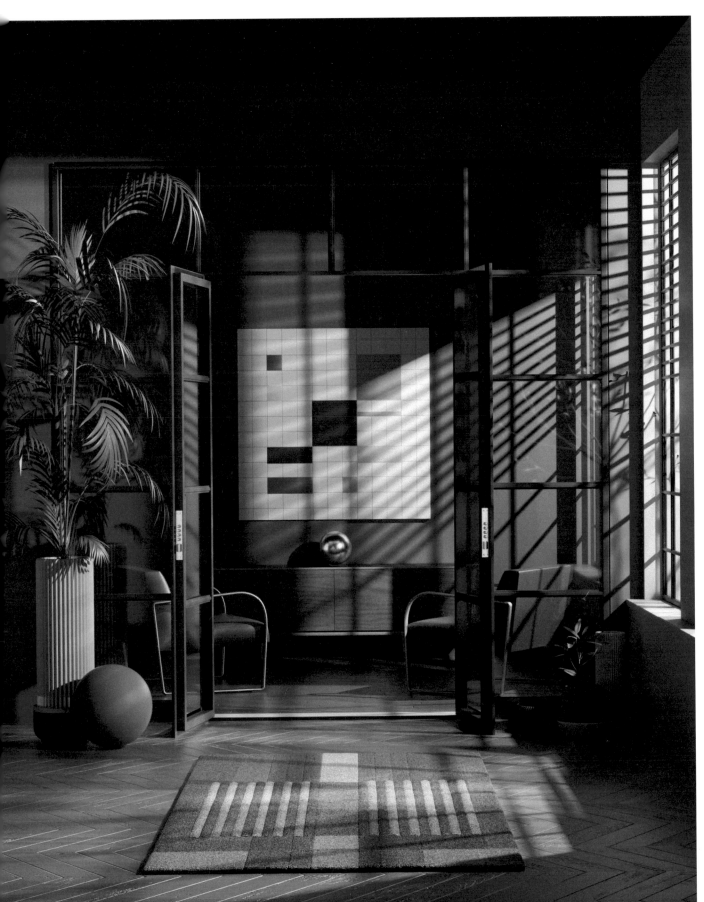

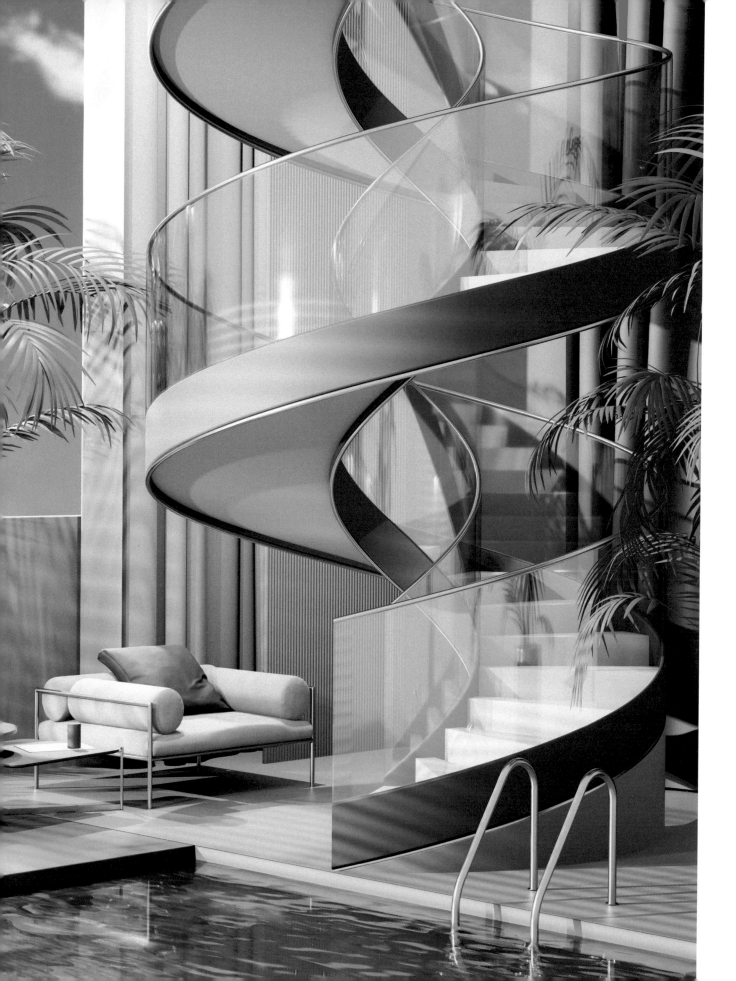

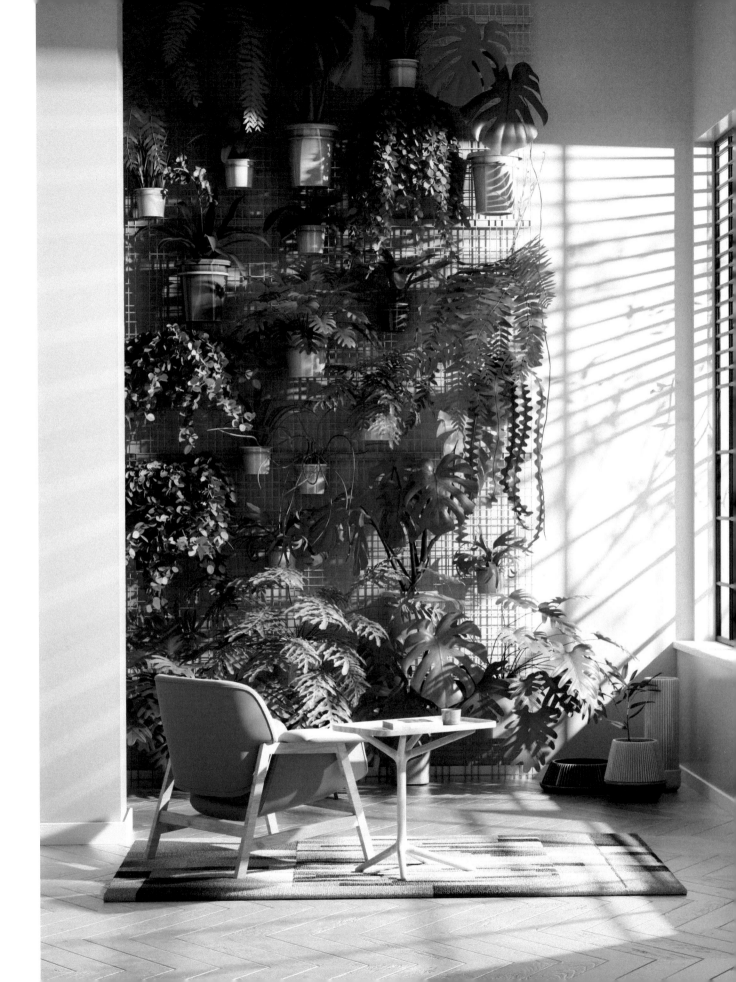

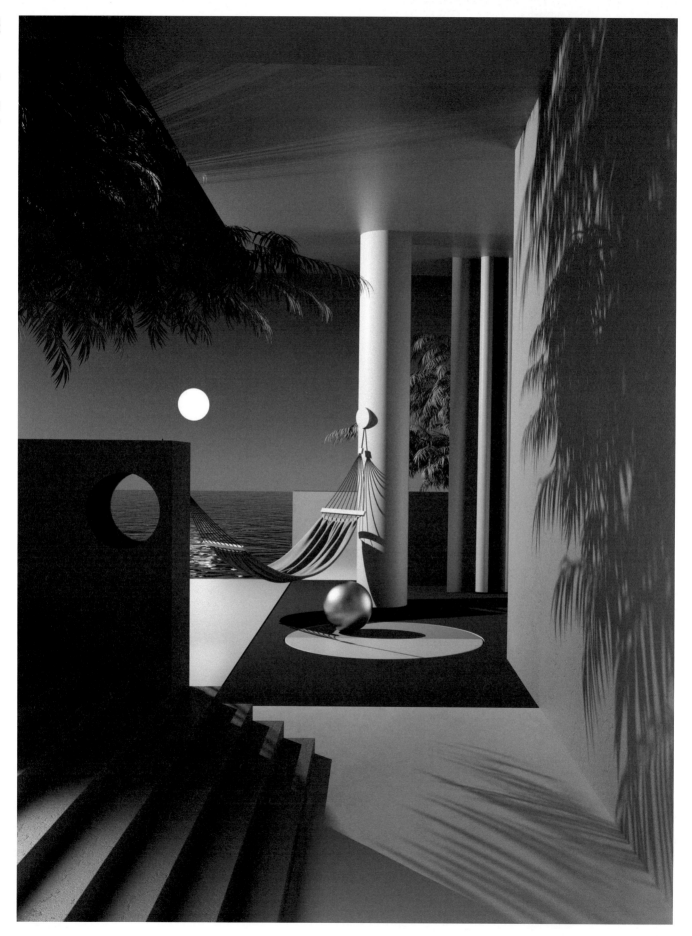

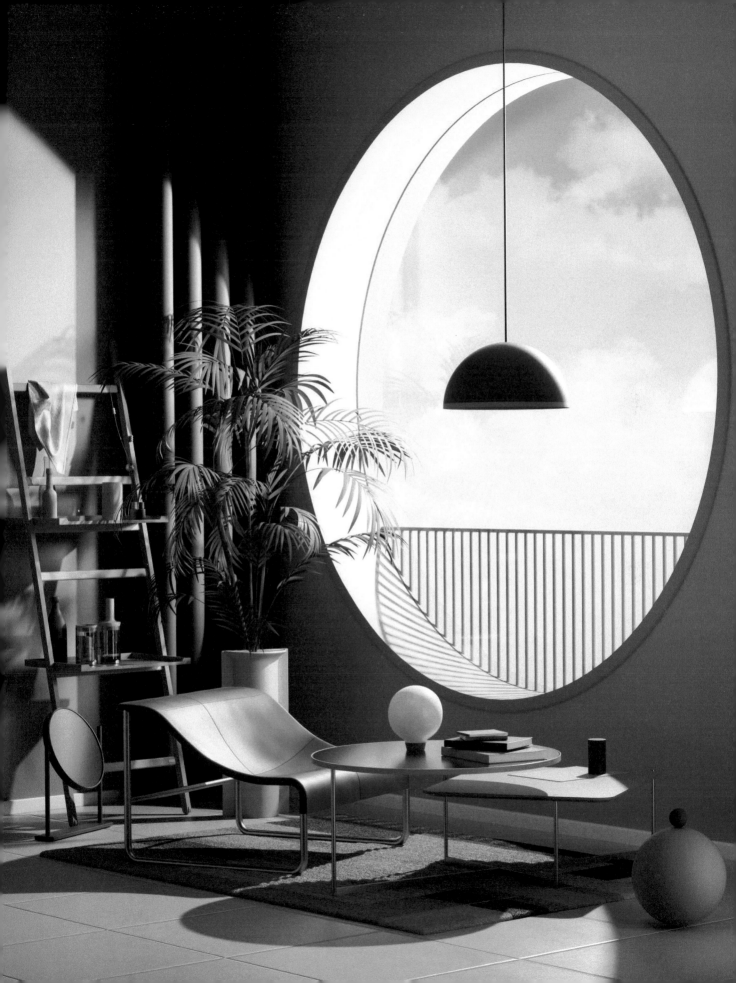

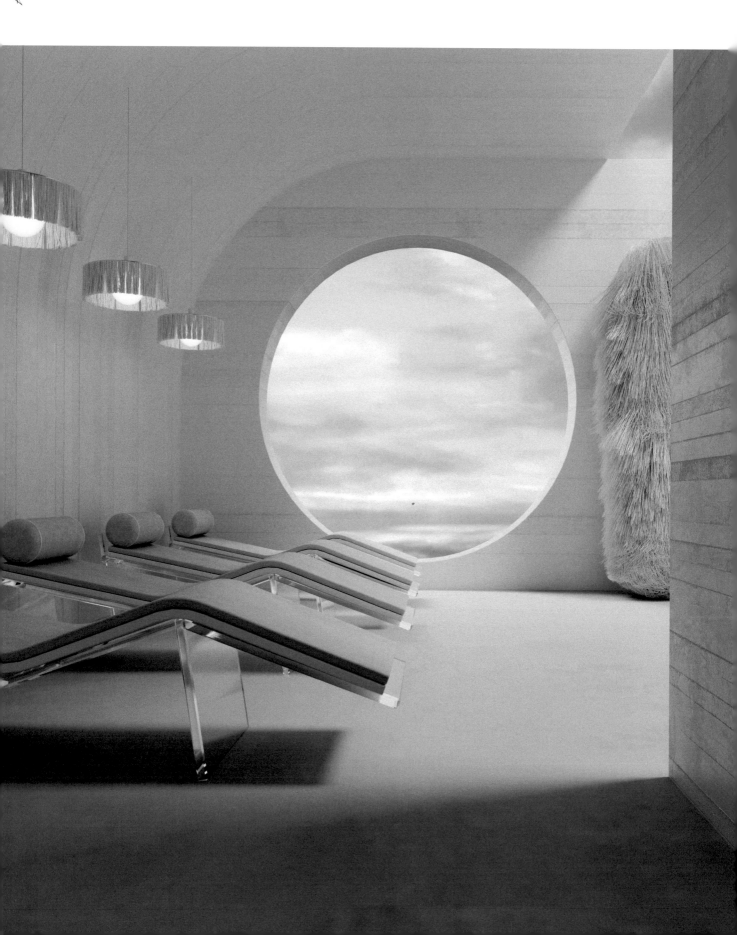

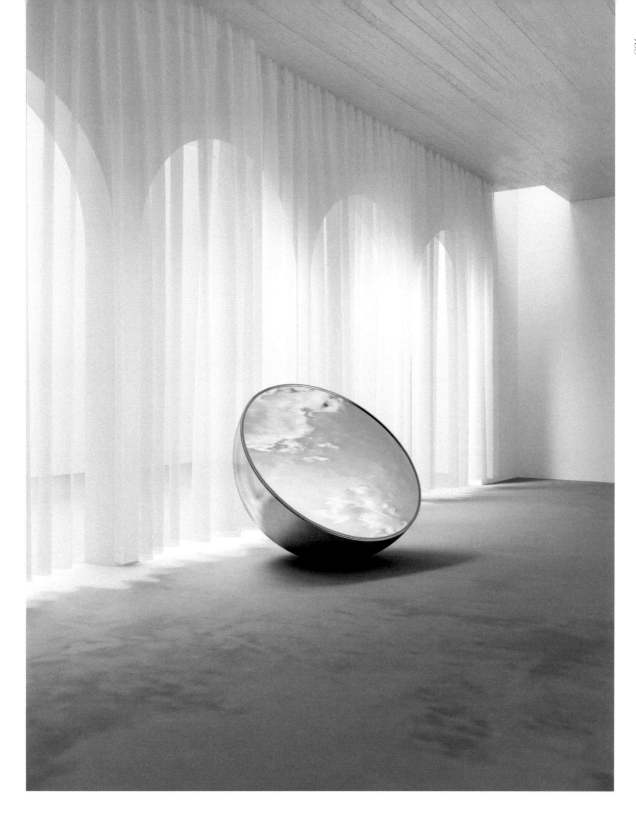

REISINGER STUDIO
Barcelona, Spain

Buenos Aires-born Andrés Reisinger began using 3D software when he was just 18, and it has since become his primary tool. During his graphic design studies, many of his professors were architects who taught him the importance of space and light for conveying his utopian visions. In his work depicting interiors, Reisinger uses plush textiles and pink tones to mirror the intimate crevices of bodies—the inside of mouths and sexual organs —which elicit an uncanny sensation. ✧

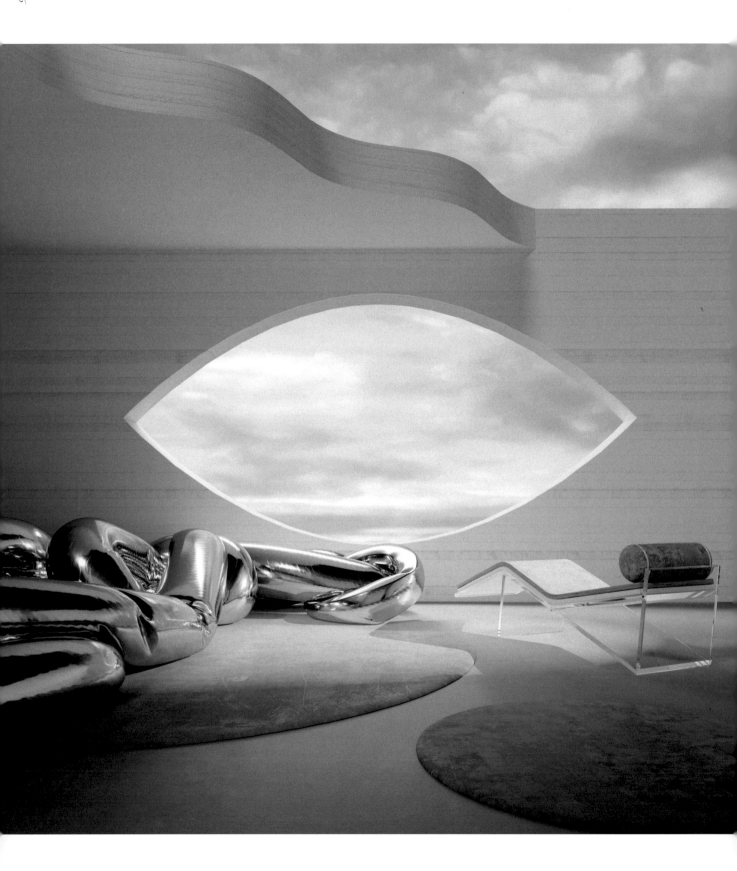

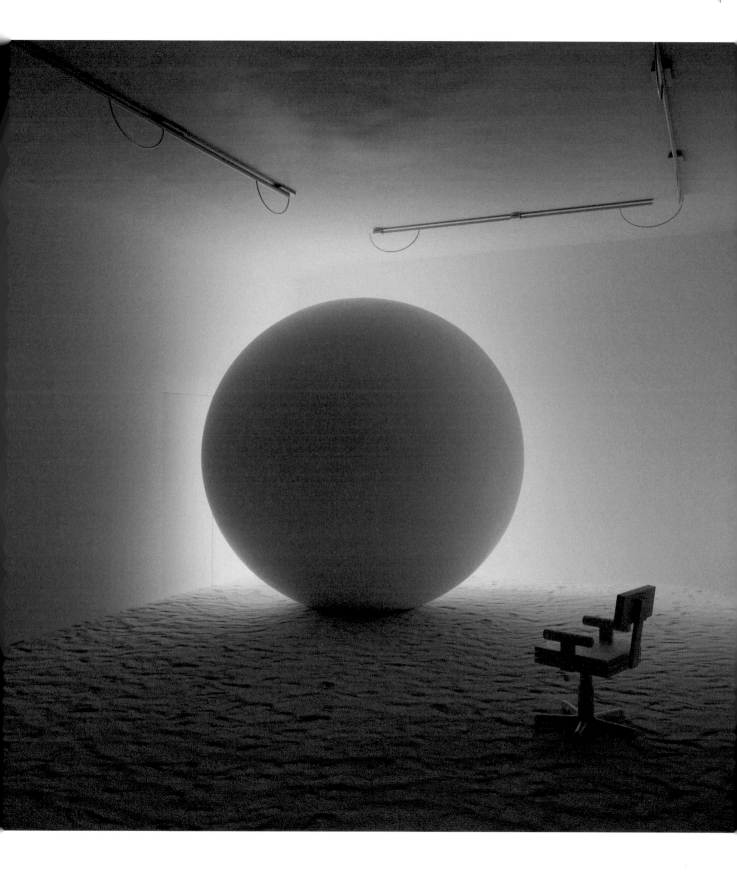

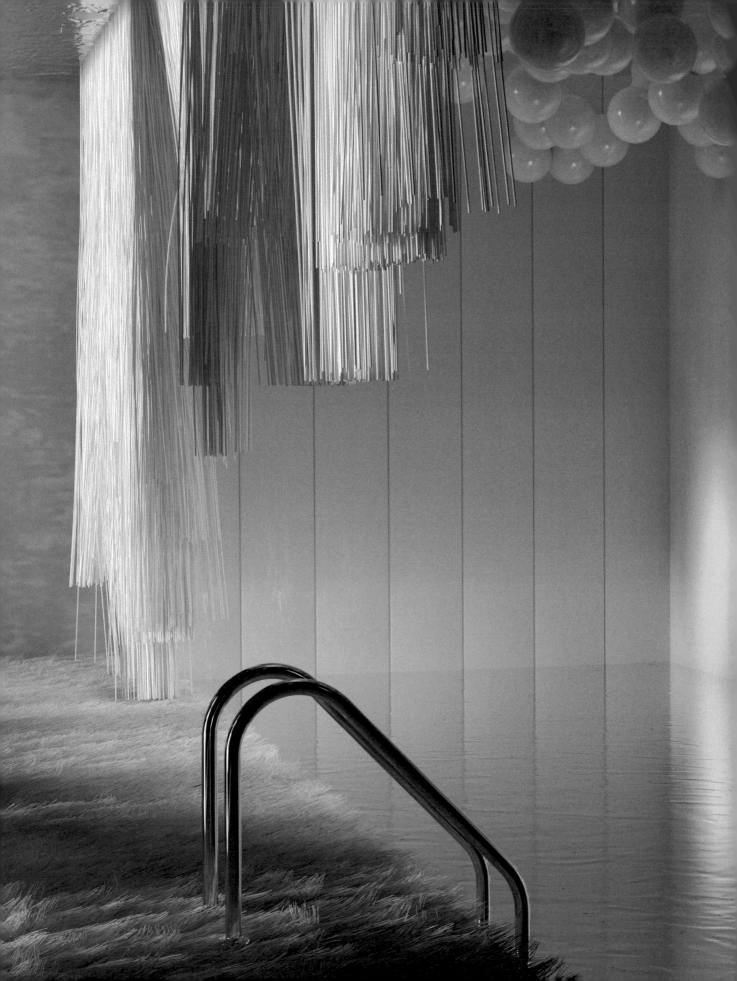

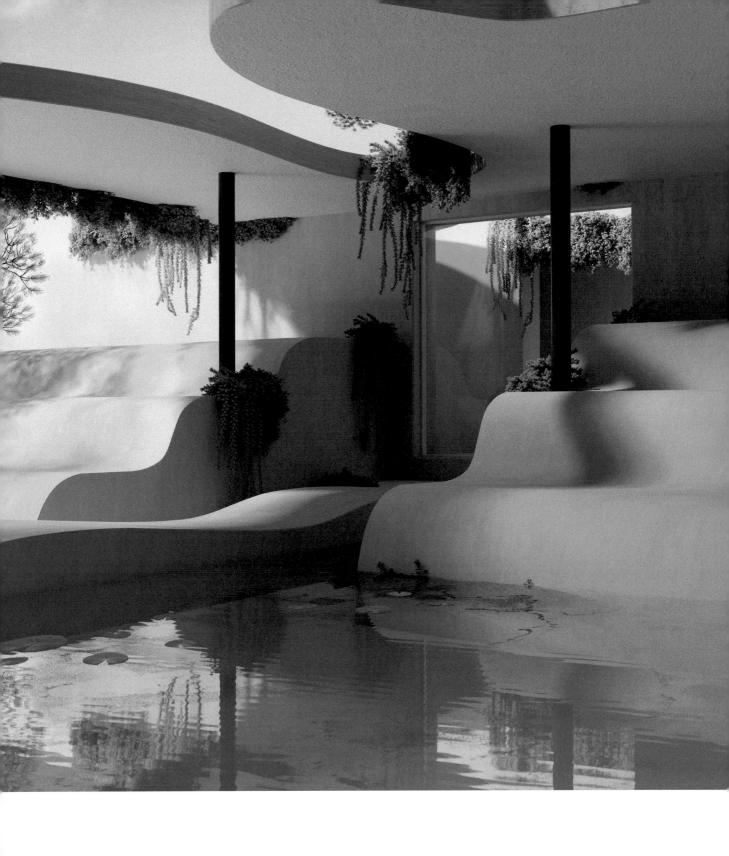

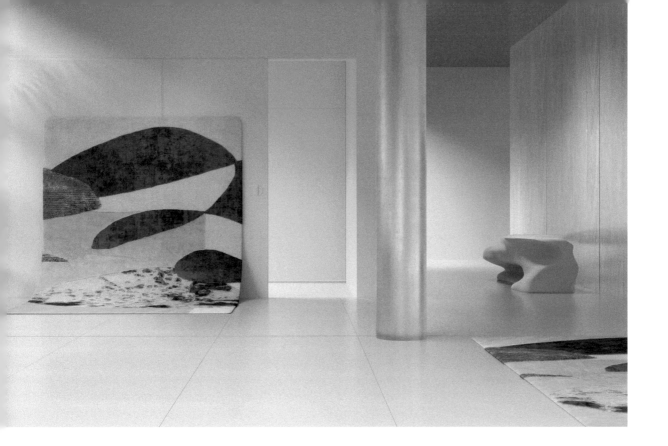

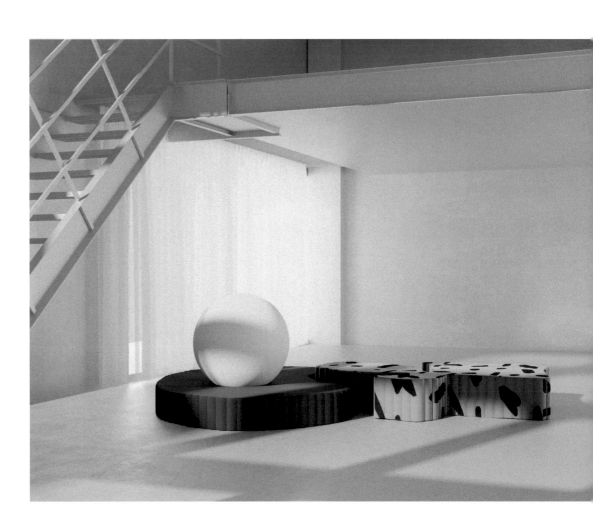

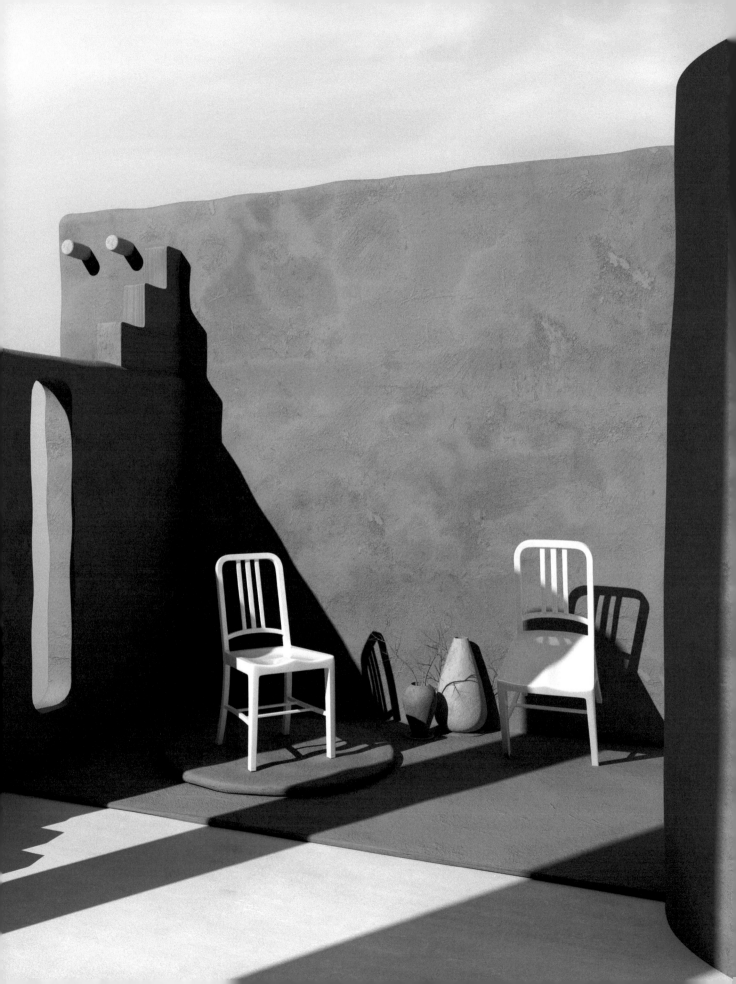

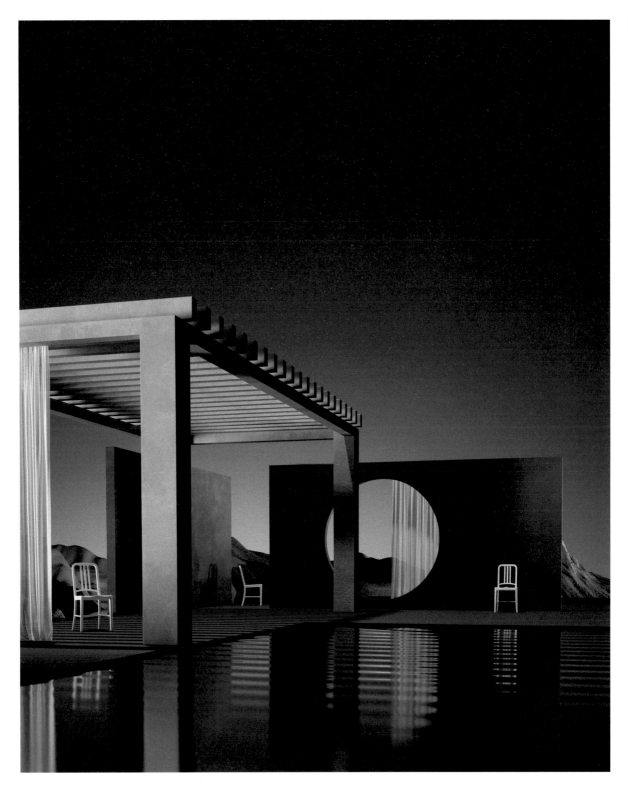

SPOT STUDIO
Barcelona, Spain

Founded in 2018 by Nicolás Cañellas, Spot Studio creates surreal images that question our conception of truth and reality. Working between the visual languages of architecture and industrial and graphic design, the studio creates worlds and spaces that play by different rules than the one we inhabit. Absurdly pink rocks and starry purple skies are combined with chairs, mirrors, and lamps to heighten the sci-fi effect of life on another planet. ✧

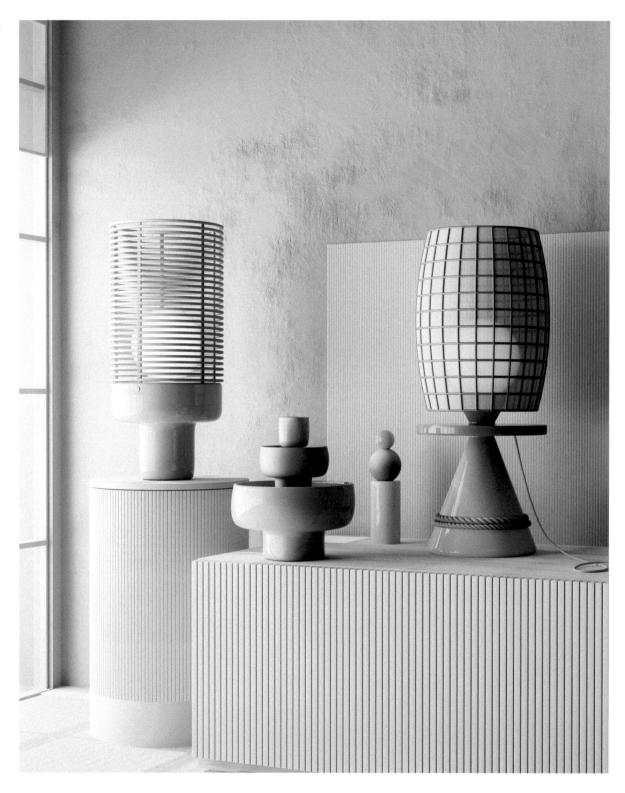

GONZALO MIRANDA
Madrid, Spain

While making visualizations for furniture product design, Gonzalo Miranda began exploring conceptual and abstract elements in his work. Furniture still often takes center stage, but he is interested in what interior and industrial design in a faraway utopian future might look like. Miranda has worked with studios including the Mill, Serial Cut, Hornet NYC, and Moniker SF, as well as clients such as Facebook, Google, and Medellín Design Week. ✧

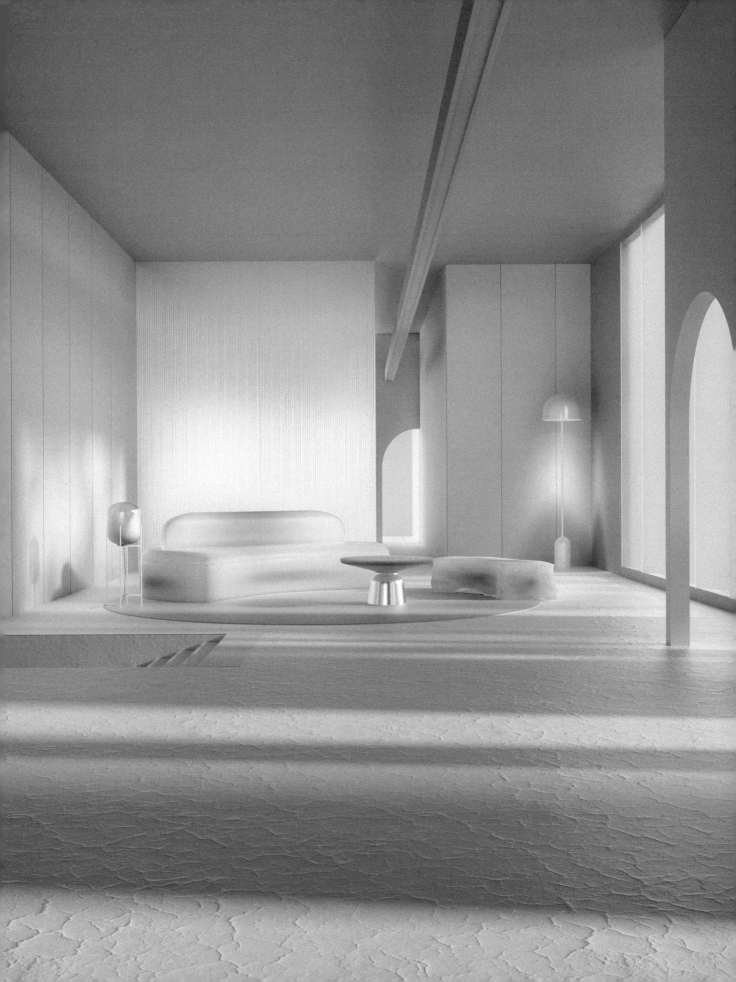

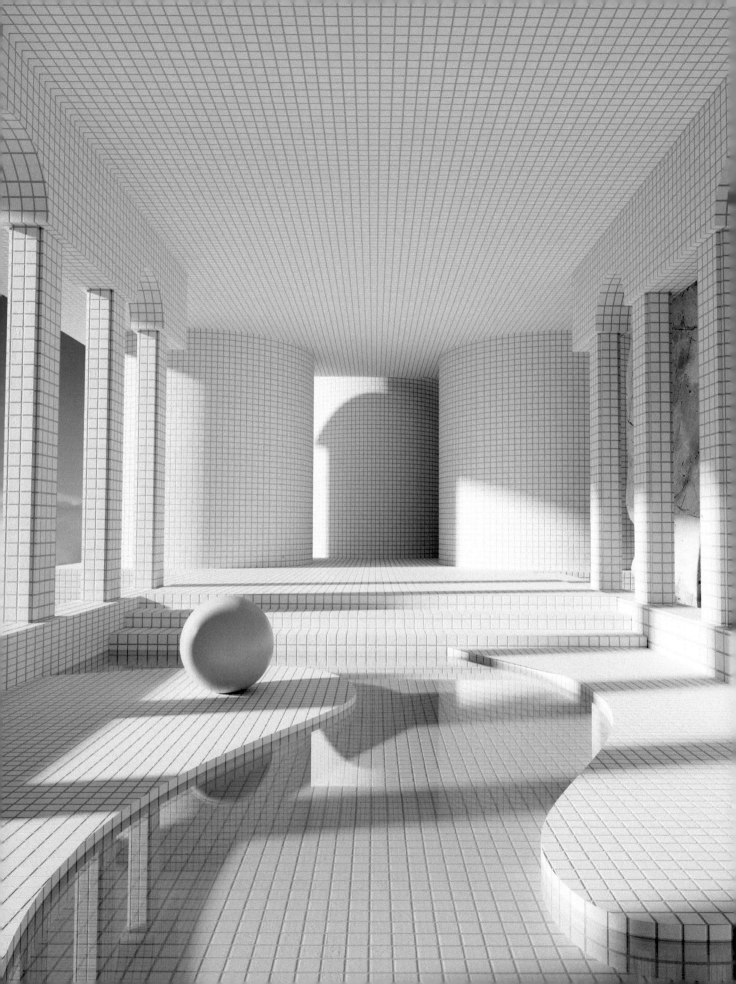

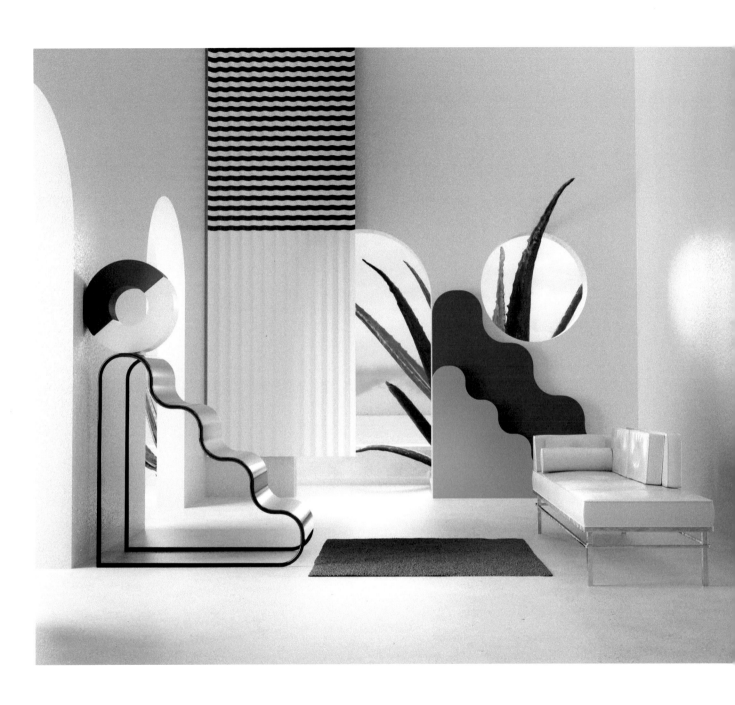

FILMDECAY
San Marcos, TX
USA

Don't let the name fool you, Filmdecay's scenes are never anything but fresh. The photorealistic images that founder Arturo Rodriguez has been producing, after a long period of working in black and white, are designed to be welcoming. Arches, circular patterns, swirls, and pathways transmit a sense of tranquility, while high ceilings evoke the sense of space he needs to think freely. He wants to encourage his viewers to imagine the scent of these imagined spaces. "Scent plays a huge part in nostalgia," he says. "But I leave it up to the viewer to decide what is what." ✧

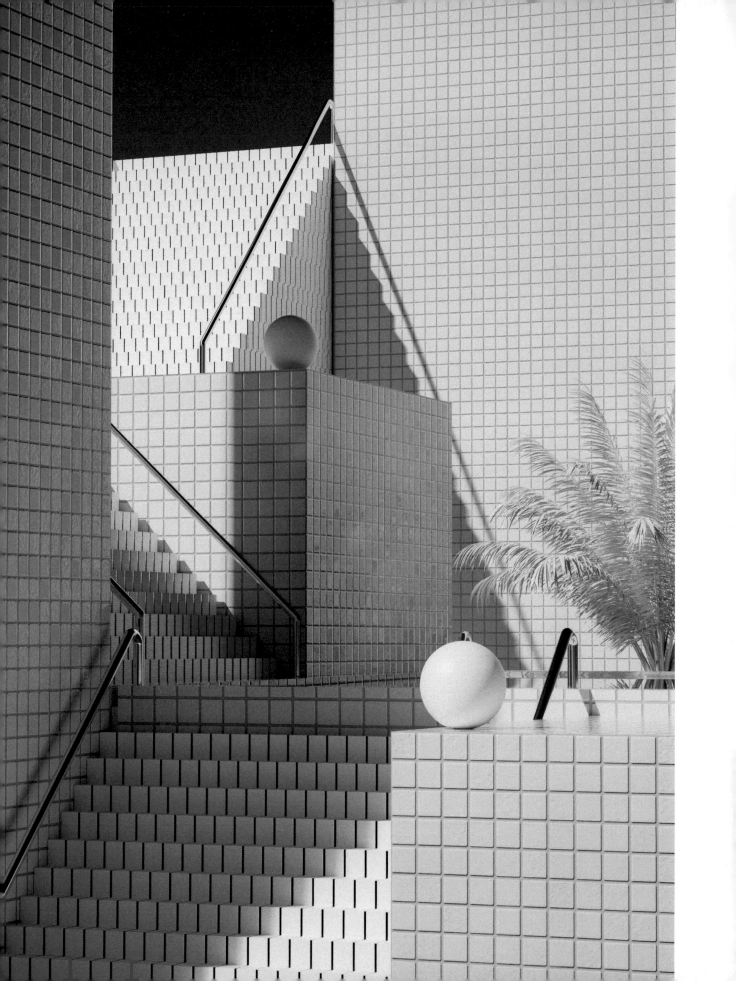

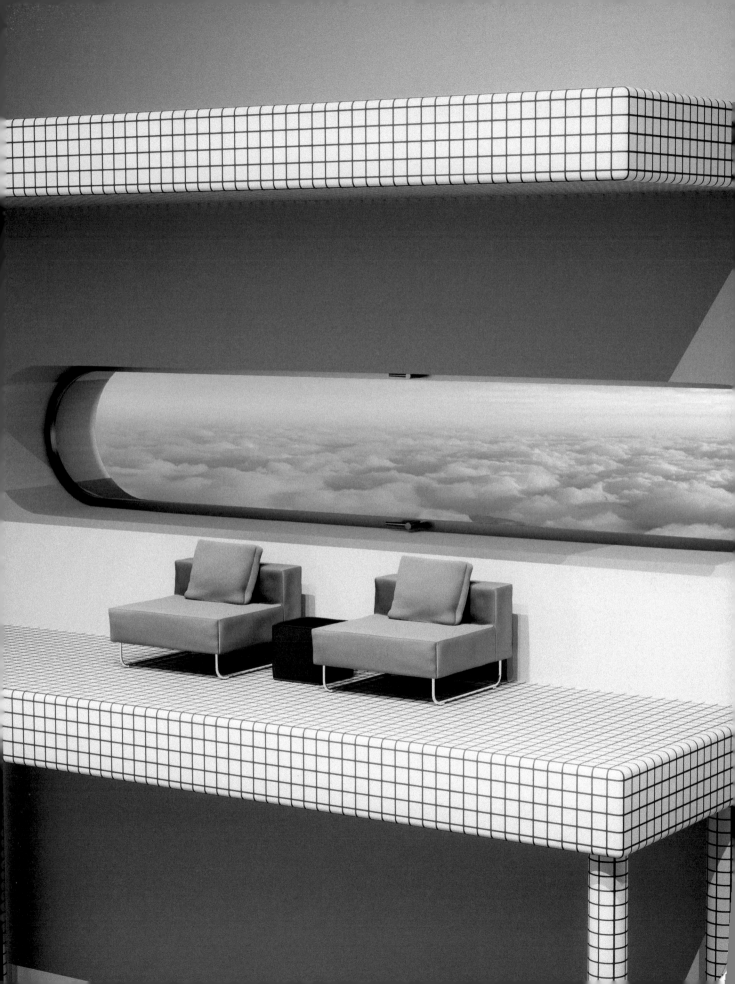

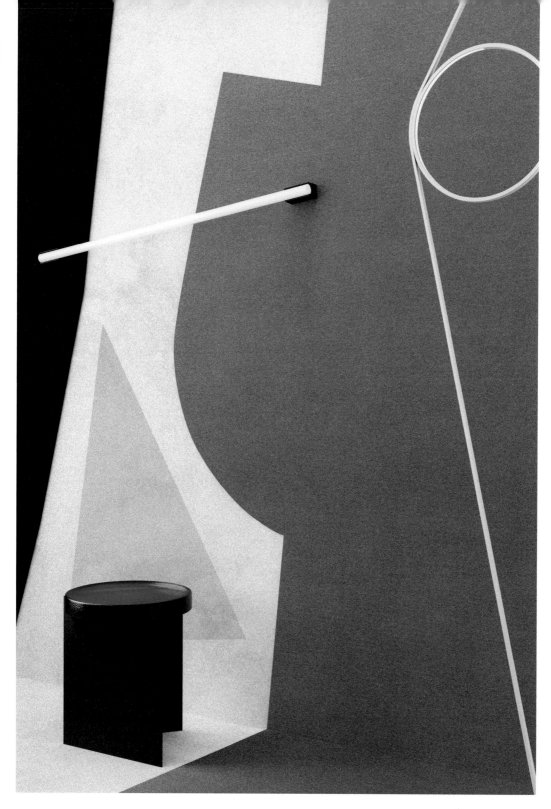

TERZO PIANO
Milan, Italy

When Terzo Piano began creating CGI images, the studio realized the enormous potential of this tool to push 3D beyond realism into the surreal. Their various series of compositions are closely related to abstractionism, and the furniture, architectural styles, and colors are all chosen to transmit the studio's aesthetic and cultural codes. In their series *Picture in Picture*, for example, blown-up photographs of classical scenes merge with contemporary design objects to stimulate a dialogue about our perceptions of space and time. ✦

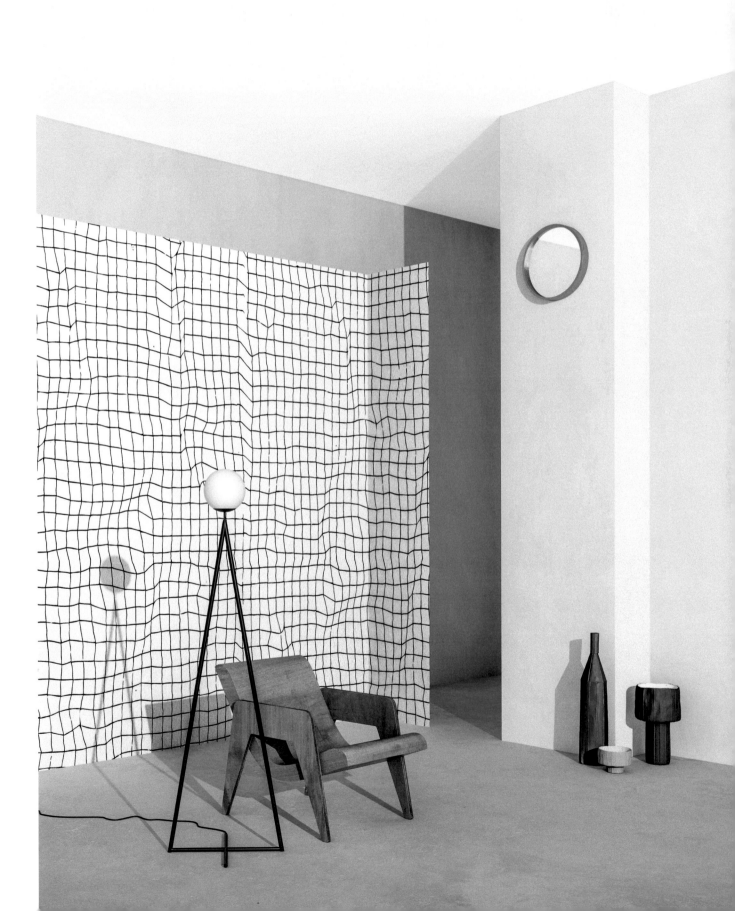

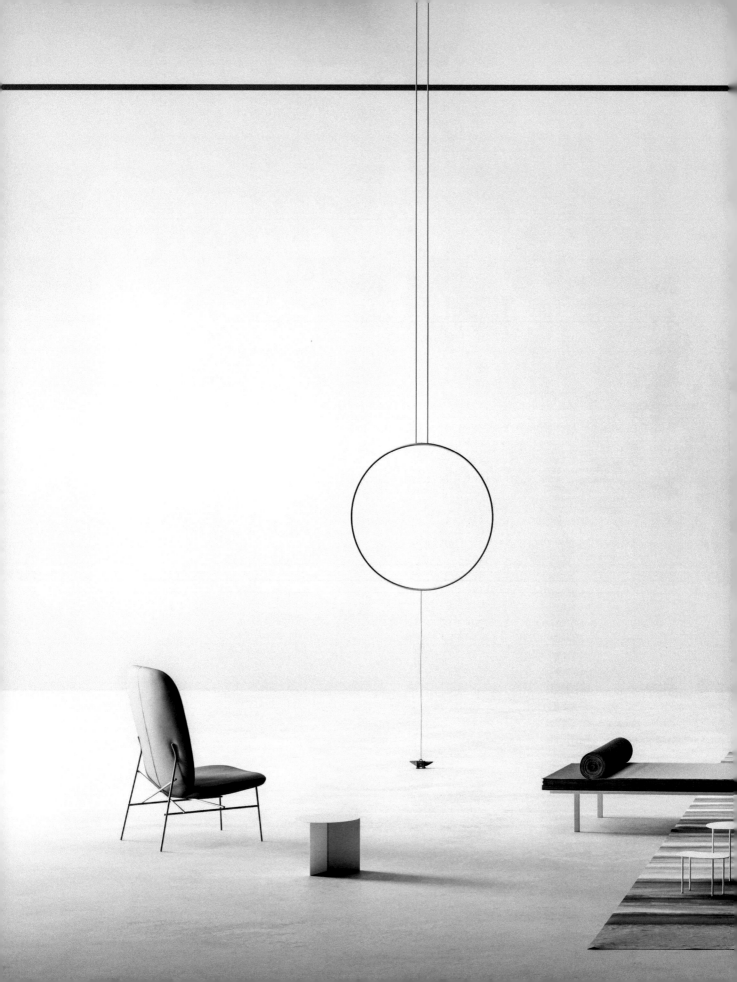

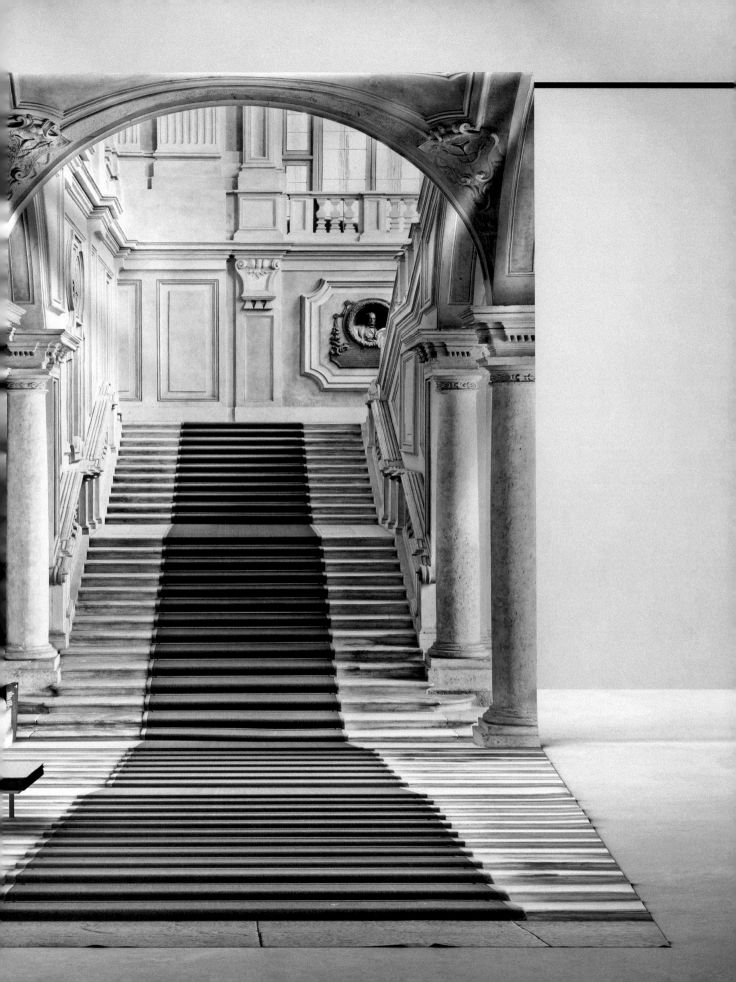

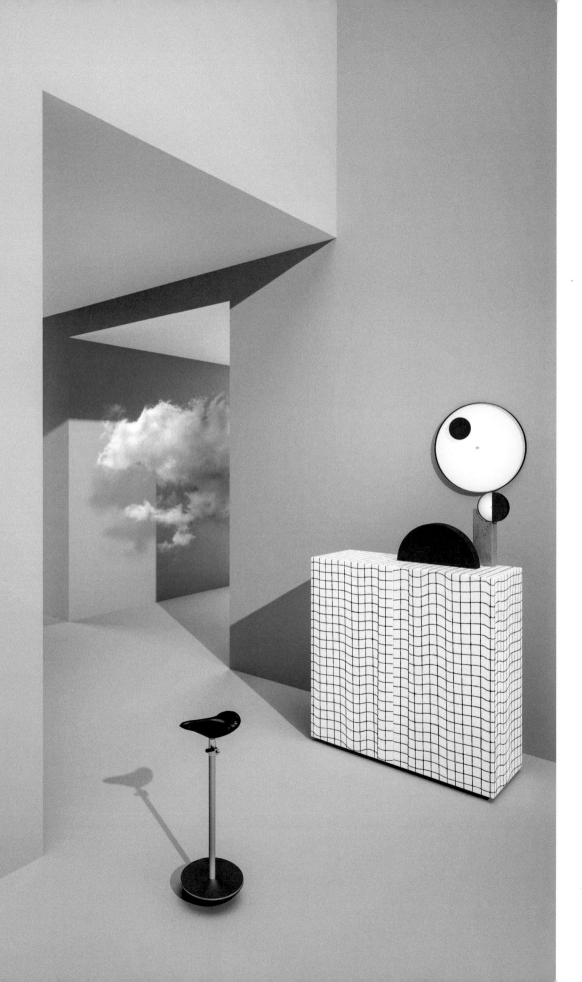

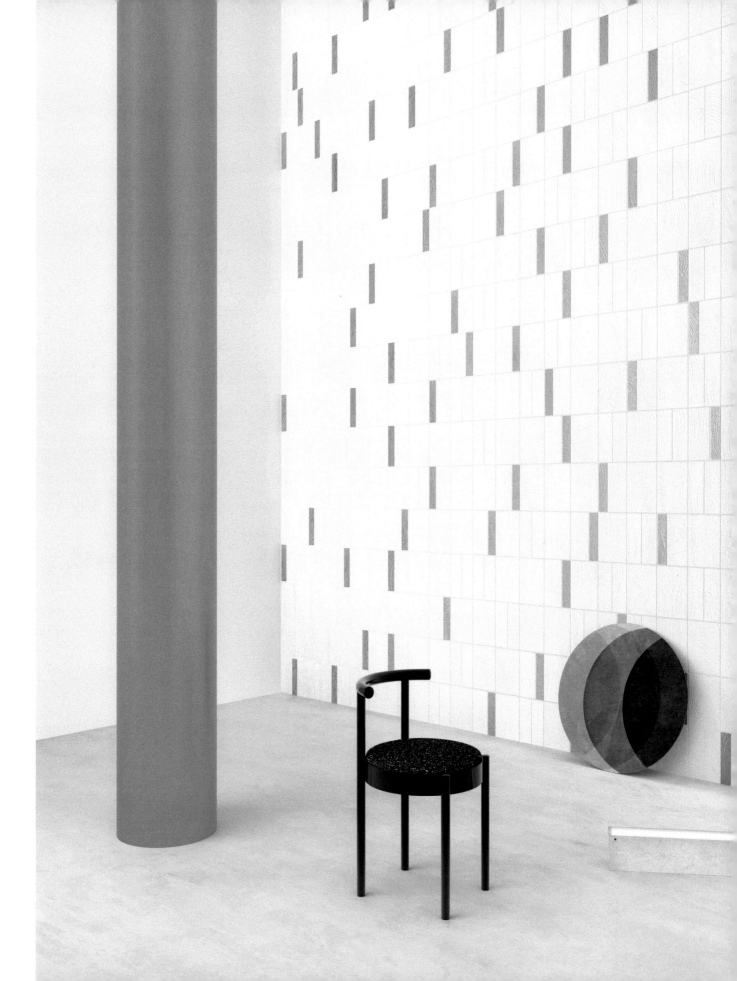

INDEX

BLUNT ACTION
New York City, NY, USA
PP. 128-129
Images: Blunt Action

ROMAN BRATSCHI
Zurich, Switzerland
PP. 158-159
Images: Roman Bratschi

CAMERON BURNS
Minneapolis, MN, USA
PP. 80-81
Images: CaptvartLLC

BÜRO UFHO
Singapore
PP. 164-165
Images: BÜRO UFHO

ALEXIS CHRISTODOULOU
Cape Town, South Africa
PP. 166-175
Images: Alexis Christodoulou

HAYDEN CLAY
Frederick, MD, USA
PP. 82-85
Images: Hayden Clay Williams

MASSIMO COLONNA
Scandiano, Italy
PP. 7 (bottom), 150-157
Images: Massimo Colonna

CRISTINA LELLO STUDIO
Venice, Italy
PP. 134-139
Images: Cristina Lello Studio
Additional Credits: Guido Medici,
pp. 137 and 138-139

ANA DE SANTOS DÍAZ
Madrid, Spain
PP. 130-133
Images: Ana de Santos Díaz

PETER FAVINGER
New York City, NY, USA
PP. 70-71
Images: Peter Favinger/
Nathaniel Garner, p. 70;
Peter Favinger, p. 71

FILMDECAY
San Marcos, TX, USA
PP. 196-199
Images: Arturo Rodriguez

HUGO FOURNIER
Paris, France
PP. 24-27
Images: Hugo Fournier

STEFANO GIACOMELLO
Montreal, Canada
PP. 98-99
Images: Stefano Giacomello

FRANK J. GUZZONE
New York City, NY, USA
PP. 44-45
Images: Frank J. Guzzone

FILIP HODAS
Prague, Czech Republic
PP. 72-79
Images: Filip Hodas Studio s.r.o.

SIMON KAEMPFER
Bremen, Germany
PP. 46-49
Images: Simon Kaempfer

BLAKE KATHRYN
Los Angeles, CA, USA
PP. 36-37
Images: Blake Kathryn

MORTEN LASSKOGEN
Copenhagen, Denmark
PP. 7 (top right), 42-43
Images: Morten Lasskogen
Additional Credits: Moteh

REBECCA LEE
New York City, NY, USA
PP. 50-51
Images: Rebecca Lee

PAUL MILINSKI
Melbourne, Australia
PP. 10-15
Images: Paul Milinski

GONZALO MIRANDA
Madrid, Spain
PP. 6, 194-195
Images: Gonzalo Miranda

JULIEN MISSAIRE
Annecy, France
PP. 116-117
Images: Julien Missaire

JONATHAN MONAGHAN
New York City, NY, USA
PP. 34-35
Images: Jonathan Monaghan

SEBA MORALES
La Plata, Argentina
PP. 28-33
Images: Seba Morales

FRIEDRICH NEUMANN
Leipzig, Germany
PP. 104–105
Images: Friedrich Neumann

NOTOOSTUDIO
Formigine, Italy
PP. 140–149
Images: notooSTUDIO

OUUM
Lvio, Ukraine
PP. 114–115
Images: OUUM
Additional Credits: Yarko Kushta

TERZO PIANO
Milan, Italy
PP. 200–205
Images: Terzo Piano
Additional Credits: Concept,
Set Design, and Styling
by Elisabetta Bongiorni,
pp. 200 and 202–205; Concept,
Set Design, and Styling
by Martina Malventi, p. 201

PZZZA STUDIO
Barcelona, Spain
PP. 118–125
Images: Xavier Cardona (Boldtron)

REISINGER STUDIO
Barcelona, Spain
PP. 7 (top left), 184–191
Images: Andrés Reisinger

SIX N. FIVE
Barcelona, Spain
PP. 52–63
Images: Six N. Five

SPOT STUDIO
Barcelona, Spain
PP. 192–193
Images: Spot Studio
Additional Credits: Nicolas
Cañellas (Creative Director)

STUDIO BRASCH
Stockholm, Sweden
PP. 16–17
Images: Studio Brasch

STUDIO MANÈGE
Montreal, Canada
PP. 160–163
Images: Renée Lamothe

NAREG TAIMOORIAN
Los Angeles, CA, USA
PP. 8, 86–89
Images: Nareg Taimoorian

PETER TARKA
London, U.K.
PP. 5, 176–183
Images: Peter Tarka

CHARLOTTE TAYLOR
London, U.K.
PP. 90–97
Images: Charlotte Taylor/
Nareg Taimoorian, p. 91;
Charlotte Taylor/Alberto
Carbonell, pp. 92–93;
Charlotte Taylor/Victor Roussel,
p. 94; Charlotte Taylor/
Stefano Giacomello, p. 95;
Charlotte Taylor for Tetra,
p. 96; Charlotte Taylor/
Danil Tabacari, p. 97

THOMAS TRAUM
London, U.K.
PP. 126–127
Images: Thomas Traum

ANTONI TUDISCO
Hamburg, Germany
PP. 22–23
Images: Antoni Tudisco

DANIEL URSULEANU
Bucharest, Romania
PP. 100–103
Images: Daniel Ursuleanu

VISUAL CITIZENS
Rotterdam, Netherlands
PP. 9, 38–41
Images: Visual Citizens

YAMBO STUDIO
Tel Avio, Israel
PP. 18–21
Images: Yambo Studio,
Joan Gracia Pons,
Mariusz Becker,
and Philip Lueck

ZEITGUISED
Berlin, Germany
PP. 64–69
Images: ZEITGUISED
Additional Credits:
Ben Sandler (Photography)

SANTI ZORAIDEZ
Buenos Aires, Argentina
PP. 106–113
Images courtesy
of Santi Zoraidez

Dreamscapes
& Artificial Architecture

IMAGINED INTERIOR DESIGN IN DIGITAL ART

This book was conceived, edited,
and designed by gestalten.

Edited by Robert Klanten and Elli Stuhler

Preface by Rosie Flanagan
Texts by Alison Hugill

Editorial Management by Sam Stevenson

Design and layout by Ilona Samcewicz-Parham

Photo Editor: Mario Udzenija

Typefaces: Millionaire by Raphaël Verona
and Panama by Roman Gornitsky

Cover image by Filip Hodas
Back cover images by Cristina Lello Studio
(middle right), Paul Milinski (left), and
Reisinger Studio (top right and bottom right)

Printed by Printer Trento S.r.l., Trento, Italy
Made in Europe

Published by gestalten, Berlin 2020
ISBN 978-3-89955-249-2

For more information, and to order books,
please visit www.gestalten.com

Bibliographic information published by the Deutsche
Nationalbibliothek. The Deutsche Nationalbibliothek lists
this publication in the Deutsche Nationalbibliografie;
detailed bibliographic data is available online at www.dnb.de

None of the content in this book was published in exchange
for payment by commercial parties or designers; gestalten
selected all included work based solely on its artistic merit.

This book was printed on paper certified according
to the standards of the FSC®.